The publisher gratefully acknowledges the generous support
of the Valerie Barth and Peter Booth Wiley Endowment Fund
in History of the University of California Press Foundation
and the Chairman's Circle of the University of California Press
Foundation, whose members are:

Anonymous
Stephen A. & Melva Arditti
Mary Dingman
Sonia H. Evers
Carol & John Field
Adele M. Hayutin
Daniel Heartz
Mrs. Charles Hine
Edmund & Jeannie Kaufman
Lata Krishnan & Ajay Shah
Marilyn Lee & Harvey Schneider
John Lescroart & Lisa Sawyer
Judith & Kim Maxwell
James & Carlin Naify
Barbara Z. Otto
Loren & Frances Rothschild
Meryl & Robert Selig
Ralph & Shirley Shapiro
Lynne Withey

INFINITE CITY

INFINITE

UNIVERSITY OF CALIFORNIA PRESS

Berkeley Los Angeles London

CITY A SAN FRANCISCO ATLAS

OF PRINCIPAL LANDMARKS AND TREASURES OF THE REGION, INCLUDING BUTTERFLY
SPECIES, QUEER SITES, MURDERS, COFFEE, WATER, POWER, CONTINGENT IDENTITIES,
SOCIAL TYPES, LIBRARIES, EARLY-MORNING BARS, THE LOST LABOR LANDSCAPE
OF 1960, AND THE MONUMENTAL MONTEREY CYPRESSES OF SAN FRANCISCO; OF
INDIGENOUS PLACE NAMES, WOMEN ENVIRONMENTALISTS, TOXINS, FOOD SITES,
RIGHT-WING ORGANIZATIONS, WORLD WAR II SHIPYARDS, ZEN BUDDHIST CENTERS,
SALMON MIGRATION, AND MUSICAL HISTORIES OF THE BAY AREA; WITH DETAILS
OF CULTURAL GEOGRAPHIES OF THE MISSION DISTRICT, THE FILLMORE'S CULTURE
WARS AND METAMORPHOSES, THE RACIAL DISCOURSES OF UNITED NATIONS PLAZA,
THE SOUTH OF MARKET WORLD THAT REDEVELOPMENT DEVOURED, AND OTHER
SIGNIFICANT PHENOMENA, VANISHED AND EXTANT.

BY REBECCA SOLNIT

WITH CARTOGRAPHERS
Ben Pease
Shizue Seigel

DESIGNER
Lia Tjandra

AND

ARTISTS	WRITERS	CHIEF RESEARCHER
Sandow Birk	Summer Brenner	Stella Lochman
Mona Caron	Adriana Camarena	
Jaime Cortez	Chris Carlsson	ADDITIONAL CARTOGRAPHY
Hugh D'Andrade	Lisa Conrad	Darin Jensen
Robert Dawson	Guillermo Gómez-Peña	
Paz de la Calzada	Joshua Jelly-Schapiro	ADDITIONAL RESEARCH
Jim Herrington	Paul La Farge	Robin Grossinger
Ira Nowinski	Genine Lentine	and Ruth Askevold,
Alison Pebworth	Aaron Shurin	San Francisco Estuary
Michael Rauner	Heather Smith	Institute
Gent Sturgeon	Richard Walker	
Sunaura Taylor		

University of California Press, one of the most distinguished university presses in the United States, enriches lives around the world by advancing scholarship in the humanities, social sciences, and natural sciences. Its activities are supported by the UC Press Foundation and by philanthropic contributions from individuals and institutions. For more information, visit www.ucpress.edu.

University of California Press
Berkeley and Los Angeles, California

University of California Press, Ltd.
London, England

Illustrations on half title and title page by Alison Pebworth

Photographs on pages 87 and 89 © Ira Nowinski, No Vacancy Photography Archive, The Bancroft Library, U.C. Berkeley

Library of Congress Cataloging-in-Publication Data

Solnit, Rebecca.
 Infinite city : a San Francisco atlas / cartography by Ben Pease and Shizue Seigel.
 p. cm.
 ISBN 978-0-520-26249-2 (cloth : alk. paper) — ISBN 978-0-520-26250-8 (pbk. : alk. paper)
 1. San Francisco Bay Area (Calif.)—Maps. 2. San Francisco (Calif.)—Maps. I. Title.
 G1527.s22S6 2010
 912.794'6—dc22

 2010019735

Designer and compositor: Lia Tjandra
Cartographers: Ben Pease and Shizue Seigel
Text: Dante MT
Display: Dante MT, Archer Pro
Prepress: Embassy Graphics
Printer and binder: QuaLibre

Manufactured in China

19 18 17 16 15
10 9

CONTENTS

EVERY PLACE DESERVES AN ATLAS, an atlas is at least implicit in every place, and to say that is to ask first of all what a place is. Places are leaky containers. They always refer beyond themselves, whether island or mainland, and can be imagined in various scales, from the drama of a back alley to transcontinental geopolitical forces and global climate. What we call places are stable locations with unstable converging forces that cannot be delineated either by fences on the ground or by boundaries in the imagination—or by the perimeter of the map. Something is always coming from elsewhere, whether it's wind, water, immigrants, trade goods, or ideas. The local exists—an endemic species may evolve out of those circumstances, or the human equivalent—but it exists in relation, whether symbiotic with or sanctuary from the larger world. Pocatello, Idaho, has had its inventions and tragedies: a heartbreak that can be mapped out in six blocks, with bars and slammed doors and a bedroom; the tale of what happened to the lands of the Shoshone and Bannock; a gold rush; the larger forces of geology and climate and animal migration and watersheds. Petaluma, California, has its radical chicken farmers and Coast Miwok name and its atlas waiting to happen, as do Flint and Buffalo, Yellowknife and Chimayo. The cup of coffee in your hand has origins reaching across the region and the world.

A city is a particular kind of place, perhaps best described as many worlds in one place; it compounds many versions without quite reconciling them, though some cross over to live in multiple worlds—in Chinatown or queer space, in a drug underworld or a university community, in a church's sphere or a hospital's intersections. An atlas is a collection of versions of a place, a compendium of perspectives, a snatching out of the infinite ether of potential versions a few that will be made concrete and visible. Every place deserves an atlas, but San Francisco is my place, and therefore the subject of this atlas, which springs from my perspective, with all its limits. And the place that is San Francisco has both a literal geography as the tip of the peninsula that juts upward like a hitchhiking thumb and another, cultural, geography as the most left part of the left coast, the un-American place where America invents itself.

ON THE INEXHAUSTIBILITY OF A CITY

I have travelled a good deal in Concord . . .
—Henry David Thoreau, *Walden*

"You take delight not in a city's seven or seventy wonders, but in the answer it
gives to a question of yours."
 "Or the question it asks you, forcing you to answer, like Thebes through the
mouth of the Sphinx."
—Marco Polo and Kublai Khan, in Italo Calvino, *Invisible Cities*

In one of Jorge Luis Borges's most famous parables, cartographers make more
and more exact maps until "the craft of Cartography attained such Perfec-
tion that the Map of a Single province covered the space of an entire City, and
the Map of the Empire itself an entire Province. In the course of Time, these
Extensive maps were found somehow wanting, and so the College of Cartog-
raphers evolved a Map of the Empire that was of the same Scale as the Empire
and that coincided with it point for point." The map in this one-paragraph
essay, "On Exactitude in Science," is meant to be a fool's triumph, a confu-
sion of the thing with its representation, an extension of logic to preposterous
lengths. Even so, the tale has been read as a serious allegory about representa-
tion overtaking its subject.

A map is in its essence and intent an arbitrary selection of information.
What the College of Cartographers could have done in pursuit of thorough-
ness and even vastness, and what many mapmakers and teams like it have done
over the past half millennium, is to produce an atlas. An atlas may represent
many places in the same way or the same place in many ways, and it is in the
myriad descriptions that the maps begin to approximate the rich complexity of
the place, of a place, of any place. Scale matters: San Francisco map collector
and scholar David Rumsey owns the first great atlas of France, in two huge
volumes, produced over eighty years and three generations by the Cassini fam-
ily of surveyors, cartographers, and engravers. The magnificent prints, page
after page, show the country in such detail that this particular spring and its
surrounding grove are visible, that hamlet, the back road between a mill and

a minor church. It's not Borges's map on a 1:1 scale, but it approaches it. Scale matters, but maps select. The big maps in those old books show terrain exquisitely, but they don't show ownership in much detail, or history, or economics, or air currents. They lack geology, biography, botany, and much else, despite the marvelous detail of their topography.

Another Borges essay, "Avatars of the Tortoise," an elaboration of a paradox by Zeno, has a better allegory for mapping. "Achilles runs ten times faster than the tortoise and gives the animal a headstart of ten metres." But the hero will never overtake the lumbering beast, according to Zeno's logic. "Movement is impossible (argues Zeno), for the moving object must cover half of the distance in order to reach its destination, and before reaching the half, half of the half, and before half of the half, half of the half of the half, and before . . ." Call the place to be mapped the distance, call mapping a race, and see that the cartographer in describing the territory must make another map, and another, and another, and that the description will never close the distance entirely between itself and its subject. Another writer, Italo Calvino, created another sense of vastness in his *Invisible Cities*, from which this atlas draws its title; his book contains descriptions of many magical and strange cities, often assumed to be the same beloved city, Venice, described many ways, with the implication that it could be described many more ways. Venice, like San Francisco, is small; they are vast not in territory but in imaginative possibility.

Every place is if not infinite then practically inexhaustible, and no quantity of maps will allow the distance to be completely traversed. Any single map can depict only an arbitrary selection of the facts on its two-dimensional surface (and today's computer-driven Geographic Information System [GIS] cartography, with its ability to layer information, is only an elegantly maneuverable electronic equivalent of the transparent pages that were, in the age of paper, more common in anatomy books). For *Infinite City*, this selection has been a pleasure, an invitation to map death and beauty, butterflies and queer histories together, with the intention not of comprehensively describing the city but rather of suggesting through these pairings the countless further ways it could be described. (I also chose pairs in order to use the space more effectively, to play up this arbitrariness, and because this city is, as all good cities are, a compilation of coexisting differences, of the Baptist church next to the dim sum dispensary, the homeless outside the Opera House.)

The Borges map may have been coextensive with its territory, but it could not have been an adequate description of that territory, could not have even approached charting its flora, its fauna, its topography, and its history. A static map cannot describe change, and every place is in constant change. I map your garden. A swarm of bees arrives, or a wind blows the petals off the flowers. You plant an apricot sapling or fell a shattered spruce; the season or even just the light changes. Now it is a different garden, and the map is out of date; another map is required; and another; yet another, to show where the marriage proposal, the later marital battle, the formative skinning of a knee or sting of a bee or first memory, and the hours of time lost to sheer pleasure and reverie took place. One of the key steps on the route to enlightenment for Siddhartha was the recollection of a childhood moment of serenity and completeness under a rose-apple tree in a garden. On the map of enlightenment, the garden has no

walls. It takes yet another map to show how the garden fits into the continental weather patterns, or the racial patterns of the neighborhood; another to indicate where the plants came from, including the Asian pomegranates and nasturtiums, the Middle Eastern damask rose and American sunflowers; and, if a bomb strikes the garden in the course of a war, still another map to fit that bomb into the geopolitics of war, bringing us to another scale.

San Francisco has eight hundred thousand inhabitants, more or less, and each of them possesses his or her own map of the place, a world of amities, amours, transit routes, resources, and perils, radiating out from home. But even to say this is to vastly underestimate. San Francisco contains many more than eight hundred thousand living maps, because each of these citizens contains multiple maps: areas of knowledge, rumors, fears, friendships, remembered histories and facts, alternate versions, desires, the map of everyday activity versus the map of occasional discovery, the past versus the present, the map of this place in relation to others that could be confined to a few neighborhoods or could include multiple continents of ancestral origin, immigration routes and lost homelands, social ties, or cultural work. Be wildly reductive: say that every San Franciscan possesses only ten maps and that this has been true for all those who preceded us, and we're already imagining tens of millions of maps. This leaves aside other maps that might reach comprehensiveness, maps of the daily—no, the hourly, for it changes—weather, of plantings, of the rise of buildings and the fall of some of them, of the journey of Oscar Wilde through the city on a day in 1882 or John Lee Hooker in 1989 or an Ohlone in 1688 (a path that cannot be mapped, though perhaps the wanderings of Wilde and Hooker could be), of every inhabitant's most adventurous day in the city, of butterfly migrations and extinctions and the return of raptors and coyotes to the city in the past decade or so. In his book *Wild Men*, writer Douglas Sackman has mapped a walk on which Ishi, the last surviving Yahi Indian, and Berkeley anthropologist Alfred L. Kroeber took members of the Sierra Club in 1912, starting from the tip of the Panhandle of Golden Gate Park and traveling across the hilltops above the University of California, San Francisco, where Ishi then lived.

About fourteen thousand years ago, during the height of the last ice age, San Francisco was not what it is now, a seven-mile-square tip of a peninsula. It was part of a landmass that extended about ten miles farther west in that age of low oceans here and huge glaciers elsewhere; San Francisco Bay did not exist. The channel of the Golden Gate was still being carved by the great convergence of rivers that drain the Sierra Nevada's western slope into the sea. The bay is, in a haunting phrase, called a drowned river mouth. Once, its islands were only hilltops, for the river channel that still goes deep beneath the bridge was carved out when the sea was lower and the rivers stretched farther west. Every stage of the rise of the seas to their present level could be a distinct map, adding a few thousand more maps at a minimum to our endless atlas, which remains incomplete. Climate change will gradually render all atlases with coastlines out of date and create a sequence of new cartographies—of the Northwest Passage, the now feasible route that was impracticable for most of nautical history; of the glaciers, the polar ice, Greenland; of beaches, low islands, and coral reefs. (The last map in this book, "Once and Future Waters,"

suggests what the San Francisco coastline might look like after a meter and a half or so of ocean rise.)

Other coastlines existed farther west once upon a time—and east. In *The Natural World of San Francisco*, ecological historian Harold Gilliam writes of the extremely limited original habitat of the Monterey pine and Monterey cypress before they were cultivated all over the world:

> The three coastal areas where the pines are native are all west of the fault. And these areas were evidently once part of Salinia, that ancient land mass that is believed to have once existed west of the present shoreline one hundred million years ago, a time when most of California was sea bottom and the waves broke on the foothills of the ancestral Sierra Nevada, one hundred and fifty miles to the east. Over the eons Salinia, presumably the original home of the Monterey pine, eroded away into a series of islands (of which the Farallones are a remnant). Some of these islands became part of the newly risen mainland, and these are today the three botanic "islands" of Monterey pine along the coast. The tree comes down to us as a botanic vestige of an earlier epoch and a vanished landscape. Unlike the popular stereotype of the pointed pine tree, the Monterey often is eccentric, with a flat or rounded crown and branches taking off into space at all angles, as if it were a remnant of an era of freedom before the pines were regimented by evolution into the conventional shape.

And the cypresses from that island exist still and have spread around the world, becoming the iconic tree of San Francisco. The tree is a majestic form, in groves and single examples all over San Francisco, from the Sunnydale Housing Projects to Lands End, with a thick gray trunk and strong branches that sweep up and out to a jagged crown of dark green that is sometimes shaped by the wind, sometimes flat and a little jagged, trees standing alone like Old Testament prophets, in formation like Greek choruses, bearing witness to wind, to light, to weather, to endurance. Monterey cypresses stand for beauty on this atlas's map "Death and Beauty."

Imagine the age when the Sierra Nevada had a seacoast and Salinia was out there in the sea, and think of the myriad maps required to describe the geological shifts between that topography and ours, and then project forward a little into the era of ocean rise and a lot into the deep time of tectonic shift, and you see more maps floating, falling, drifting, an autumn storm of maps like leaves, off the trees of memory and history, a drift of maps, an escarpment of versions. Imagine these maps by the millions of this one place and know that if they could possibly exist and be placed next to each other, they would cover far more than the small cityscape of San Francisco. Borges's map that covers up its territory is by comparison a modest achievement.

A book is an elegant technique for folding a lot of surface area into a compact, convenient volume; a library is likewise a compounding of such volumes, a temple of compression of many worlds. A city itself strikes me at times as a sort of library, folding many phenomena into one dense space—and San Francisco has the second densest concentration of people among American cities, trailing only New York, a folding together of cosmologies and riches and poverties and possibilities. After living in a much more homogenous rural place for several months in 1997, I came home to San Francisco and wrote,

in delight· "Every building, every storefront seemed to open onto a different world, compressing all the variety of human life into a jumble of conjunctions. Just as a bookshelf can jam together wildly different books, each book a small box opening onto a different world, so seemed the buildings of my city: every row of houses and shops brought near many kinds of abundance, opened onto many mysteries: crack houses, zen centers, gospel churches, tattoo parlors, produce stores, movie palaces, dim sum shops." A friend visiting from Mexico and staying on Clement Street remarked on the fantastic jumble that this city in particular provides, the dim sum, Burmese food, Korean barbecue, sushi, Thai curries, and more just on the stretch where he was residing. Another friend who moved here from Salt Lake City pointed out that she could eat at a different restaurant every night of the year for the rest of her life—and even if she exhausted the thousands that currently exist, new restaurants would presumably keep opening so that she would never have to repeat. Her city is more inexhaustible than her appetite.

As a citizen of this city for some thirty years, I am constantly struck that no two people live in the same city. Your current surroundings exist in relation to your other places, your formative place and whatever place shaped your ethnic heritage and education, and in relation to your role in this current place—whether people look at you with suspicion, whether you're fearful or confident, whether lots of people or few look like you, whether you run in the park or drink in the alleys, whether you swim in the bay or work in the towers by day as a broker or by night as a janitor. If you pay attention to the neighbors, you find other worlds within them, and other neighborhoods magnify this effect. Most of us settle into familiar routines in which we see the same places and people—people like ourselves, mostly—in the city, but it takes very little, just looking around on the bus or getting a bit lost on the way to some everyday place and sometimes not even that, to land in an unfamiliar city, to find that the place is inexhaustible. I share my neighborhood with undocumented immigrants who seem to trail behind them the paths they took from their homelands; San Francisco is to them a new place and something of a wilderness in which they are hunted by immigration authorities and must live by their wits. I share it too with inner-city teenagers, many of whom have hardly left the neighborhood and know little of what lies beyond it, but who know the neighborhood itself with a vividness that is also about survival, knowing where friends and enemies are situated, where rivals' boundaries are drawn, and how to navigate a space that is for them far more dramatic than it is for most of us. (In one map for this atlas, Adriana Camarena has charted this dual relationship in the Mission.) A city is many worlds in the same place.

Or many maps of the same place. One of the pleasures of this project has been the encounters with people who are incarnate histories of this locality. The poet-artist Genine Lentine of the San Francisco Zen Center told me about her friends at the Academy of Sciences who had described the recent death of a biologist as the loss of a living bibliography no printed volume or online archive could replicate, and I thought of the living books in Angeleno Ray Bradbury's novel *Fahrenheit 451*. Set in a book-burning future, the tale ends in a literal forest full of fugitives who have each memorized a book and thus become it: they are introduced not as individuals but as incarnate books, clas-

sics. Books in our time are made of paper from trees, but that forest is full of books made of memory, flesh, and passion. In the course of making this atlas, I have met people who have become living atlases, met the glorious library of my fellow citizens: Labor, Butterflies, Bars, Zen in America, Salmon in California, and Water, Toxics, Food, Trees, Weather, Movie Theaters, Lost Worlds, and—the list is long, the population is large. These are some of the unmappable treasures of the region, not the places and systems themselves but the people dedicated to knowing them. At the core of *Fahrenheit 451* is the belief that knowledge is a passionate pleasure, reflected in the pleasure of these local scholars and experts. The knowledge needs to be passed on to the extent that it can and built in part from scratch by each savant, as it was for each of these living books that have guided me.

I live among these trees, these books. I also live among ghosts. For better or worse, the familiar vanishes, so that the longer you live here, the more you live with a map that no longer matches the actual terrain. After the great 1972 earthquake, Managua, Nicaragua, lost many of its landmarks; people long after gave directions by saying things like, "Turn left where the tree used to be." I remember when the bar Toronado was the flying wedge prying open the Lower Haight for white kids in the hitherto African American zone; I still miss the gigantic iron 17 Reasons Why rooftop sign at Seventeenth and Mission that Alison Pebworth installed on our title page (and after many years here found out from the now-deceased San Francisco filmmaker and artist Bruce Conner what it meant, and yet more recently where it's gone); I vividly recall the Musée Mécanique when it was at the Cliff House; and I have faint memories of Playland at the Beach, the gritty amusement park at Lands End, destroyed in 1972, which sets me apart from all my friends who moved here after and groups me with some of the older locals I know.

More than that, I remember the worn old industrial city with its vacant lots and low pressure of the 1980s and how booms filled up all the empty space and squeezed everything in tight. I remember the ruined brewery where the fortress-like Costco now sits south of Market, and when the beer vats at 145 Florida Street in the armpit of the Central Freeway were a squat and a punk rehearsal space, not retail and offices adjoining the new big-box zone of Best Buy and Office Max. I remember the vacant lots that succeeded the old men's neighborhood south of Market and the raucous resistance there to the 1984 Democratic Convention happening in the new Moscone Center, where another piece of that neighborhood had been, but I don't remember the old neighborhood before redevelopment. That erasure became Yerba Buena Center, an amnesiac place with a memorious name (Yerba Buena, the little herb that adorns the cover of this book, is also the original name of the place that was rechristened San Francisco in 1847).

San Francisco is divided into those who remember a vanished or mutated landmark or institution and those who came later, from Zim's and the Doggie Diners to the pre-1989 Embarcadero Freeway—to, if you reach much further back in time, the ninety-nine-year-old painter Add Bonn's astonishing comment that she didn't like the Golden Gate Bridge because the view had been so much more majestic beforehand. And then she told me of sitting on hilltops watching the ships come through an unshackled gate, the magnificent entry-

way to one of the great estuaries of the world, which John C. Fremont in 1846 named after the Golden Gate of Istanbul, which was then still Constantinople and had once been Byzantium, and after the Golden Horn, which was Constantinople's great harbor. (Add Bonn's life in San Francisco is charted in the "Four Hundred Years" map here.)

I remember the African Orthodox Church of St. John Coltrane when it was at Divisadero just off Oak, before it was evicted by a greedy landlord during the dot-com boom, and remember further back when my old North-of-Panhandle neighborhood was so full of local churchgoers attending the many places of worship there that the Sunday morning streets were like a festival of dressed-up people heading in all directions and greeting each other on the way, back before the long stretch of shuttered storefronts between Divisadero's black and white eras. I remember the revelation of Sunday hats. Over the years, most of the churchgoers moved and began driving to church, and then some of the churches dried up and went away, and then I moved a short stroll away to another world.

I spent my first several months as a San Franciscan in a residential hotel in Polk Gulch, coexisting with Vietnamese transvestites and disabled bikers and grumbling building managers and scurrying cockroaches. Later I resided for twenty-five years in that part of the Western Addition, seeing many of my African American neighbors navigate a neighborhood that was radically different from mine, more gregarious, maybe more limited, and much more dangerous for the young men. The older people I came to know were part of the great African American migration northward during the economic boom of the Second World War (the subject of the map "Shipyards and Sounds"). They remembered another San Francisco, one in which Fillmore Street was a thriving center—its wartime arches of lights were fondly remembered by Ernest Teal, my wonderful former neighbor, dapper and radiant, like a cross between Cab Calloway and Gandhi—not the redevelopment-gutted boulevard I found in the early 1980s. They lived in some ways as though they were in small southern towns; James V. Young and Veobie Moss, both gone long ago, spent a lot of time out in front of their buildings talking to passersby and keeping an eye on the street, improvising front porches out of the architecture at hand. When I found myself in the South in this decade, it felt oddly familiar at times, and I realized I'd been in a version of it all those years, or at least a faint overlay of it, not as explicit an ethnic atmosphere from elsewhere as a Little Saigon or a Manilatown—but something hovered in the air. As the neighborhood turned paler and more affluent, it became more suburban; the newcomers didn't move around as much on foot, and a lot of them considered direct contact an affront or a threat, though that has softened and some have become good neighbors. Same place, different world.

I know where the last brown satyr butterfly on earth was found: on Lone Mountain, not far from my home, the mountain that stands out so starkly in Eadweard Muybridge's magnificent 1878 photographic panoramas of the place, taken before the western half of the city was much developed. (It was the disappearance of the Xerxes blue butterfly in the Presidio, during wartime expansion of this military reservation on the city's north coast, that became famous, though.) Only recently, on a walk with Deirdre Elmansouri and Liam

O'Brien to see the last local habitat of the green hairstreak butterfly, I found myself standing atop what Liam told us is the largest sand dune on the West Coast, more than a mile inland from the beach, on part of what were once the great sandy wastes of San Francisco, now largely covered up or converted to something lusher. (Though indignant partisans have sometimes portrayed Golden Gate Park as a natural landscape trammeled by its museums, it was little but sand before soil and then trees and landscaping were built up in the late nineteenth century.) That day I saw my first green hairstreak, a delightful tiny butterfly in the most exquisite chartreuse, but also saw portions of that dune, which constitutes a hilltop neighborhood around Fourteenth Avenue from Moraga to Rivera in the Sunset (the alphabetical streets of the west side of town are a litany of conquistadors and Spaniards: Noriega, Ortega, Pacheco, Quintara, Rivera, and so on).

Over the maps of any theater of war in 1945 can be inscribed the maps of bird migration, the flights of the swallows and cranes who sabotage borders and nationalism by demonstrating that such phenomena do not exist in their avian world. (East Bay beekeeper and artist Mark Thompson put a beehive next to the Berlin Wall in the summer of 1989 to gather honey indiscriminately from both sides of the city, for the bees did not acknowledge merely political boundaries; earlier, in San Francisco, he interpreted bee dances and followed his bees to draw up apicentric maps of the city.) While my story is mine, my map of San Francisco is also potentially yours; both can be charted on the same map, and where the past has been mapped the future may yet inscribe other adventures. The maps we get most of the time show conventional reality—freeways and not bird migration routes, shopping highlights and not subjective memories—but those other things can always be planted atop the usual versions.

Maps are always invitations in ways that texts and pictures are not; you can enter a map, alter it, add to it, plan with it. A map is a ticket to actual territory, while a novel is only a ticket to emotion and imagination. *Infinite City* is meant to be such an invitation to go beyond what is mapped within it. The amount of knowledge about a place is, in Borges's 1:1 scale map, coextensive with it, but that map is not nearly as informative as our imaginary archive of atlases. This mapping of San Francisco would beget something more akin to Borges's infinite libraries and endlessly expand to contain this atlas in hundreds of thousands of volumes, or perhaps not.

The library system at the University of California, Berkeley, added its ten millionth book in 2005, and the collection is housed in the spatial equivalent of not so many warehouses. If every page were unbound and stitched into a quilt of information, it would be, says my brother Steve, who runs the city of San Francisco's mental health database and is good at math, almost twenty miles square (if you assume that each book contains 250 pages, or 125 leaves, and that each leaf is about seven by nine inches; to say that actual dimensions vary would be to make an understatement far vaster than the quilt). San Francisco is a little over forty-seven square miles, a bit bigger than twenty million such books spread out. Reading that quilt or any book is another business altogether. Since every sentence is a line the eye travels over, I once measured my book *Savage Dreams* by line length and number of lines and concluded that

the narrative was literally about five miles long—but I digress. Or meander. Unmappably. Or perhaps into the territory of maps.

Such an atlas as I describe could never be produced, and it would not be useful. The quantity of potential information is inexhaustible; the ability of any human being to absorb information is not. We select, and a map is a selection of relevant data that arises from relevant desires and questions. The atlas you have in your hands is a small, modest, and deeply arbitrary rendering of one citizen's sense of her place in conversation and collaboration with others. In the course of making it, I have discovered how many more maps each of us contains, how much more knowledge of this place is out there in the minds of librarians and lepidopterists and artists and Norteños and everyday travelers of the streets, and how much of the region in which I have spent my life and often researched and sometimes written about remains terra incognita to me.

Still, I hope that the infinite atlas will remain an imagined companion and corrective for everyone looking at this particular atlas, which aspires to suggest something of the inexhaustibility of even a small city but is itself finite and even capricious in its mappings. My aspiration is that these limits will prompt viewers to go beyond it, to map their own lives and imagine other ways of mapping, to bring some of the density of mapping we've suggested to this place and to other places, perhaps to become themselves some of the living books of this city or their cities, or to recognize that they always have been. This atlas is a beginning, and not any kind of end, as a comprehensive representation might be. Such a representation is impossible anyway, for all cities are practically infinite ∞

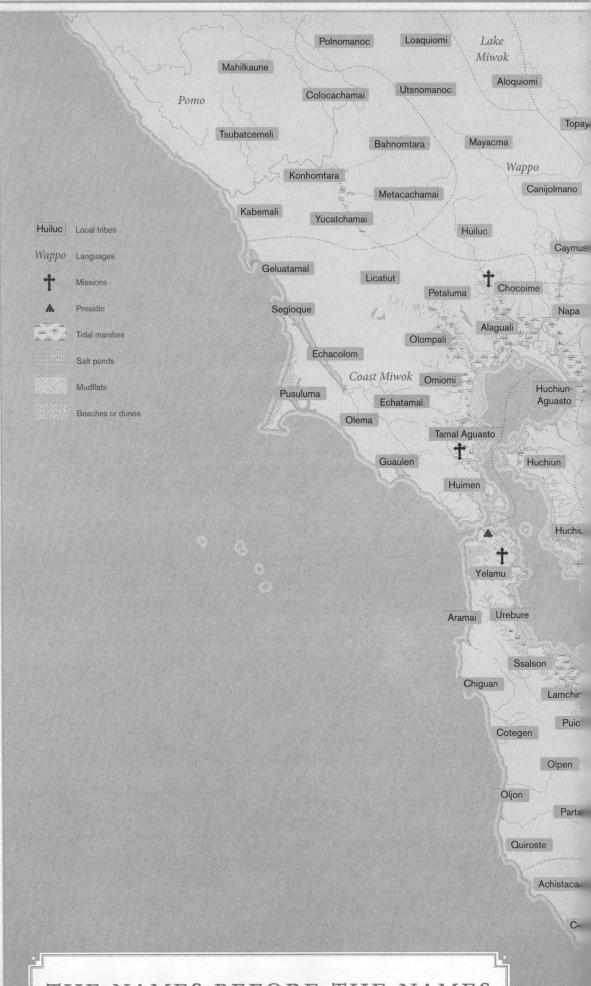

Pomo

Polnomanoc
Loaquiomi
Lake Miwok
Mahilkaune
Aloquiomi
Colocachamai
Utsnomanoc
Topay
Tsubatcemeli
Bahnomtara
Mayacma
Wappo
Konhomtara
Metacachamai
Canijolmano
Kabemali
Yucatchamai
Huiluc
Caymus
Geluatamal
Licatiut
Chocoime
Petaluma
Napa
Segloque
Alaguali
Omiomi
Olompali
Echacolom
Huchiun-Aguasto
Coast Miwok
Pusuluma
Echatamal
Olema
Tamal Aguasto
Huchiun
Guaulen
Huimen
Huchiu
Yelamu
Huchiu
Aramai
Urebure
Ssalson
Chiguan
Lamchir
Puic
Cotegen
Olpen
Oljon
Part...
Quiroste
Achistaca
C...

Huiluc	Local tribes
Wappo	Languages
✝	Missions
⚛	Presidio
	Tidal marshes
	Salt ponds
	Mudflats
	Beaches or dunes

THE NAMES BEFORE THE NAMES

THE INDIGENOUS BAY AREA, 1769

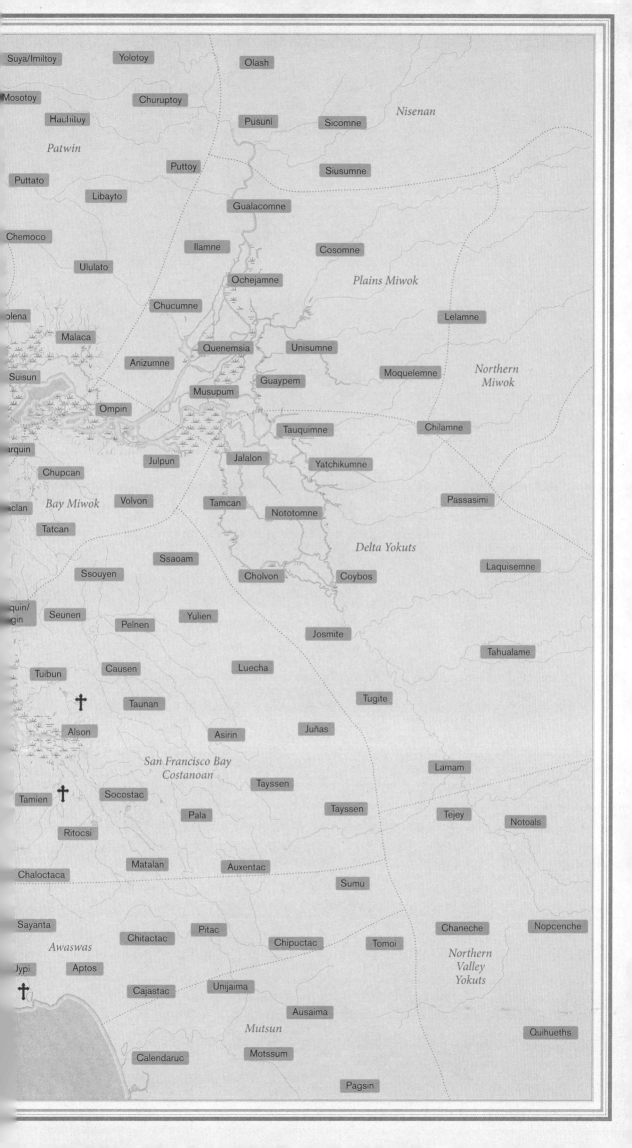

1 THE NAMES BEFORE THE NAMES

The juxtaposition of unfamiliar place names and the intensely familiar lay of the land on this map of the Bay Area are direct evidence that this was once someplace very different. It was the homeland of highly localized people who knew their terrain intimately and invested it with names, stories, memories, and associations that made the place incredibly rich in ways beyond the biotic richness that also existed then, when the Bay Area teemed with salmon, with antelope, with shellfish, with huge flocks of migratory birds that would later be decimated. It was also blessed with extensive marshes and wetlands, which would later be partly filled, and an abundance of pure water, which would be contaminated with mercury during the Gold Rush and with other effluents thereafter. Roadless and only subtly marked by humans, this place could be imagined as wild but is more aptly imagined as interfused with a light but intensely engaged human presence. This is a map of what was here first as well as who was here long before the later layers of history and culture depicted in most of the subsequent maps in this atlas began to accumulate.

But this is not entirely a map of the past: surviving place names remind us that not only the legacy of their cultures but also the people themselves are still here. Words in their languages are said countless times each day, though they are rarely recognized as survivors from these local cultures. CARTOGRAPHY: BEN PEASE ∞ MAP APPEARS ON PAGES 10–11

A MAP THE SIZE OF THE LAND BY LISA CONRAD

A familiar place with unfamiliar names: for those of us who live in the Bay Area, everywhere we walk, others walked before us. Many of our present-day towns—Olema, Petaluma, Half Moon Bay, Nicasio—are sites where villages once stood and communities thrived. Underneath the grid of our streets, their stories go back fourteen thousand years, to when the shore began at the Farallon Islands and the great San Francisco Bay was a meadow. Descendants of those communities still live in the Bay Area, where they participate in cultural traditions and are experiencing a revitalization of their languages.

On a recent drive down the Northern California coast, from Humboldt County toward the Bay Area, I gazed out at the redwoods that reached nearer and farther to the sky and imagined the streams and tributaries that draw their way over the land, down its ridges and into the Eel River. Picture any historical, contemporary, or imagined map of a place as a diaphanous layer upon the

landscape, and you will find that the first layer, that of the indigenous people, is inextricably interlaced with the physical geography. Under, around, and within our beehive infrastructure, you will see the watersheds that were the geographic organizing principle behind the Hupa and Yurok lands, now Humboldt County, and that of the Miwok, Pomo, and Ohlone (Costanoan) speakers, now San Francisco and environs.

California has attracted migrating peoples to its shores for thousands of years, as it does even today. Ancient immigrants encountered a mild climate and an ecosystem ridiculously abundant with flora and fauna; perhaps because of this they gradually evolved from hunter-gatherers into members of a "complex collector pattern," an evolutionary stage equivalent to but quite different from the early agriculture of other cultures. When the Spaniards arrived, local tribes practiced sustainable land management, which included the cyclical burning of meadows to promote the growth of desirable plants. As archaeologist Kent Lightfoot writes in *California Indians and Their Environment*, "Rather than simply exploiting the richness of California's many habitats, it is now generally recognized that indigenous populations helped create and shape much of the ecosystem diversity by means of various kinds of cultural activities and indigenous management practices *that can still be seen today.*"

Unlike in the rest of the United States, where large groups of individuals operating as tribes or bands led by chiefs or heads were the norm, in California, small communities numbering from as few as fifty to as many as four hundred possessed regional identities, living together and managing a defined area. Within, say, a twenty- or forty-square-mile area, they generally maintained a primary village and multiple smaller villages. The social and political community took precedence over the village site. Their tribes were divided into craftspeople, religious experts, secret societies, elites, and commoners. Shells were used as a form of currency (the largest shell-processing site in California was in Sonoma County).

These self-governing groups traveled over their territory according to the season, collecting and managing their resources, moving among villages. The Spaniards referred to the local tribes and villages as *rancherías*. Alfred Louis Kroeber, the famous California anthropologist, called these communities "tribelets"; today they are often referred to as "local tribes" or "polities" (political communities). The varied, fertile environment of the San Francisco Bay Area may well have fostered the development of these highly differentiated groups and localized languages, enabling them to coexist in close proximity to one another.

The population of the region shown in this map was an estimated seventeen thousand in 1769 (today's population, by contrast, is almost seven million). The density of population in a given area depended upon what the land could support. Watershed villages were often found where two creeks converged, and villages were located on the east side of hills, near fresh water and food, according to Nick Tipon, a descendant of Coast Miwok speakers. Property was communal in some groups, but in others, families or individuals sometimes possessed rights to certain resource areas and passed down those rights over generations—for example, individual oak trees were privately held by Coast Miwok speakers. Ethnogeographer Randall Milliken writes

in *Ohlone/Costanoan Indians of the San Francisco Peninsula and their Neighbors, Yesterday and Today*: "Throughout west-central California oral narratives about creation and the nature of the universe shared common over-arching themes. . . . The specific narratives of each group were linked to the local landscape, and served as a charter that established the group's origins and rights of ownership to a particular territory."

Interactions between neighboring local tribes varied—people intermarried, visited one another, and occasionally warred. Though their territories were clearly bounded, individuals and families were interconnected in an open network belied by the names on this map.

So how does one define a place-name? How does one signify both presence and history? In whose eyes? Counties, cities, mountains, valleys, or more singular spots—a rock along a path, a meadow's entrance—the places that we name identify us as a people. Not only that, but changing place-names provide a historical template of priorities, invasions, dreams, disasters. For Bay Area Indians, the very local was political, storied, alive; current geopolitical boundaries express a quite distinct understanding of space and narrative.

Tipon emphasizes the rich and intimate knowledge of the environment his ancestors possessed, their navigation of the landscape through stories as much as names. Milliken estimates an enormously detailed tapestry of thirty-five thousand place-names for every seven square miles. In *Ethnohistory and Ethnogeography of the Coast Miwok and Their Neighbors, 1783–1840*, he writes, "Each local Coast Miwok region may have had as many as two hundred named village locations (unused, seasonal, and permanent)." Add to that the two hundred or more languages and dialects spoken, and you may imagine a living map, impossibly covered in names and lore, perhaps the size of the land itself. Most of these names were never recorded and have been lost.

Maps are often a tool of those in power or, at the least, a projection of the cartographer. Maps are also a kind of classificatory system, which, if laid over a place from outside it, may reflect the maker's priorities more than those of the culture(s) they depict. "The practice of dividing sections of the North American continent into separate culture areas was developed in the late nineteenth century *as a means of organizing museum collections*" (Milliken, *Ohlone/Costanoan Indians*; my italics). Where does one begin in light of a labyrinthian observation of this sort? For the purposes of this map, we considered shellmounds, villages, archaeological dig sites, original indigenous place-names, local-tribe regions, and current Indian lands as possible representations of place. Portraying these social and political groupings, or local tribes, seemed to offer the most vibrant portrait of Bay Area Indians at the moment of contact with the Spaniards.

In 2002 Paul Scolari, of the National Park Service, commissioned detailed reports of the cultural associations of Bay Area indigenous peoples with regard to Golden Gate National Recreational Area lands. In maps drawn to illustrate the ensuing reports, the local-tribe names and their placement derive from Milliken's research on local tribes and his extensive review of mission registers.

Spanish Catholic missions were built from the late 1700s into the early 1800s. Missionaries enticed Indians to the missions, baptized them, and then did not allow them to leave, intermingling and dislocating people from different local

tribes. The Franciscan missionaries kept records of everyone they baptized, listing their ages and the Spanish names they had been given, as well as their marriages and deaths. The priests also often added the name of the community (and sometimes the village) a person was from, and the names of children or parents. Using this data and other historical clues, Milliken assembled a list of likely communities and assigned them to geographic regions. After the initial placement of a local tribe, he reviewed its estimated population and modified the estimate based on the habitability of the particular landscape.

The mission registers were not always consistent: in the first twenty years of the missions, priests tended to record village names; after that, newer priests enlarged the scope of detail to the more encompassing local-tribe names. Ambiguities cropped up in the registers: different names for the same communities, multiple spellings of similar terms, questions regarding the origins of names—for example, were they names that tribe members used to refer to themselves, or were they names by which adjacent communities identified them? Kroeber and others did not believe that local tribes named themselves, instead arguing that neighboring tribes named one another, often using directional terms, such as "Northerners" or "Westerners." Milliken, for one, disagrees; he believes that local tribes did, in fact, name themselves.

Chiguan, Ssaoam, Tauquimne, Suisun, Olema—these are but representations of sounds that fell on foreign ears, recorded by Spanish priests or by Indian interpreters, who might not have spoken the language of the individual being recorded. The names on the map generally reflect the most common eighteenth-century Spanish spellings, but they aren't necessarily a guide to pronunciation; Milliken has observed that "some consonant sounds in the Ohlone . . . and Yokuts languages . . . baffled [the recorders], and caused them to use various spellings."

"Yelamu," the name Milliken settled on for the people who lived in San Francisco, is less definitive than other local-tribe names. The Spaniards gathered very little information about this group—none of their myths are known. Fathers Palóu and Cambón of Mission Dolores in San Francisco called them "Aguazios," which means "Northerners," but this was the term the neighboring Ssalsons used to label them. More often, the name "Yelamu" was recorded in the mission registers. But Yelamu was also a village name. Linguistic research reveals that "ela" is a directional term and that it may possibly mean "Westerners." This local tribe maintained villages in what are now the Presidio, Fort Mason, Fort Miley, Ocean Beach, and Fort Funston Beach, and perhaps on Alcatraz Island.

Another hazy area of the map is north of San Francisco, from Olema to Bodega Bay. No community names exist for this huge stretch of land other than "Tamal"—a Coast Miwok term meaning "where the water meets the land" (according to Angela Striplen, a Coast Miwok descendant). For this stretch of northern coast, Milliken retained the shape of the areas that are still populated today and used the village names, inferring population sizes of a few hundred, similar to those around the San Francisco Bay and down the peninsula.

The areas on the map with dotted outlines and gray italic labels (San Francisco Bay Costanoan, Nisenan, Coast Miwok, and so on) indicate core *language* groupings, not tribal affiliations. These are lineages defined by anthropolo-

gists and linguists during the past two hundred years or so of contact. Ohlone (Costanoan) and Miwok are branches of the same proto-language, Utian; six different Ohlone (Costanoan) languages were spoken along the coast, including Karkin, each as distinct as Spanish and Italian. Nowhere else in the United States could such a thicket of languages and dialects in such close quarters be found—local tribes within twenty miles of one another might have spoken languages that were, at least initially, mutually unintelligible.

What was the relationship between language families and local tribes? Delta Yokuts, Plains Miwok, Patwin—these language names were inventions/interventions after the fact: California's indigenous peoples would not have recognized them and would not have identified with them as any sort of cultural grouping. The Indians of the greater Bay Area experienced life on a local scale, knew themselves as Uypi, Tamcan, Atenomac. They distinguished between those who spoke related but dialectically different languages and those who spoke an altogether different tongue, but they would not have grouped people together accordingly. This conflating of language and culture by anthropologists and linguists, more appropriate in other parts of the country, has proved to be difficult to unravel.

Of the 128 local-tribe names on this map, a handful have persisted, imprecise symbols of indigeneity, sloughed into the shifting sea of English. One can trace these words as they passed through missions, land grants, ranches, newspapers, and state bureaucracies, until they became fixed within our current geography. The local-tribe names that have survived have not strayed far from their original regions.

The word "Ohlone," often used synonymously with Bay Area Indians, offers a case study of the complexity and capriciousness of translation, on multiple levels: that of a foreign sound transformed into a written word in a foreign language (with the expected variations); that of a culture and people who, in being forced to give up their language and ways of living, lost much of it or sent it underground. From Pedro Alcantara comes the first documentation of the word "Ol-hones" ("Costanos" in Spanish, "people of the coast"), which he stated was the name of one of five Bay Area local tribes. "Ol-hones" and "Costano" were subsequently plucked arbitrarily from a vocabulary list as labels for the language family of the entire Bay Area region.

The following is an etymological time line for the name "Ohlone":

1831 *Alchones* This term is used by Frederick Beechey.

1851 *Oljon* Alexander Taylor uses this name in the California Farmer newspaper.

1853 *Ol-hones* (*Costanos* in Spanish) "Ol-hones" appears in a vocabulary list of the language of the Indians of the San Francisco peninsula—the only such list ever recorded—published by Henry Rowe Schoolcraft and compiled by Adam Johnson from Pedro Alcantara, a "native of the Romonan tribe." The term "Ol-hones" referred to a local tribe (called "Oljones" by Spanish missionaries), of the San Mateo County Coast at San Gregorio. Schoolcraft took the word "Costano" from Johnson's cover note and used it as the name for the family of languages that included Alcantara's. "Ol-hones" is the root for "Olhonean" and "Ohlone," alternative names for the Costanoan language.

1861 *Ohlone* This version appears in an article by Alexander Taylor, as a typographical error in the California Farmer newspaper.

1871 *Ol-hones* Frederick Hall employs this term in "History of San Jose and Surroundings" (an East Bay local history publication).

1883 *Ohlone* In the series *Wild Tribes, Native Races*, Hubert Howe Bancroft chooses to use this name.

1915 *Ohlone* This term appears on a bronze plaque at the Indian cemetery at Mission San Jose, dedicated to the Indian people buried there.

1930s *Ohlone* Mission San Jose Indian people identify themselves as "Ohlone" and "Olonian" on questionnaires sent to them by the Federal Office of Indian Affairs.

1930s *O'lo'no wit* Miwok elder John Porter suggests that "Ohlone" is a variant of the Sierra Miwok word meaning "west." Milliken suggests the possibility that "Oljon" and "O'lo'no wit" come from a "root term that signified a western area or a westerly direction."

1967 *Olhonean* Anthropologist C. Hart Merriam chooses "Olhonean" in place of "Costanoan," believing that Indian words should be used for indigenous people and languages.

1969 *Ohlonean* Anthropologist and Yuma Indian Jack Forbes uses this alternative spelling in *Native Americans of California and Nevada* to match the "Ohlone" used by Mission San Jose descendants.

1978 *Ohlone* Malcolm Margolin's *The Ohlone Way* is the first time the label "Ohlone" is applied to the Costanoan language family. Not all descendants favor this term.

TODAY *Amah, Muwekma* Some descendants of the San Francisco Bay Area prefer these terms: "Amah," used by the Mutsun, meaning "the people"; and "Muwekma" in the north, meaning "the people" in Tamien and Chochenyo Ohlone (Costanoan).

Whereas early maps aided foreign states in their quest for land and resources, in recent years, a practice referred to as counter-mapping has emerged in a number of indigenous communities in different parts of the world, including the United States. After the long silence of colonialism, stores of history are reappearing, pulled from their hiding places, their diasporas, and coalescing onto new maps. Counter-mapping involves the creation of maps using indigenous knowledge, often to advance land claims in court. Although this approach is powerful and creative, viewing this cache of wisdom and history solely through the lens of property and ownership keeps the unique perspectives that might be expressed trapped within contemporary cultural values; one looks forward to future uses that may further reveal its prismatic nature.

I hold this map of local names in my mind's eye as I bicycle down Telegraph Avenue in Oakland's Temescal (an indigenous word) neighborhood, as I trace the bay's edges, from the Port of Oakland to the Embarcadero, run the names over my tongue, experience a simultaneity of worlds, layer upon layer, the old world brightening under the new ∞

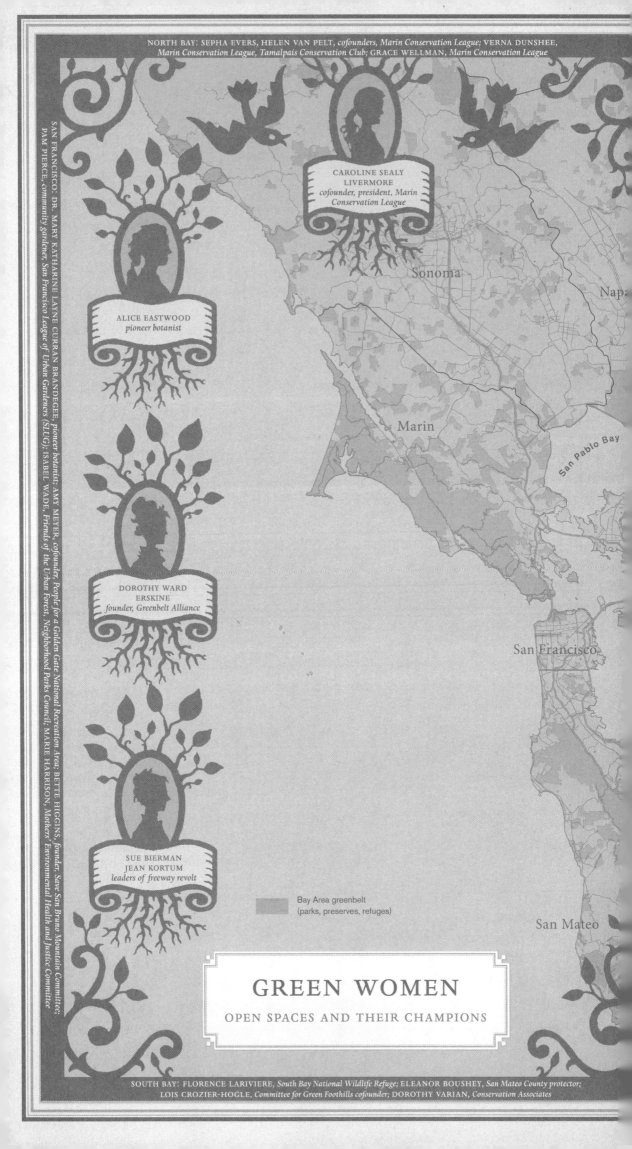

NORTH BAY: SEPHA EVERS, HELEN VAN PELT, *cofounders, Marin Conservation League;* VERNA DUNSHEE,
Marin Conservation League, Tamalpais Conservation Club; GRACE WELLMAN, *Marin Conservation League*

SAN FRANCISCO: DR. MARY KATHARINE LAYNE CURRAN BRANDEGEE, *pioneer botanist;* AMY MEYER, *cofounder, People for a Golden Gate National Recreation Area;* BETTE HIGGINS, *founder, Save San Bruno Mountain Committee;* PAM PIERCE, *community gardener, San Francisco League of Urban Gardeners (SLUG);* ISABEL WADE, *Friends of the Urban Forest, Neighborhood Parks Council;* MARIE HARRISON, *Mothers' Environmental Health and Justice Committee*

CAROLINE SEALY
LIVERMORE
*cofounder, president, Marin
Conservation League*

ALICE EASTWOOD
pioneer botanist

DOROTHY WARD
ERSKINE
founder, Greenbelt Alliance

SUE BIERMAN
JEAN KORTUM
leaders of freeway revolt

Sonoma

Napa

Marin

San Pablo Bay

San Francisco

San Mateo

■ Bay Area greenbelt
(parks, preserves, refuges)

GREEN WOMEN

OPEN SPACES AND THEIR CHAMPIONS

SOUTH BAY: FLORENCE LARIVIERE, *South Bay National Wildlife Refuge;* ELEANOR BOUSHEY, *San Mateo County protector;*
LOIS CROZIER-HOGLE, *Committee for Green Foothills cofounder;* DOROTHY VARIAN, *Conservation Associates*

BARBARA SALZMAN, *Audubon Society;* BARBARA EASTMAN, *Save Our Seashore;* PHYLLIS FABER, *Marin Conservation League, Marin Agricultural Land Trust cofounder;* LAURA LYON WHITE, *president, Sempervirens Club, Muir Woods donor*

Solano

Contra Costa

Alameda

Santa Clara

ELLEN STRAUS
cofounder, Marin Agricultural Land Trust

SYLVIA MCLAUGHLIN
KAY KERR
ESTHER GULICK
Save the Bay

AHMADIA THOMAS
cofounder, chair, West County Toxics Project

JEAN SIRI
BARBARA VINCENT
East Bay Regional Parks and Save the Bay

CLAIRE DEDRICK
JANET ADAMS
cofounders, Peninsula Conservation Center

EAST BAY: DORIS SLOAN, *helped stop Bodega Head nuclear power plant;* MARJORIE BRIDGE FARQUHAR, *pioneer mountaineer, Save-the-Redwoods League;* DR. MARY BOWERMAN, *cofounder, Save Mount Diablo;* PEGGY SAIKA, *cofounder, first director, Asian Pacific Islander Environmental Network;* PAM TAU LEE, *cofounder, Asian Pacific Islander Environmental Network, anti-toxics activist*

MARY DAVEY, LENNIE ROBERTS, *Committee for Green Foothills, Mid-Peninsula Regional Open Space District;* JOSEPHINE MCCRACKIN, CARRIE STEVENS WALTER, *cofounders, Sempervirens Club*

2 GREEN WOMEN

That a vast portion of the nine-county Bay Area has been protected as some kind of green space—state park, national park, county park, wildlife refuge, watershed preserve, rural land trust—is well known and celebrated. But it's much less well known that much of the tireless work to protect these 3.5 million acres of land was done by women. This map, in the style of nineteenth-century commemorative maps, marks both the green space and the green women who defended it—and who defended not only the land but also the San Francisco Bay, which some of the more progress-drunk land-use planners wanted to fill in half a century ago.

Standard maps of the Bay Area bear witness to our green men and to others not so beneficent: places here are named after John Muir, after St. Francis and St. Joseph (San Francisco and San José, in Spanish), after John C. Fremont, after Irish Bishop George Berkeley, after landowners like the Stinsons or José de Jesús Noé, whose name lingers on a San Francisco neighborhood, as does that of Mexican-era Governor José Castro, or the Berryessa dynasty for whom Lake Berryessa was named. Even the streets of downtown San Francisco are a who's who of early wars and powers: Montgomery was a naval captain in the war on Mexico; Kearny was a military commander; Brannan was a Gold Rush millionaire. But other than some cities named after female saints—Santa Rosa, Santa Clara—the names on the land are not those of women. This map is compensatory commemoration. CARTOGRAPHY: DARIN JENSEN; ARTWORK: HUGH D'ANDRADE ∞ MAP APPEARS ON PAGES 18–19

GREAT WOMEN AND GREEN SPACES BY RICHARD WALKER

The San Francisco Bay Area is more than houses, highways, and high-rises: it harbors the greatest urban greenbelt in the United States. Out of 4.5 million acres in the nine-county region, more than 3.5 million are open space. The Bay Area's open spaces are less a belt than a coat of many colors—blue, green, red, brown, and gold—quilted around the branches and limbs of the city. The centerpiece is the bay, the watery heart of the city's circulation; then there are the mountain ridges marking off the central bay region, wet and wooded to the west and north, gilded with grass to the east and south. Toward the outskirts, large tracts are actively agricultural, mostly vineyards and pastures. Deep within the city are hundreds of enclaves, from mammoth Golden Gate Park to creekside hideaways.

Over a million acres are held in public trust. Such public lands bear many labels, such as parks, preserves, playgrounds, reserves, watersheds, and trails; they are held by agencies of government, from the federal to the local. Non-profit land trusts watch over the rest, including conservation easements on private land. And there is the protective embrace of the bay and coastal commissions. The greenbelt is deeply embedded in law and institutions.

Behind this immense open space edifice is a living thing: the people and pursuits of a century-old environmental movement. Starting as a preoccupation of elite conservationists, it broadened out to a mass public long before the word "environmentalism" was coined, particularly through the efforts of Save the Bay and the Sierra Club in the 1960s. Scores of local organizations and thousands of activists spread the gospel of green to people around the bay, making this area the center of global conservation through most of the twentieth century.

The majority of these activists were women. The Bay Area has long been blessed with savvy, independent, and talented women. Some were pioneers in professions such as landscape architecture and botany; others were housewives looking beyond homemaking and child-raising. Some had to force themselves to take a public role, and others were natural-born politicians. They ran the gamut from grande dames to schoolteachers. It is no surprise that women would have an affinity for environmental protection, as part of the "public domestic sphere" and their traditional role in caring for children, family, and neighbors. What is surprising, however, is how little recognition such women have received in the annals of American environmentalism.

Bay Area women were present at the dawn of American conservation. Josephine McCrackin and Carrie Stevens Walter of San Jose were two of the founders of the Sempervirens Club, which saved the redwoods at Big Basin by creating the first state park in 1902. Laura Lyon White stepped in as president of the club, using her social connections to protect redwoods and the Calaveras Big Trees in the Sierra. Mary Katharine Layne Curran Brandegee and Alice Eastwood, curators at the California Academy of Sciences, were world-famous botanists at the turn of the century. Marjorie Bridge Farquhar was one of the first female mountaineers and served on the council of the Save-the-Redwoods League in the 1920s.

In the 1930s, Caroline Sealy Livermore and her friends Sepha Evers and Helen Van Pelt founded the Marin Conservation League, which became the center of environmental activism in the North Bay. They saved local parklands such as Angel Island (with its peak named after Livermore) and created the first county plan in the 1940s—the basis for the 1972 plan that would later set aside almost all of West Marin. As Marin turned into the greenest part of the Bay Area in the 1960s, Barbara Eastman led the fight to save Point Reyes National Seashore. In the following decade, Ellen Straus and Phyllis Faber salvaged northern Marin's dairy land by means of the Marin Agricultural Land Trust.

In the burst of building after the Second World War, San Francisco refused to build all the freeways drawn up by the state highway department. That freeway revolt, led by the likes of Jean Kortum and Sue Bierman, was repeated up and down the West Bay. At the high tide of mid-century conservation, San Francisco's Amy Meyer took it upon herself to organize the movement for the Golden Gate National Recreation Area, established in 1972.

Down on the Peninsula, a band of stalwart women that included Lois Crozier-Hogle and Ruth Spangenberg established the Committee for Green Foothills in 1962 to combat the expansion of Stanford University. The battle soon spread, encompassing Nonette Hanko's fight to create the Palo Alto Foothills Park and Eleanor Boushey's efforts to keep highways out of the Santa Cruz Mountains. The Committee for Green Foothills went on to be the guiding force in preserving open space and resisting suburbanization in the South Bay, led by such seasoned combatants as Mary Davey and Lennie Roberts. Meanwhile, Florence LaRiviere and her allies quietly reclaimed the whole of southern San Francisco Bay from salt ponds for a national wildlife refuge and restored marshland.

Over in the East Bay, botanist Mary Bowerman was the first to discover the immense biodiversity of Mount Diablo, in the 1930s. She founded Save Mount Diablo, and today open space covers almost the entire peak (a model later adopted by the Save Mount San Bruno Committee under Bette Higgins and her friends around South San Francisco). Meantime, Jean Siri, Barbara Vincent, and Kay Kerr were working to expand the East Bay Regional Parks into Contra Costa County and along the bay shore.

The Bay Area's most famous female advocates are undoubtedly the three Berkeley women who founded Save the Bay in 1961: Kay Kerr, Sylvia McLaughlin, and Esther Gulick. Against all odds, they turned the tide against unrestrained bay filling and in the process transformed the bay from a watery freight yard to the region's beloved centerpiece. Meanwhile, Dorothy Ward Erskine created People for Open Space (later the Greenbelt Alliance), the single most important force for regional thinking over the last fifty years. She was also responsible for the agricultural conservation district that saved the Napa Valley from the subdividers *before* it became world-famous. Two other key regionalists came out of the South Bay: Claire Dedrick and Janet Adams, cofounders of the Peninsula Conservation Center. Adams led the battle for the California Coastal Commission, which was established in 1972, while Dedrick went on to serve as secretary of resources for the state of California.

In the 1980s, Bay Area environmentalism grew a new branch that spoke to the concerns of inner-city residents and people of color. Street fighters such as Ahmadia Thomas, Peggy Saika, and Pam Tau Lee took up the struggle against toxic hazards from refineries, dumps, and other polluters along the East Bay industrial belt. Marie Harrison did the same in San Francisco's Bayview–Hunters Point. Meanwhile, activists such as Pam Pierce and Isabel Wade promoted community gardens and neighborhood parks as a way of reclaiming the urban brownfields.

The great achievements of the women conservationists of the Bay Area were not merely acts of enlightened public service. Preserving open space, saving the bay, and stopping development are always political acts. Nothing came easy for these women warriors. Every acre of land and water has been fought over, often in campaigns lasting years. To carry out these fights, activists created new organizations, saw laws enacted, and put in place the institutional structure that locks up the Bay Area greenbelt. More than this, they helped create a green public culture that runs deep among Bay Area residents. As a result, every generation brings forth new legions of environmentalists ready to take on the forces of profiteering and desecration ∞

3 CINEMA CITY

This is a map about two moments in the history of film and San Francisco: one in which photographer Eadweard Muybridge laid the foundation for a new technology of moving pictures that would evolve into cinema as we know it; and another, eighty years later, when his fellow Englishman Alfred Hitchcock filmed his dark valentine to San Francisco, *Vertigo*, here. Of course, there are countless other moving picture and media moments of note—movies such as *Bullitt*, with its lyrical car chases, breakthroughs such as Philo T. Farnsworth's invention of television on Green Street—but maps are always selective, and Muybridge and Hitchcock are a striking pair of imagemakers. The genesis and an apotheosis of cinema are charted on this map, whose last theme is decline—if not of the medium, at least of its dream palaces, the movie houses that once were the exclusive home of cinema. There were over seventy such theaters in San Francisco, many of them in the neighborhoods, when *Vertigo* debuted in 1958, but only a handful remain open. They were replaced first by television, then by video rentals, and by other digital ways of watching films on small screens, even more than they were by the downtown multiplexes. So there are three eras on this map, the 1870s–1880s, the 1950s, and the present, in which we are heirs to their wealth but makers of a curious imagistic poverty as well.

CARTOGRAPHY: SHIZUE SEIGEL ∞ MAP APPEARS ON PAGES 24–25

THE EYES OF THE GODS BY REBECCA SOLNIT

The Cahuillas of the southeastern California desert tell a story in which the creators of the world argue about death. One of the gods is against it, because it is, after all, sad; and the other one points out that without death, the earth would get very crowded. For historians and people preoccupied with the past, the city as seen and imagined is crowded with ghosts, and the past walks through the present. We are ourselves ghosts of other times, not fully present in our own; and we see what is no longer here and feel the future as a wind through the streets, a wind that is for us who look backward always blowing away what we cherish, the storm of loss. But when solid time melts, the past can be recovered.

Imagine that time does not exist, and the photographer Eadweard Muybridge (in San Francisco intermittently from 1855 to 1881) moves through a wavering, foggy city that is also inhabited by another Englishman, Alfred Hitchcock, as he films *Vertigo*, his 1957 movie about fear, longing, remorse,

CINEMA CITY

MUYBRIDGE INVENTING MOVIES, HITCHCOCK MAKING *VERTIGO*

MUYBRIDGE AND THE BIRTH OF CINEMA

1 U.S. Mint, Fifth and Mission, photographed sequentially by Muybridge, May 1870

2 3 South Park, possible home address of Flora and Eadweard Muybridge, circa 1872–1873

3 550 Howard, Muybridge's home address, 1873

4 112 Fourth, Muybridge's home address, 1874

5 605 Montgomery, home of confidence man Harry Larkyns

6 South Park, where Flora Muybridge first met Larkyns, who became her lover

7 Cliff House, photographed by Muybridge in 1869, where Flora went into labor on April 15, 1874, in the company of Larkyns

8 Corner of Howard and Third, home where Flora gave birth to a son of uncertain paternity

9 Odd Fellows Cemetery, where Flora Muybridge was buried, 1875

10 Protestant Orphan Asylum, west side of Laguna between Haight and Waller, where that son was deposited, 1876

11 613 Pine, Muybridge's home address in 1876–1877

12 Southwest corner of California and Montgomery, Muybridge's address in 1878

13 999 California, Mark Hopkins Mansion (now the Mark Hopkins Hotel) where Muybridge made his 360-degree panoramas of San Francisco

14 Southwest corner of California at Powell, where Muybridge's motion-studies patron Leland Stanford lived (Muybridge photographed the mansion)

15 Northeast corner of Fourth and Townsend, Southern Pacific Railroad head-quarters, where Muybridge got technical assistance with his high-speed camera shutters

16 Bay District Racing Track, between First and Fifth, Fulton and Point Lobos (now Geary), where Muybridge likely made the crucial breakthrough in high-speed motion photography (of horses) that would lead to the birth of motion pictures

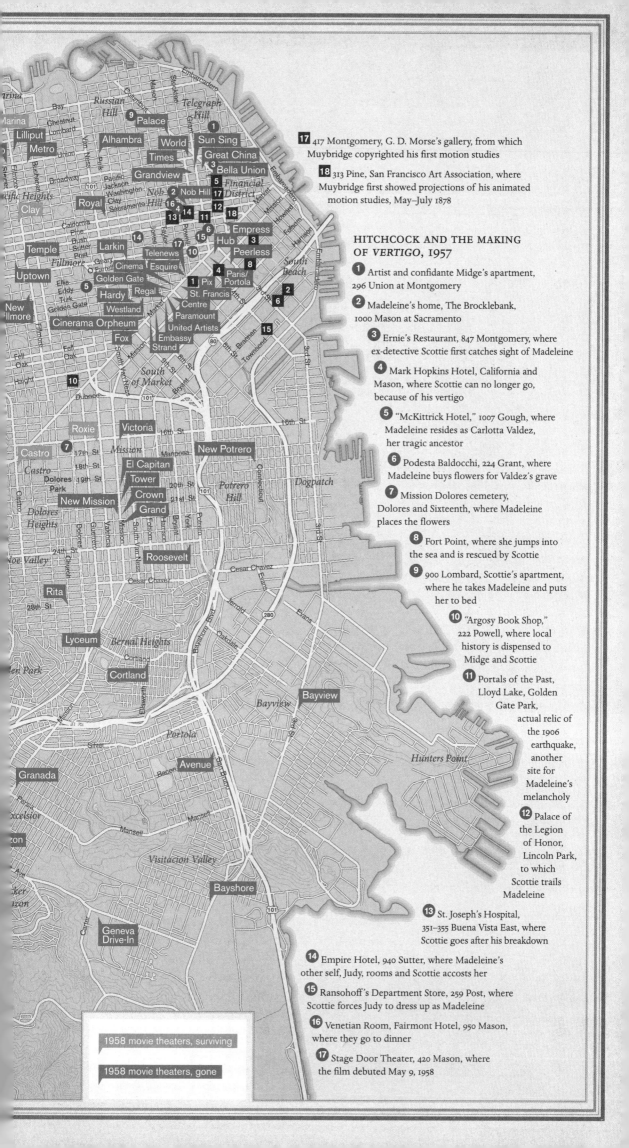

17 417 Montgomery, G. D. Morse's gallery, from which Muybridge copyrighted his first motion studies

18 313 Pine, San Francisco Art Association, where Muybridge first showed projections of his animated motion studies, May–July 1878

HITCHCOCK AND THE MAKING OF *VERTIGO*, 1957

1 Artist and confidante Midge's apartment, 296 Union at Montgomery

2 Madeleine's home, The Brocklebank, 1000 Mason at Sacramento

3 Ernie's Restaurant, 847 Montgomery, where ex-detective Scottie first catches sight of Madeleine

4 Mark Hopkins Hotel, California and Mason, where Scottie can no longer go, because of his vertigo

5 "McKittrick Hotel," 1007 Gough, where Madeleine resides as Carlotta Valdez, her tragic ancestor

6 Podesta Baldocchi, 224 Grant, where Madeleine buys flowers for Valdez's grave

7 Mission Dolores cemetery, Dolores and Sixteenth, where Madeleine places the flowers

8 Fort Point, where she jumps into the sea and is rescued by Scottie

9 900 Lombard, Scottie's apartment, where he takes Madeleine and puts her to bed

10 "Argosy Book Shop," 222 Powell, where local history is dispensed to Midge and Scottie

11 Portals of the Past, Lloyd Lake, Golden Gate Park, actual relic of the 1906 earthquake, another site for Madeleine's melancholy

12 Palace of the Legion of Honor, Lincoln Park, to which Scottie trails Madeleine

13 St. Joseph's Hospital, 351–355 Buena Vista East, where Scottie goes after his breakdown

14 Empire Hotel, 940 Sutter, where Madeleine's other self, Judy, rooms and Scottie accosts her

15 Ransohoff's Department Store, 259 Post, where Scottie forces Judy to dress up as Madeleine

16 Venetian Room, Fairmont Hotel, 950 Mason, where they go to dinner

17 Stage Door Theater, 420 Mason, where the film debuted May 9, 1958

1958 movie theaters, surviving

1958 movie theaters, gone

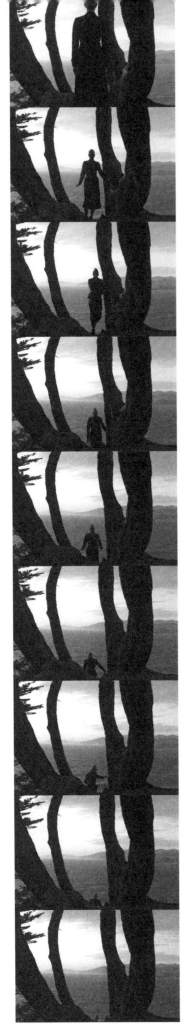

Jim Herrington, *Motion Study, Lands End,* 2010

fantasy, and San Francisco. The fat director is working in the medium for which his lean compatriot laid the foundations during his own restless years in San Francisco and Palo Alto. In that period, Muybridge sped up photography, which hitherto could produce those images the film business calls "stills" but so far had been able to capture only the slow world and the world stopped for the camera. Muybridge made photography fast; he was the fastest camera in the West, the first photographer who could capture horses and men in motion. He shot them in series that could be projected onto a big screen, projected in quick sequences that simulated motion and thereby simulated life. Thus began the road to cinema. It was as though the ice of frozen photographic time had broken free into a river of images. Brought to life, we say, because motion is the essence of life. Muybridge's new medium of photographic motion, moving pictures, was itself ghostly, unearthly, though within the limits of the new medium before flexible celluloid films came along, he made only short looping segments of horses and men in motion, and then of women, children, and other animals.

He had made a medium that blurred past and present, and people in his time saw how haunted it was. As Thomas Edison tinkered to see if sound and image could be harnessed together into a yet more powerful verisimilitude, he proposed, wildly, "that grand opera can be given at the Metropolitan Opera House at New York . . . with artists and musicians long since dead." Which suggests what séances they were holding, what grave-robbing we do now, in the medium of movies. In film we see the dead all the time. Watch the movie *Vertigo* tomorrow and see that Jimmy Stewart (1908–1997) as Scottie is still a rangy man in his prime, pacing, scowling, pining, and chasing the phantasm of the young ice goddess Madeleine (Kim Novak, born 1933) through a San Francisco whose downtown is not yet spiky with skyscrapers but whose streets are oddly familiar.

Of course, *Vertigo* is a story within a story that is a movie that was filmed in reality, the reality of this city, the real that makes the illusion all the more compelling. For San Franciscans, the film features fictional characters but real actors loosed on a real and familiar city, an illusion that exists in the same space as our actualities. And maybe *Vertigo* is a perfect specimen of film, for it is about uncertain boundaries between reality and illusion, about a passion that can never be fulfilled, about haunting and losing. The fictitious Madeleine—a poor woman paid to impersonate a shipping tycoon's wife—is haunted by her

ancestress; the less fictitious Scottie is haunted by her, though she may not exist; and in the film she dies twice. Time does not quite exist, but death does, emphatically. And as in much film noir and several surrealists' books on the city, the beloved is really the eternally elusive, unpossessable city itself, forever slipping through fingers like water, but never entirely gone. Film haunts. And cities are haunted.

Muybridge's own story is a little like *Vertigo*, or his personal story is, a story of people who might not be who they were supposed to be, of deceptions, betrayals, uncertain identities, and a murder, all threaded through the decade in which he made his technical breakthrough that led to cinema. It is a story in the Hollywood sense, for much of Muybridge's life has no story—no personal drama that we know of, though it has a long arc of self-invention that began with his emigration and was furthered by his name changes (Edward Muggeridge became, in stages, Eadweard Muybridge) and his launch into the medium in which he would do such astounding things.

In 1871, he married a beautiful young blonde divorcée, Flora Stone, sometimes also known as Lily Shallcross, who deceived him with a man who called himself Harry Larkyns. While Muybridge was off chasing landscape images, Larkyns haunted theaters, reviewed shows, and took Flora with him. He was a fiction himself, a confidence man out of nowhere, whose short known past involved cheating a foolish young man out of considerable money, but who told glamorous stories about himself, stories of having fought with Italy's revolutionaries, of being a member of the Foreign Legion and a soldier in the British Army, then of being a rajah in Asia with a trunkful of diamonds, somehow lost, along with various other fortunes. Flora paid the ex-rajah's laundry bills.

They were quintessential San Franciscans, these people who were self-made men and women, and sometimes self-invented, or just made up. The possibility that his son, too, might have a shadowy identity—as Larkyns's

Eadweard Muybridge, *The Cliff House*, late 1860s or 1870s

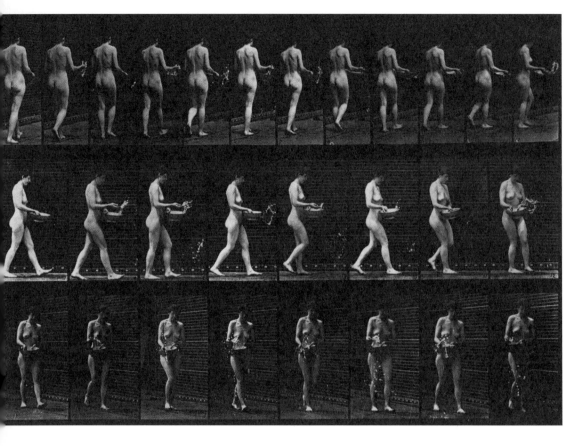

Eadweard Muybridge, *Female Walking, Sprinkling Water from Basin, Turning Around*, 1880s

son—sent Muybridge on a furious expedition to the mercury mine east of Calistoga where Larkyns was holed up. There, one dark October night in 1874, the photographer shot the drama critic "an inch below the left nipple," as the *San Francisco Chronicle* reported. The murderer Muybridge was held for trial but was exonerated by a Wild West jury of husbands who thought the punishment suited the crime, whereupon he exiled himself to Central America for several months. He had already begun his great project of turning photography into a faster medium that could apprehend the world in motion, but the murder disrupted the project for a few years.

Aboard a ship on his return from Central America, Muybridge solved, he said, the problem of high-speed photography, one of the technical challenges to be surmounted on the path to cinema. He also made breakthroughs in the chemistry of film, "speeding" it up so that exposures of a fraction of a second were possible. And then came his 360-degree panoramas of San Francisco, visions of space and place as seen by an impossible eye, one that surveys the whole horizon simultaneously, a divine or diabolical gaze. The motion studies, themselves appearing first in a trickle and then, after Muybridge had left the city and set in motion the route to cinema, a flood.

I have been both a ghost and haunted in the city I love, and have been possessed as well by the movies I've seen in its theaters. One of the signs of a good movie is how it lingers after you leave—and this aftertaste of enchant-

ment happens most effectively with films seen in the contemplative zone of a theater. Often, leaving a theater, I enter a night in which the mood, the characters, the spectacles, and the possibilities all seem to continue the movie's sensibility, as though it were an incantation summoning up experiences far beyond the screen.

When *Vertigo* was released, there were about seventy movie theaters in the city, far more than now when films have moved, at best, to the less ceremonial space of multiplexes—and films are now even shown on airplanes and laptops and cell phones as well as televisions and monitors at home. But the old theaters were sometimes called dream palaces, and dreaming then was done collectively, in the dark, with rituals beforehand, with appointed times and places, and it had another kind of magic.

Anyone who grew up going to movies knows the steps: the arrival in the vicinity; the examination of film schedules or movie posters out front; the purchase of the ticket, often at one of those glassed-in booths facing the street; the ticket torn from a roll and made of a particular kind of soft, fibrous, colored cardboard, red most often, sometimes orange or lavender or gray, to be found later crumpled in pockets; then the taking of the ticket; the promenade past the refreshment stand; the aroma of popcorn; the worn carpet of lobbies; and then the filing down dark aisles to the rows of velvet folding chairs and maybe the argument about an ideal seat. I even love the trailers, which serve as advertisements but also as mad little movies, cramped up like a peony before bloom, a butterfly in chrysalis, everything smashed in together, a burst of what you didn't choose before the launching of what you did.

For a long time, I lived across the street from a building that was for a decade or so an AIDS hospice. Called the House of Love, it was run by white-sari-wearing nuns in Mother Teresa's order—she came by a few times herself. After her death, the nuns left, and the big Victorian building became just another San Francisco collective household, though the residents held onto the name House of Love, threw great rave parties, grew a Rousseau-like jungle in the old storefront downstairs, and showed movies. Or, rather, one of the roommates, whose bay window faced my kitchen window, screened movies for himself with a DVD projector that turned his back wall into a theater of flickering faces and acts. I'd get out of a taxi at midnight and stand mesmerized for ten minutes, key in hand, as huge figures loomed and jumped on that wall, or I'd watch those silent movies for a while from my window.

That little impromptu home theater with its giant faces and careening motion lurching inside the house reminded me how supernatural movies once were and still are, given an arena to exercise their full power of uncanniness. A whole dinner party in my kitchen halted once to try to identify the movie in the window during an episode featuring Nick Cage's lugubrious face about nine feet high. You could picture a body filling up the house to go with that head, a giant folded up inside a wooden box, Alice after one of her Drink Me moments. On that happy strange evening of Nick Cage as apparition, the filmmakers and San Francisco aficionados Sam Green and Chip Lord were at my kitchen table puzzling out his looming, flickering face with me. That was long before Sam had begun his beautiful movie about the city's fog, but Chip had already completed his video splicing the car chase scenes in *Vertigo* and *Bullitt*

into one dreamy Möbius strip of cars plunging at various speeds through an impossible geography of hills.

In my early teens, when my mother worked in San Francisco, I would take the bus into the city and join her in watching Fred Astaire / Ginger Rogers movies at the Castro Theater. Its broad arcs of seats, its ornamental box-seat balconies, its oxidized gilt, and its great ceiling mural of the zodiac with a pendulum-like ornament dangling from its center are all still there in this theater where I've seen so many westerns, film festival offerings, silent movies, all the classics; seen *Milk*, the movie about the "Mayor of Castro Street," made doubly magical as the street outside and the theater itself keep showing up on the screen. The gay men in the dark with me educated me over the years about reading the sexual subtexts and preposterous elements of movies, about how to enjoy the homoeroticism of westerns, the spectacle of over-the-top femininity, the endless supply of unlikely plot twists and overwrought emotions. They taught me with sniggers and murmurs and sighs up and down the rows.

It's a big theater with a big screen, and the supernatural splendor I had found in my neighbor's dark room I found in the closeups at the Castro. In *Once Upon a Time in the West*, the camera comes closer and closer to Charles Bronson's squinting eyes, and you expect the camera, as conventional American cameras would have, to stop when his face fills the screen, a head as big and obdurate as one of those giant Toltec stone heads. But the camera travels inward and further in until the glare of his two staring, narrowed eyes fills the great sail of the screen. It's as though God were looking at you, for if there is one attribute of the medieval divinity that makes sense cinematically, it's that he's gigantic, looming, a force that fills the sky. There's a little twelfth-century church up in the Pyrenees mountains on the pilgrimage route from Paris to Santiago de Compostela, the church of Ste. Foy de Conques, and on its western façade the saint herself is shown, a tiny figure bent in prayer toward a huge hand coming out of the sky, wonderful and terrifying. Charles Bronson's fierce light eyes were that big. They haunt me still; they are what I see when I picture that screen.

In the creation myth of the Cahuilla, the creators argue about death. One of the gods is against it, because it is, after all, sad; and the other one points out that without it, the earth will get very crowded. Film has given us the ghosts who make it crowded and who make us ghosts wandering through time and place, dissolved the solidity of those categories, and set us all free to haunt and be haunted in the city of cinema, the city in which you dwell with Madeleine, with Muybridge, with strangers in the dark, with the ghosts among whom you yourself are a ghost, haunting, your own eyes like those of a god, for, thanks to cinema, you too see the dead now ∞

4 RIGHT WING OF THE DOVE

Though many of the maps in this atlas bring together complementary or conflicting versions and systems and species to generate dual subjects, this map is a response to the Bay Area that everyone thinks they know, the one all about left politics and peace movements. That version of this place is so well known that there was no reason to show it, but it lives in imagination everywhere. But the Bay Area is also a crucial part of the military machine. Its technocrats are forever imagining new devices for destruction, from thermonuclear bombs to robot soldiers, and the region hosts a powerful array of right-wing organizations and individuals, while the major universities remain major research centers for war and dominance. With the help of artist Sandow Birk's own beautifully dystopian imagination, we've tried to make this version of the place visible. CARTOGRAPHY: BEN PEASE; ARTWORK: SANDOW BIRK, COURTESY OF CATHARINE CLARK GALLERY, SAN FRANCISCO ∞ MAP APPEARS ON PAGES 32–33

THE SINEWS OF WAR ARE BOUNDLESS MONEY AND THE BRAINS OF WAR ARE IN THE BAY AREA BY REBECCA SOLNIT

When Nancy Pelosi became Speaker of the House, Republicans muttered about "San Francisco values." It was meant to be a damning epithet, summing up a place that was antiwar and thus presumed to be anti-soldier, that was liberal to libertine, that was—well, everyone knows what the clichés are. But the term, whether you love or hate what it describes, overlooks a huge portion of the region's economic muscle and global impact: we are the brain of the war machine, or perhaps its imagination. If this place is a dove rather than a hawk, the right wing of that wealthy, powerful dove merits scrutiny.

And yet the hawk departed only recently. The Bay Area was for decades a military powerhouse, from Hamilton Air Force Base in the North Bay, closed in 1976, to the Blue Cube of Onizuka Air Force Station just outside Sunnyvale, in the South Bay, where military spy satellites were tracked and directed until 2007. In between were a host of naval bases—Mare Island, Treasure Island, Alameda, Oakland, Hunters Point—and San Francisco's Presidio, the military's western headquarters since the 1860s and a Spanish and Mexican military site before that. At the city's Fort Mason Center, more than a million soldiers boarded ships for the Pacific front during the Second World War; at inland Travis Air Force Base, hordes of soldiers still board aircraft bound for our foreign wars. In between, in the delta, vast quantities of munitions are loaded at Concord Naval Weapons Station. Concord and Travis aside, most of these places are gone now, except for the toxic waste they left behind and some ruins, notably the dramatic bunkers and fortifications around the Golden Gate from

Bohemian Grove, annual gathering site of conservative power brokers

Chevron's Richmond refinery, where Iraqi crude oil is refined

Bechtel corporate headquarters, major nuclear, oil, and defense contractor

KSFO, conservative talk radio station

Ninth Circuit Court of Appeals, where torture memo architect Jay Bybee sits as a federal judge

AT&T offices, involved in Bush administration's warrantless wiretapping operations

Walmart.com, Internet headquarters for the world's largest public corporation and funder of right-wing causes

Stanford University, employer of Professor Condoleezza Rice, instigator of war in Iraq

Hoover Institution, right-wing think tank

RoboteX, maker of robot soldiers

NERVI·BELLI PECUNIA INFINITA

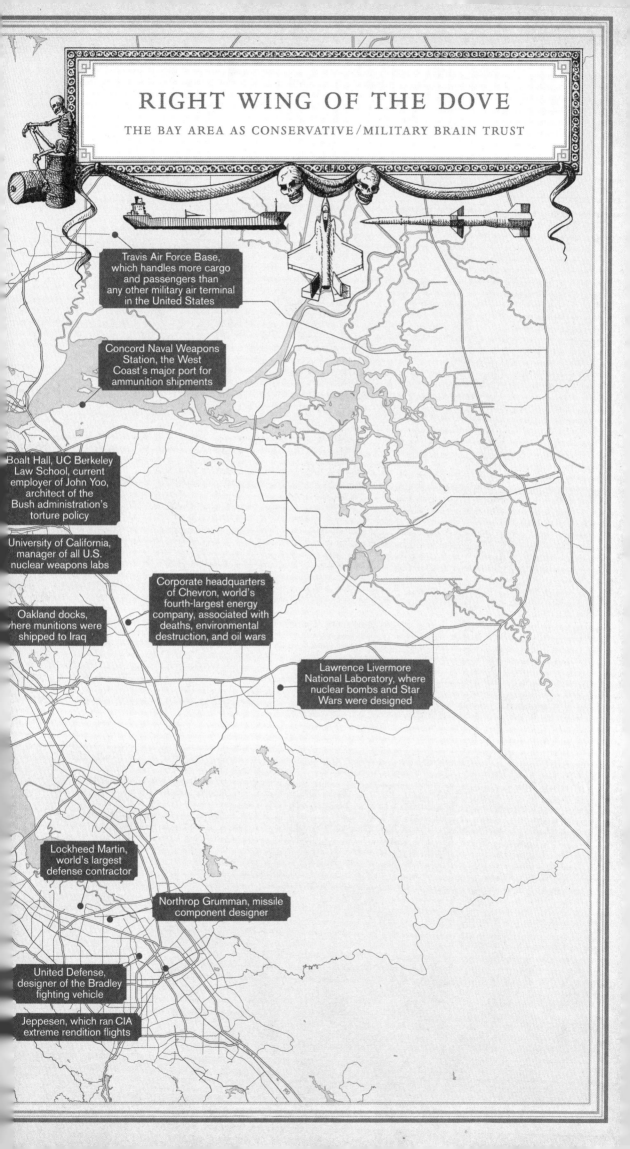

RIGHT WING OF THE DOVE

THE BAY AREA AS CONSERVATIVE/MILITARY BRAIN TRUST

Travis Air Force Base, which handles more cargo and passengers than any other military air terminal in the United States

Concord Naval Weapons Station, the West Coast's major port for ammunition shipments

Boalt Hall, UC Berkeley Law School, current employer of John Yoo, architect of the Bush administration's torture policy

University of California, manager of all U.S. nuclear weapons labs

Corporate headquarters of Chevron, world's fourth-largest energy company, associated with deaths, environmental destruction, and oil wars

Oakland docks, where munitions were shipped to Iraq

Lawrence Livermore National Laboratory, where nuclear bombs and Star Wars were designed

Lockheed Martin, world's largest defense contractor

Northrop Grumman, missile component designer

United Defense, designer of the Bradley fighting vehicle

Jeppesen, which ran CIA extreme rendition flights

World War II. But the research, development, and profiteering continue as a dense tangle of civilian and military work, technological innovation, economic muscle, and political maneuvering for both economic and ideological purposes. A figure such as Condoleezza Rice, who was a provost at Stanford University and a board member at Chevron before she became national security advisor and then secretary of state in the Bush administration, demonstrates the fluid boundaries between the universities, corporations, and government.

Much of the story is off the map. In Pelosi's San Francisco, for example, sits the world headquarters of the Bechtel Corporation; the engineering giant has been a key player in the war on Iraq and in the development of oil pipelines and oil infrastructure around the world. Bechtel also attempted to privatize water in Cochabamba, Bolivia, triggering a rebellion that was one of the great victories against corporate globalization. As my friend Antonia Juhasz told me:

> [Bechtel in Bolivia] privatized the rain, they started charging people for the water that you would catch on your roof, they started charging people for the water that was caught in handmade dykes that carried the water from the mountains. They were then promptly kicked out. Part of the organizing that we did when Bechtel got the contract to reconstruct Iraq—water systems, electricity were the dominant ones they had hopes of privatizing—was to have a letter written from the Cochabambans to the Iraqis warning them of what Bechtel was really all about.

This to me is the real essence of the Bay Area: it contains both Bechtel and Global Exchange, where Juhasz now heads an anti-Chevron project, both Chevron and the Goldman Fund, which gave Cochabamba organizer Oscar Olivera one of its environmental prizes. When Olivera came to San Francisco to receive the award, he led local activists on a march to Bechtel's headquarters.

Maybe it all began with the Southern Pacific Corporation, the outgrowth of the Central Pacific transcontinental railroad, whose builders managed to seize hold of huge sums of government money (some legitimately, some through fraud) and create one of the first modern corporations. Southern Pacific was nicknamed the Octopus because its tentacles reached far into California's and the nation's economy and government. Today, many of the corporations here

Throw a Shoe at Bush (a booth made by Tom Cohen and David Solnit),
San Francisco Civic Center, 2009. Photo by Mona Caron.

have tentacles with global reach. Chevron Corporation's second-largest refinery worldwide is in Richmond, and (thanks to too many protestors) its corporate headquarters moved to suburban San Ramon from downtown San Francisco, where the gigantic oil corporation had been based for decades. But Chevron has also been in Saudi Arabia since the 1930s (where Bechtel built much of the oil infrastructure), and it is involved in supporting the dictatorship in Burma and in oil drilling in Nigeria and Ecuador with concomitant human rights and environmental degradation; the Richmond facility began refining Iraqi crude oil early in the war on that nation. You can put the refinery and world headquarters on a map of the Bay Area, but that map in turn implies a global map of power, resources, suffering, and profit. You need then to imagine a map that includes Ecuador, Alaska, Iraq, Africa, Asia, the Arabian Peninsula—the world. This is the old globalization, the one we hardly talk about or see.

One constructive outgrowth of the original Southern Pacific octopus was Stanford University, founded by railroad baron Leland Stanford. The university is the home of the right-wing Hoover Institution think tank, and it is also the place where technology and business were hybridized into the powerhouse of Silicon Valley. Everything from Hewlett-Packard (once a significant defense contractor) to Yahoo and Google came directly from the university, and far more ventures came to fruition in the peculiar environment that thereby arose. As artist-geographer Trevor Paglen put it in a conversation with me:

> On the map you have Lockheed, but specifically what they do here is spy satellites. These are super-high-technology devices. There are entire industries that happen in secret that go into things like spy satellites, research done in secret. Livermore [Lawrence Livermore National Laboratory] is another example of a place where research like that is done, and the Onizuka Air Force Station down in Silicon Valley was a downlink for spy satellites until recently as well. So if you look at the research and development part of the military, you definitely find that here to a huge extent, and it's not really distinct from the computer industry or the technology industry in general.

Paglen points out that all this is not capitalism or free-market neoliberalism; rather, it's what he calls "military Keynesianism," a patronage economy in which the government commissions great works of military technology, new possibilities for killing and controlling. Robot soldiers, surveillance and satellite technologies, bomb and missile parts are all developed here. On the other side of the bay is Livermore Labs, where hydrogen bomb research and development took place in the 1950s and the Star Wars scheme to protect against nuclear missiles was hatched in the 1980s, both under Edward Teller, one of the models for Stanley Kubrick's Dr. Strangelove. In fact, the entire American nuclear weapons research program, dating from the first atom bomb, designed at Los Alamos, was directed by the University of California, Berkeley, Paglen's and my alma mater.

The university and its Berkeley campus are forever associated with the Free Speech Movement, student rebellions, and left politics, even though its Boalt Hall law school is now also the home of tenured faculty member John Yoo, one of the key architects of the Bush administration's torture policies, who also played an instrumental role in the administration's warrantless wiretap-

ping program (which was run to some extent out of AT&T offices in downtown San Francisco). Another such architect of Bush policies is Jay Bybee, who was rewarded with a federal judgeship in the U.S. Court of Appeals for the Ninth Circuit, which convenes in San Francisco's Civic Center complex. In addition, as Antonia Juhasz points out:

> The highest-ranking civilian lawyer at the Pentagon, who was also part of the torture memos, is now the managing lawyer at Chevron. He got his job coming out of the Pentagon to represent Chevron in its lawsuits—many of which are mass human rights abuses. So the lawyer they got was one of the torture memo lawyers. And actually he had been presented by the Bush administration for a judgeship, and there was a huge outcry in the military, leading former military officers to write a letter to the Senate saying that he advocates torture. Instead he got his job at Chevron.

The Sierra Club was founded in San Francisco in 1892 at Warren Olney's offices at 101 Sansome Street and evolved fairly quickly into the world's first environmental organization of note. But until the 1960s, its members and board were mostly engineers and business leaders who imagined that protecting scenic places and doing business—doing well and doing good—were entirely compatible. Sometimes this was possible—for example, some of the wealthier "Green Women" shown in another map in this atlas, who saved much of the Bay Area from development, were often wives of the captains of industry. But Olney himself was forced to resign from the Sierra Club when he found himself on the wrong side of the group's struggle to prevent scenic Hetch Hetchy Valley in the Sierra Nevada from being dammed to provide water for the city of San Francisco. He saw the municipal water plan as a blow against the private water profiteers, but his fellow club members saw it as the loss of a marvelous valley. Such contradictions came out in full force in the 1950s and after, with the Dinosaur and Glen Canyon dam struggles, the battles over placing nuclear power plants on the California coast, and other crises that demonstrated the rift between environmental commitment and business interests. The club survived—it's still headquartered on Second Street—and a host of more radical environmental groups sprang up here, some with global scope, like the International Rivers Network and Rainforest Action Network, and some local, like the Silicon Valley Toxics Coalition and Save the Bay.

The old Bay Area was home to a comfortable culture that thought you could have it all, but the postwar era has been a series of rifts that some straddle without noticing. And much of the rest of the world doesn't even know that there's more here than gourmet opportunities and progressive activities.

The title of this essay comes from the Cicero quote in Sandow Birk's map art: Nervi belli pecunia infinita—*the sinews of war are infinite money* ∞

5 TRUTH TO POWER

United Nations Plaza, poised between San Francisco's Civic Center and skid row, is also the axis along which stand many monuments, both obvious and unknown, to the history of race, justice, and power, a version of the heart of the city this map tries to make visible, with the help of Michael Rauner's magnificent photographs. Cities such as Paris had intentional axes built into them—like the straight line from the Louvre and the Tuileries to the Arc de Triomphe—but in American cities they're often unintentional and unrecognized. This map attempts to recognize only some of the turbulence that swirled around San Francisco's administrative heart, which is also a heart of struggle, of suffering, and sometimes of overcoming.

CARTOGRAPHY: BEN PEASE; PHOTOGRAPHS: MICHAEL RAUNER ∞ MAP APPEARS ON PAGES 38–39

THE CITY'S TANGLED HEART BY REBECCA SOLNIT

Once upon a time, much of what is now the city of San Francisco remained undeveloped land, and much of that undeveloped land was sand. One such parcel was known as the Sand Lot. It was to the city what the Hyde Park Speakers' Corner was to London, a place where demagogues could speak to crowds. Once upon a time, San Francisco was a boomtown at the end of the world, in which almost everyone was an immigrant from the eastern United States, from Europe, from South America—and from China, for a great many men (and very few women) had come to Gold Mountain, as the Chinese called it, to seek their fortunes in the mines. Some toiled in the mines; some found other work; many became cooks and laundrymen; and the Chinese in great numbers became cheap labor on the great railroad-building project that would connect the two coasts of the country in 1869. They were blamed by other workers for undercutting pay scales and then were blamed for the general plight of the white working man.

Once upon a time, the building of that railroad turned four Sacramento storekeepers—Stanford, Crocker, Huntington, and Hopkins—into San Francisco millionaires, the nobs whose palaces gave Nob Hill its name. And the railroad corporation, one of the first modern corporations, became a monstrous force, a python wrapped around California, squeezing it for money, controlling its movements and setting its policy.

The railroad was headquartered near Mission Bay, which had ceased to be a bay as it was filled in with garbage and sand from the flattened dunes. The Chinese were headquartered in Chinatown, which still stands because the government of China and local Chinese-Americans refused to let the city's

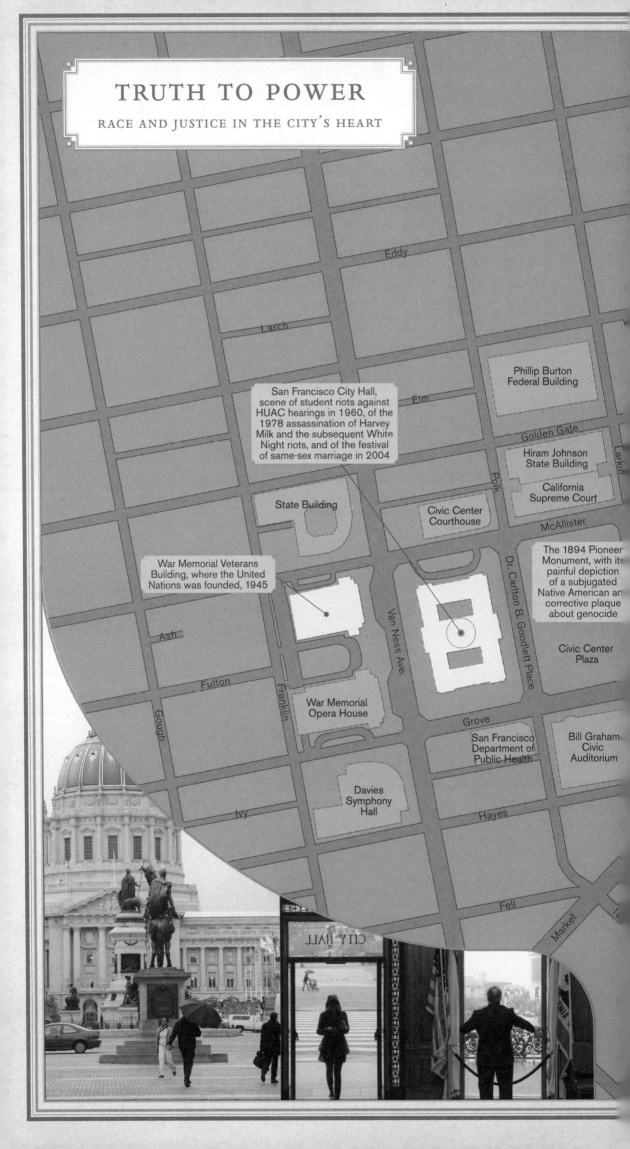

TRUTH TO POWER

RACE AND JUSTICE IN THE CITY'S HEART

Phillip Burton
Federal Building

San Francisco City Hall,
scene of student riots against
HUAC hearings in 1960, of the
1978 assassination of Harvey
Milk and the subsequent White
Night riots, and of the festival
of same-sex marriage in 2004

Hiram Johnson
State Building

California
Supreme Court

State Building

Civic Center
Courthouse

The 1894 Pioneer
Monument, with its
painful depiction
of a subjugated
Native American an
corrective plaque
about genocide

War Memorial Veterans
Building, where the United
Nations was founded, 1945

Civic Center
Plaza

War Memorial
Opera House

San Francisco
Department of
Public Health

Bill Graham
Civic
Auditorium

Davies
Symphony
Hall

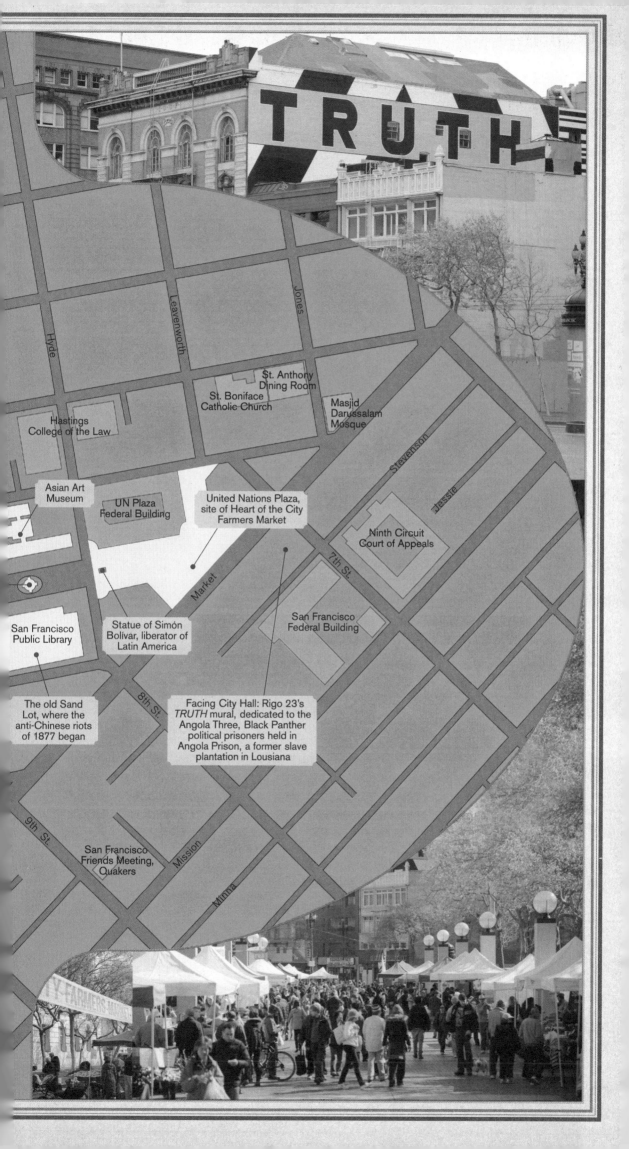

TRUTH

Leavenworth

Jones

Hyde

St. Anthony
Dining Room

St. Boniface
Catholic Church

Masjid
Darussalam
Mosque

Hastings
College of the Law

Stevenson

Jessie

Asian Art
Museum

UN Plaza
Federal Building

United Nations Plaza,
site of Heart of the City
Farmers Market

Ninth Circuit
Court of Appeals

7th St.

San Francisco
Public Library

Statue of Simón
Bolívar, liberator of
Latin America

San Francisco
Federal Building

Market

8th St.

The old Sand
Lot, where the
anti-Chinese riots
of 1877 began

Facing City Hall: Rigo 23's
TRUTH mural, dedicated to the
Angola Three, Black Panther
political prisoners held in
Angola Prison, a former slave
plantation in Lousiana

9th St.

San Francisco
Friends Meeting,
Quakers

Mission

Minna

Pioneer Monument, Civic Center, 2010. Photo by Michael Rauner.

business leaders relocate them to Hunters Point, in southeastern San Francisco, after the great earthquake of 1906. That was the earthquake that would destroy the garish, unstable City Hall whose construction had begun in 1872, its bricks mortared, it is sometimes said, with corruption.

That City Hall was still being built when the Sand Lot riots of 1877 launched the terrible anti-Chinese violence of that year. The rest of the country was being convulsed by the closest thing to a revolution the United States had seen since its founding, a revolution against capital, against wealth, and most particularly against the railroads. But in San Francisco, the outrage at the wealth of the railroad barons and the poverty of the workers in that recession was misdirected at the Chinese, and a hysterical rage was whipped up by the demagogue Dennis Kearney, speaking at the Sand Lot and demanding the expulsion of Chinese laborers. Chinese people, homes, and businesses were attacked, and buildings and wharves were set ablaze—the city fathers were afraid the whole city would burn down, and it might well have.

A century passed and more, a century and twelve years from the fiery riots, and there was a largish earthquake, the Loma Prieta quake of October 17, 1989. The City Hall destroyed by the 1906 earthquake had long ago been rebuilt farther from Market Street, this time as a magnificent building. In 1989, the new City Hall fared well in the quake, but the public library from the same Beaux-Arts era of building did not. Across the street, in the vacant lot where the Sand Lot riots had been launched, a new library was built. The old library building, subsequently revamped, became the new home of the Asian Art Museum, a museum founded on the vast art collection of Avery Brundage, who gave nearly eight thousand artworks to the museum from the late 1950s onward, a treasure trove. Now one of the largest such museums in the Western Hemisphere stares down at the site of the anti-Chinese Sand Lot riots, and the irony there is perhaps sour, perhaps sweet.

Once upon a time, there was a Sac and Fox chief, Black Hawk, fierce enough to have a war named after him, and though he and his band fought bravely in

this war in the Midwest, he didn't win back those lands that supposedly had been ceded to his nation "forever," and his descendants were sent to Indian Territory/Oklahoma. Once upon a time thereafter, in 1888, to be precise, in a place called Prague, Oklahoma, a Sac and Fox boy was born and thrived, though his twin died. The boy had an uncanny talent for almost any sport he tried; he grew up to compete in both the decathlon and the pentathlon at the Stockholm Olympics of 1912, defeating competitor Avery Brundage, among others, and setting some world records. King Gustav V of Sweden said to him, with a handshake, "Sir, you are the greatest athlete in the world." Jim Thorpe casually replied, "Thanks, King." But he was stripped of his medals because he had once played baseball for a modest sum and thereby didn't qualify as an amateur athlete. Thorpe's subsequent life was turbulent, in part as a result of this humiliation, but it was long and not without its triumphs, one of which was surely his daughter Grace Thorpe. She was one of the occupiers of Alcatraz Island in 1969–1971, that great stand to demand rights and land for Native Americans. She went on to become a powerful antinuclear and human rights activist, a tradition her daughter Dagmar Thorpe continued.

Thorpe's unsuccessful rival, Avery Brundage, became a wealthy businessman and, in 1929, president of the U.S. Olympic Committee. In that role, he refused to protest or boycott the 1936 Berlin Olympics. He also joined the International Olympic Committee after the American member was expelled for calling for a boycott. The boycott did not take place. The two Jews on the American team were replaced by Jesse Owens and Ralph Metcalfe, so as not to offend the Nazis. Owens, an African American, was himself a defiant presence at what history remembers as the Nazi Olympics, winning four gold medals in track. Brundage became a champion of Nazi filmmaker Leni Riefenstahl, whose film of the 1936 Olympics is considered the acme of fascist art. Brundage complained that the movie wasn't screened commercially in the United States because "unfortunately the theaters and moving picture companies are owned by Jews." Many considered him to have been one of the obstacles to Thorpe's medals being reinstated, which happened only after both men were dead.

Brundage became president of the IOC in 1952. During the 1968 Mexico City Olympics, he suspended African American track athletes Tommie Smith and John Wesley Carlos, gold and bronze medal winners in the 200 meter event, for their Black Power salute during the medal ceremony; Brundage even protested the inclusion of their "shameful abuse of hospitality" in the film of the games. San Francisco's Portuguese émigré artist Rigo 23 built a monument to Smith and Carlos at their alma mater, San Jose State University, a larger-than-life pair of mosaic figures on their platform, still giving the salute today.

Rigo also painted the huge mural *TRUTH* on a Market Street building facing San Francisco City Hall and dedicated it to the Angola Three, the trio of Black Panthers unjustly thrust into solitary confinement for decades in Angola Prison, a former slave plantation in Louisiana. The Black Panther movement was founded in Oakland, just across the bay. Robert King Wilkerson, former Panther and member of the Angola Three, who was eventually exonerated and freed, was there at the dedication of the mural in United Nations Plaza one cool sunny day in 2002. *TRUTH*, the simplest of words and maybe the

most demanding, the one that measures all other words, glares back at City Hall and the courtrooms and federal buildings grouped around UN Plaza, demanding that the truth of this place be known, or the many truths.

Once upon a time, not so far from the state university where Smith and Carlos trained for the Olympics, in East San Jose, there was a barrio called Sal Se Puede (Get Out If You Can), where a young man named Cesar Chavez lived during his childhood and to which he returned when he began to train as an organizer of farmworkers. Chavez became so legendary a figure that the young members of the Norteños gang in the Mission District tell my friend Adriana, as they deal drugs a few blocks from Cesar Chavez Street, formerly Army Street, that the gang began as Chavez's bodyguards. And perhaps they did, for the Norteños were involved with the Brown Berets then and immigration marches now, the Chicano and Chilango performance artists Roberto Sifuentes and Guillermo Gómez-Peña tell me one night at Tadich Grill— Roberto had Norteño babysitters when his father was a radical UCLA student, but that's another story.

In the great classical gardens of Europe, the designers would line up fountains, statues, and other ornaments on long axes, as though they were building alignments of power, constellations of meaning. Around UN Plaza, a long axis leads from *TRUTH* to the plaza itself, to the statue of Simón Bolívar, to the Pioneer Monument, and then, crossing Larkin Street, to Civic Center Plaza, once full of wartime victory gardens, and across Polk to City Hall. The statue of Bolívar, El Libertador, the liberator of Latin America from European rule, was donated by the country of Venezuela. The warrior and his rearing horse preside over the produce of the farmers market that has filled the plaza twice a week for three decades. Bolívar is the symbolic figure in what Venezuelan president Hugo Chavez calls the Bolívarian revolution, aiming to create a Latin America that is at last truly free of colonial domination.

In 1894, ninety years before the bronze Bolívar arrived in the complex of meanings that is greater UN Plaza, the Pioneer Monument was dedicated. Actually a whole crowd of bronze figures, it was moved when the new library was built, amid protests by Native Americans. Below the central pillar, bearing California represented as a warrior goddess, are four sculptural groupings. One of the four, called "Early Days," represents a vaquero and a padre looming over a handsome Native American man who is lying prone before them. The sculptor, Frank Happersberger, likely did not know quite how unpleasant his Californio priest and cowboy would come to seem; but when the new library opened and the statue was relocated, Native Americans protested it as demeaning. It was accurate, however, in its depiction of the brutality visited against Native Californians, and the city declined to remove it, instead adding a plaque. After much arguing by the Catholic archbishop, the Spanish embassy, and others about what had happened in the nineteenth century and who was most murderous then, it now reads in part, "At least 300,000 Native people— and perhaps far more—lived in California at the time of the first settlement in 1769. During contact with colonizers from Europe and the United States, the Native population of California was devastated by disease, malnutrition, and armed attacks. The most dramatic decline of the Native population occurred in the years following the discovery of gold in 1848." The discovery of gold is

Statue of Simón Bolívar, UN Plaza, 2010. Photo by Michael Rauner.

commemorated on the other side of the monument, with a grouping of men with pick and pan.

Once upon a time, not long enough ago, when being gay meant that one risked being treated as a criminal or a crazy person, there was a cross-dressing San Francisco performer named José Sarria, the perennial star of the bar called the Black Cat. Sarria ran for election as a San Francisco supervisor in 1962, long before there were out gay people in any politics anywhere else in the United States. Sarria had trained as a teacher but was unable to obtain a teaching credential because of his sexuality. He then turned to singing, singing operas in women's clothes at the Black Cat, and began as well the great drag balls that peaked in the 1970s and set up the court system of empresses, queens, kings, and so forth that still exists all over queenly America. Sarria, who was sometimes known as Empress José, sometimes called himself the Widow Norton, as though this bold twentieth-century personality had been married somehow to the great nineteenth-century eccentric Emperor Norton, who ruled the streets of San Francisco and proclaimed himself the ruler of the country, who was manageably mad from 1859 to his death in 1880, and who nowadays might be regarded as just a crazy homeless person. Norton was indulged by the people of San Francisco for decades; Empress José ran for office in 1962.

San Francisco was already a turbulent place in the early 1960s. Though many date the beginning of the student movement from the 1964 Free Speech Movement in Berkeley, at the University of California, the San Francisco State University student protests against the anti-communist witch hunts of the House Un-American Activities Committee (HUAC), at San Francisco City Hall in 1960 were all too literally a watershed—the students were washed down the broad marble steps of the Beaux-Arts building with fire hoses.

Fifteen years after Sarria's largely symbolic run, Castro District resident Harvey Milk ran for supervisor and won. He took office in City Hall, where fellow supervisor Dan White gunned him down the following November. White also murdered liberal mayor George Moscone, after whom, ironically, Moscone Center is named, the convention center created by displacing a neighborhood of mostly elderly and poor men. When White was given a light sentence for the murders, gay San Francisco was furious. The White Night riots that followed smashed up City Hall; the police themselves became vengefully violent, and more court action ensued.

Twenty-seven years after Milk's assassination, in the spring of 2004, Mayor

Gavin Newsom presided over the first wave of same-sex weddings in the United States, beginning just before Valentine's Day with the marriage of long-time activists and life partners Del Martin and Phyllis Lyon. Before the courts put an end to it, 3,995 jubilant weddings took place at City Hall, and the streets were full of veils and gowns and tuxes and flowers, sometimes flowers brought by strangers to celebrate the opening for love. The month of marriages raised the issue internationally and moved it forward in many states, even though the California courts first banned it, then permitted it, and then banned it again for a while, after the passage of a ballot measure run by religious groups.

Cities should have hearts. Old ones do, some new ones don't; and the heart of San Francisco is the complex of monuments around UN Plaza in the Civic Center, a complex, or tangle, that brings together the city's and country's victories and disgraces when it comes to race and rights. Reading it means reading history, including histories that stretch back to the eighteenth century and overseas to Berlin and China, down the road to San Jose, and down the continent and across the isthmus to Venezuela.

A little way away from the plaza, in the War Memorial Veterans Building, which housed the San Francisco Museum of Modern Art from 1935 to 1995, the United Nations was founded. The meetings that shaped the organization were held mostly at the Opera House next door, but the formal signing of the United Nations Charter took place in the beautiful mural-adorned Veterans Auditorium (now the Herbst Theatre) on June 26, 1945. The words of the founding charter were laid out in golden letters on the pavement of the awkward expanse now known as United Nations Plaza by landscape architect Lawrence Halprin.

Every Wednesday and Sunday since the early 1980s, a farmers market has been held at UN Plaza. The market serves the food desert of the Tenderloin and its many immigrant Asian families, and the vendors and buyers are themselves of many ethnicities, so that the market seems itself like an embodiment of the hopes of the United Nations, though all around the stands selling pomegranates and beautiful lavender and violet Chinese eggplants and roses and beets and Two Dog Farm's famous dry-farmed tomatoes are monuments to the tangled history of race, rights, and power in San Francisco, California, and the United States. Grace, who is half Japanese, sells me my lettuces and tells me about the adventures and woes of a farmer year-round; the Man in the Porkpie Hat shows up at various booths, in various hats; the south Asian family has the best peaches and second-best tomatoes; the Vietnamese organic farmers have ginger, cilantro, parsley, and lemons; the Chinese family provides the orchids that tropicalize my house; the old Latino booth with everything from roses to onions dominates the corner next to Bolívar as it has for twenty years, the booth where I saw how thorny roses were in the lacerated hands of the men; the new Latino organics booth has beautiful greens and root vegetables—and it all grows on the native soil of California. This is the best monument to the complexity and the possibility of the place, not a monument in bronze or stone, but one that is raised up again week after week by the farmers and devoured again and again by San Franciscans, nourished by the food sold atop the UN Charter, now a meeting place between soil and city and strangers from all places ∞

6 MONARCHS AND QUEENS

San Francisco has always been something of a sanctuary city for both human beings and others, isolated as the tip of a long peninsula at continent's end with its own climate and its own cultures and sometimes its own species. This map is about the butterflies of the city, including migratory species such as monarchs that are found across the continent and others such as the mission blue that are found only on a few hilltops here and across the Golden Gate, and about the queer cultures that flourished in San Francisco over most of the past century. Advancing human settlement has been hard on butterflies—a few species have gone extinct altogether, a few more disappeared locally—but both governmental and independent efforts now protect some of the key remaining habitat. For its part, queer culture has continued to evolve and shift its home ground from the lesbian and drag bars of North Beach in the 1930s through the 1950s (with Finocchio's lasting until a few weeks before the millennium) to Polk Gulch to Folsom Street and the Castro, with even a brief efflorescence of gay and lesbian bars along Valencia Street long before that strip's straighter gourmet-hipster fate descended upon it. Artist Mona Caron invented a winged version of one of the Sisters of Perpetual Indulgence—the AIDS activists in nun drag who are definitely an endemic San Francisco species—as the presiding figure of this map, whose butterfly images all represent actual species found in the city. CARTOGRAPHY: BEN PEASE; ARTWORK: MONA CARON ∞ MAP APPEARS ON PAGES 46–47

FULL SPECTRUM BY AARON SHURIN

Among my friends it's generally agreed that the boys from Down Under perfected the art of drag names: witness the diurnal/nocturnal urban revelation known as Jacqueline Hyde, or New Zealand's deliciously indigenous royal, Maori Antoinette. We could happily add their San Francisco cohort, the ponytailed Vegas-style dancer with a single giddy name, whose contractual billing for every movie in which she appeared was "and *introducing:* Tippi!" Itty-bitty Tippi was coltish and supple and could toss her tiny body across the stage with nutty abandon (or, more precisely, be tossed by the hunky dancers supporting her); "Tippi," then, was the perfect metonym for the fearless sprite she transformed herself into, a petite projectile, tipped into space, twirled in the air, cartwheeling to the horizon. (Years later, when she was dying from AIDS, I visited her apartment, where she lay in general seclusion behind the closed

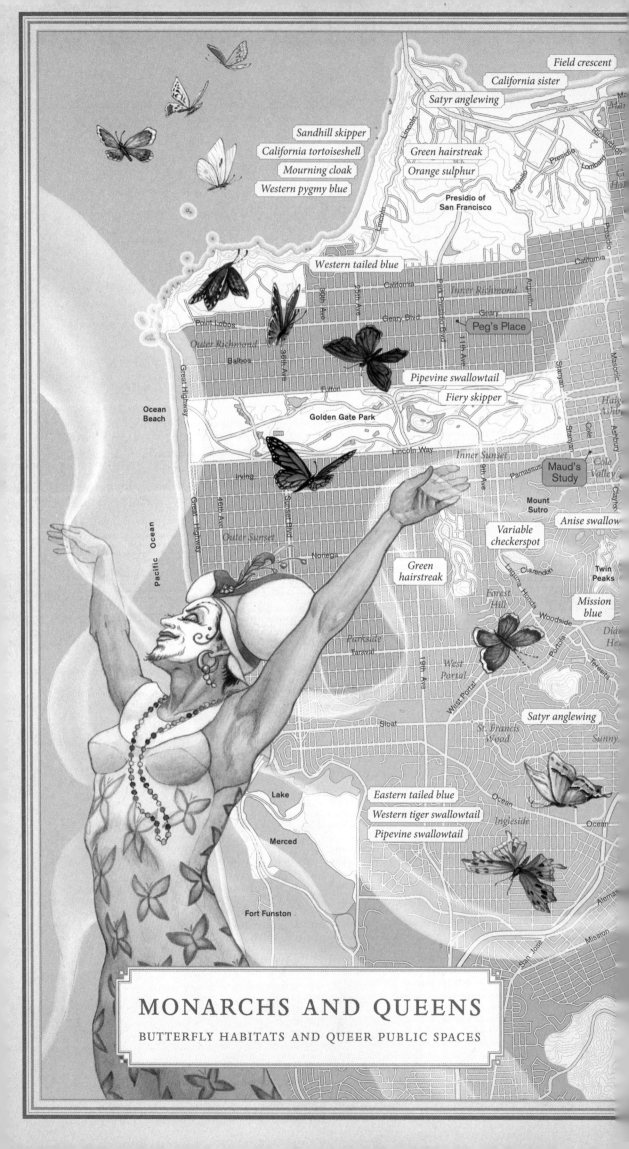

Field crescent

California sister

Satyr anglewing

Sandhill skipper
California tortoiseshell
Mourning cloak
Western pygmy blue

Green hairstreak
Orange sulphur

Presidio of
San Francisco

Western tailed blue

Inner Richmond

Point Lobos

Outer Richmond

Balboa

Geary Blvd

Geary

Peg's Place

Pipevine swallowtail

Fiery skipper

Fulton

Golden Gate Park

Lincoln Way

Inner Sunset

Maud's
Study

Cole
Valley

Mount
Sutro

Anise swallow

Variable
checkerspot

Irving

Outer Sunset

Twin
Peaks

Mission
blue

Noriega

Green
hairstreak

Forest
Hill

Parkside

Taraval

West
Portal

St. Francis
Wood

Sloat

Satyr anglewing

Lake

Eastern tailed blue

Western tiger swallowtail

Pipevine swallowtail

Merced

Ingleside

Ocean

Ocean

Fort Funston

Ocean
Beach

Pacific
Ocean

Great Highway

Great Highway

MONARCHS AND QUEENS

BUTTERFLY HABITATS AND QUEER PUBLIC SPACES

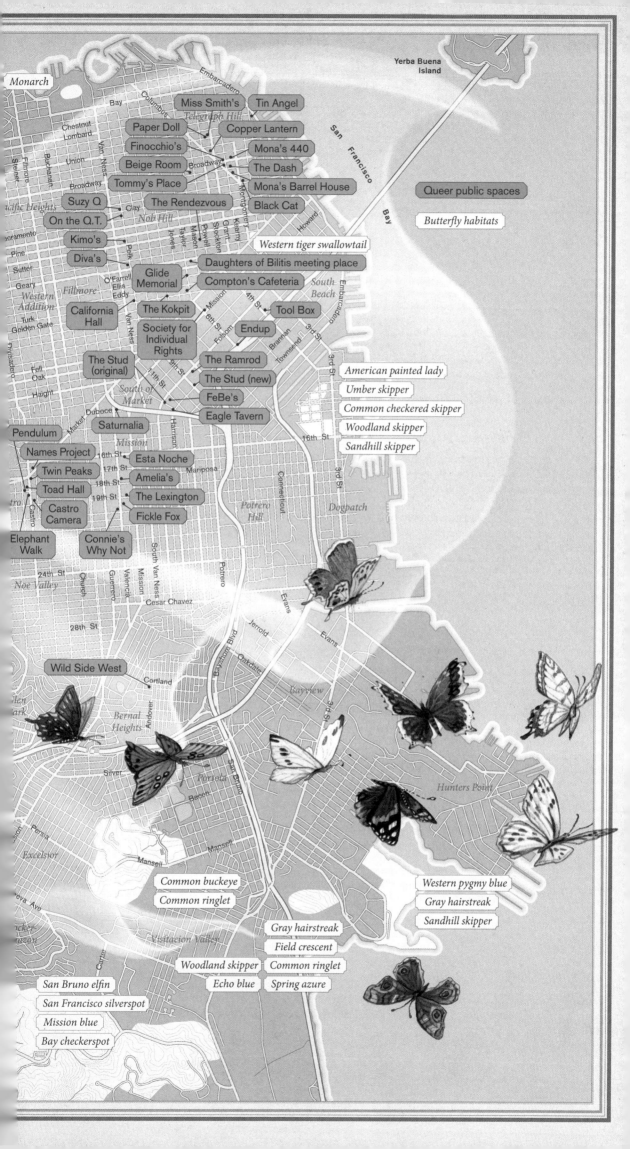

The Sisters of Perpetual Indulgence, ritual procession through the Castro, 2010. Photos by Michael Rauner.

door to her room. A small end table with a vase of flowers had been nailed to the outside of the door, effectively masking it as part of the hallway. The door to her inner sanctum was in drag as a wall, keeping unwanted visitors at bay and helping Tippi remain unaged and unblemished like Garbo; one would always be able to say, "and *introducing:* Tippi!")

In my day, at least, every gay man searched for a drag name that acted as a (hysterical) key to secret identity. The name was like a wig worn to rearrange your public face: a *language* wig! It could frame and reframe; it carried drag's ability to simultaneously mask and disclose. It was a verbal impersonation, yes, but more—it was a *personation*. The hidden true self, urged to emerge, could convert to full spectrum: I name myself and become my flamboyant self. ("I celebrate myself, and sing myself"—Whitman.) How thoroughly the lexical landscape of gay history is invested with this paradigm of emergence: to come out of the closet, to rename yourself with your real name, to find the right wig, to own your true nature and emerge in living color. As Genet tells it in *Our Lady of the Flowers*, "It is customary to come in drag, dressed as ourselves."

Nature, living color, emergence. In the '90s, a San Francisco guerilla group printed flaming orange stickers that announced, "Unleash the queen!" We add one letter to our wigs and we have "wings." This is a map of "monarchs and queens," of butterflies and flutter-bys, of caterpillars in drag and men and women with wings. This is a map of transmutations, a map of cocoons torn open and places of refuge for winged creatures, of antennae on the wind and feelers that feel you up, of *mariposas* and of Marys. This is a map of tribes, of flitting things and their gathering spots, of wings and of wingspread, of extravagant names and impossible migrations, of will-o'-the-wisps and force of will, a map of fritillaries and fairies. On this map you may find congregating the green hairstreak, the satyr anglewing, the American painted lady, the umber skipper, and the anise swallowtail, alongside Goldie Glitters, Pinky Bubbles, Sister Boom Boom, Sissy Spaceout, and the legendary pink-cheeked Dawn (of Aquarius).

Or you may find me on this map, too, there on the landing to the Rendezvous at the innocent age of eighteen—creased chinos and pressed hair—spasming with anticipation and dread, totally larval but aching to unfold. And if I spread my wings, where would the wild West Wind take me? And if I didn't, where would I have to remain? My shoulder bones ached from pressure and began to shake as I trembled into the room on a rumor of feathers. If not here in this common refuge, where then? If not tonight, which night? I shook

out my back with a shiver; wing-nubs pressed at my flesh. What could such wings be made of? They had long hair and misty eyes, they had lean stomachs and tender kisses, they had hard-ons in company and interlocked smiles; they were made of silly gestures and dramatic arches and too-muchness and high language, of alliteration and sibilance and "sensibility"; they were full of grunts and long sighs, of knowing glances and more glances, of warrior wands and sorcerer robes and thumping drums; they were braids of brother- and sisterhoods, of secret prayers and common purposes, of gender intuition and involution, of fury and of fervor . . . On that landing, in that room, in the spring of 1966, I shuddered, stepped forward, and began to unfold my map . . .

This is a map of unfurled maps.

"Unleash the queen," they wrote, where the focus now falls on removing the "leash," that restraint to carnal immediacy, to the body's pure animal pleasure, lack of shame, spontaneity, bestial innocence. And so the bars, those wildlife sanctuaries, bore the imprint of this unleashing, as the Elephant Walk, the Stallion, and the Stud; as the Eagle and the Black Cat, the Fickle Fox, Toad Hall, Jumping Frog, Missouri Mule, and Red Lizard; as Moby Dick, the Lion, and the Lonely Bull; as the Rainbow Cattle Company and the RoundUp, the Blackbird and the Old Crow. This map unleashes its legends.

Did the city itself bust out, bank into flight? Did it quiver and stretch, following the contours of community as it spread from Grant Street to Polk Street, from Sutter down to Folsom, to Valencia, and out to Castro? Did it rise up on rarer air, leaning into the unforeseeable elaborations of liberation? Out of the old bars into the raging streets, out of the private societies into City Hall, out of the psych wards and into the wards of voting booths, from bitter dark rooms to ecstatic back rooms, from paddy wagon to parade . . . Didn't the city itself change shape, burst through, take wing, blaze into color, catch fire and light? This is a map of incendiary lights!

"This morning with a blue flame burning/," wrote the great gay poet John Wieners in San Francisco in 1959, "this thing wings its way in. / Wind shakes the edges of its yellow being." In a rented room in the heart of the city, through a long morning dispossessed but filled with clarity, he watches the radiant insect flutter at the window. "Furred chest, ragged silk under / wings beating against the glass . . . blue diamonds on your back." In the sanctuary city in quiet light, he pictures "a giant fan on the back of / a beetle. / A caterpillar, chrysalis that seeks / a new home apart from this room." A poet, too, must come into poetry, take a name, leave home, find kin, unfold, and soar. "So tenuous, so fine / this thing is," he muses, hand over mouth, "I know the butterfly is my soul."

This is a map of a place people come to for wingspread and wigmaking, for monarchial identity and queenly conversions, for animal nature and long morning light; for soul ∞

NORTH BEACH, 1908–1960S

Beige Room, 831 Broadway, 1951–1958

Black Cat, 710 Montgomery St.,
1933–1963

Copper Lantern, 1335 Grant Ave.,
1955–1965

The Dash, 574 Pacific Ave., 1908

Finocchio's, 506 Broadway,
1937–1999

Miss Smith's Tea Room,
1533 Grant Ave., 1954–1960

Mona's 440, 440 Broadway, 1939–1948

Mona's Barrel House, 140 Columbus
Ave., 1936–1938

Mona's Candlelight, 473 Broadway,
1948–1957

Paper Doll, 524 Union St., 1948–1952

Tin Angel, 987 The Embarcadero,
1954–1960

Tommy's Place, 529 Broadway,
1952–1954

POLK GULCH AND THE TENDERLOIN,
1960S AND AFTER

California Hall, 625 Polk St., site of the
1965 New Year's Ball for the Council
on Religion and Homosexuality

Compton's Cafeteria, 101 Taylor St.,
site of the August 1966 drag queens'
battle with police

Daughters of Bilitis (founded 1955)
meeting place, 465 Geary St.

Diva's, 1081 Polk St., 2000–present;
formerly the Motherlode, Post and
Larkin, 1987–2000

Glide Memorial Church, 330 Ellis St.,
1931–present (social services began
in 1955)

Kimo's, 1351 Polk St., 1977–present

The Kokpit, 301 Turk St., 1971–1994

On the Q.T., 1695 Polk St., 1970–2000

The Rendezvous, 567 Sutter St.,
1962–1976

Suzy Q, 1741 Polk St., 1960-1962;
site of the Tavern Guild's first meeting

FOLSOM STREET, 1960S AND AFTER

Eagle Tavern, 398 Twelfth St.,
1980–present

Endup, 401 Sixth St, 1973–present

FeBe's, 1501 Folsom St., 1966–1987

The Ramrod, 1225 Folsom St.,
1970–1976

Society For Individual Rights,
83 Sixth St., 1964–1971

The Stud, 399 Ninth St. (originally
1535 Folsom St.), 1966–present

Tool Box, Fourth and Harrison,
1962–1971

VALENCIA STREET, 1970S AND AFTER

Amelia's, 647 Valencia St., 1980–1991

Connie's Why Not, 878 Valencia St.,
1972–1982

Esta Noche, 3079 Sixteenth St.,
1981–present

Fickle Fox, 842 Valencia St., 1973–1984

The Lexington, 3464 Nineteenth St.,
1954–present

Saturnalia, 1969–1971, then Hans Off,
1972–1974, then the Rainbow Cattle
Company, 1974–1979, 199 Valencia St.

CASTRO STREET, 1970S AND AFTER

Castro Camera (Harvey Milk's camera
shop), 573–575 Castro St., 1972–1978

Elephant Walk, then Harvey's,
500 Castro St., 1975–1996

Names Project, 2362 Market St.,
1987–present

Pendulum, 4146 Eighteenth St.,
1970–2005

Toad Hall, 482 Castro St., 1971–1979

Twin Peaks, Castro and Seventeenth,
1973–present

OTHER NEIGHBORHOODS,
1970S AND AFTER

Maud's Study, 937 Cole St., 1966–1989

Wild Side West, 424 Cortland Ave.,
1977–present

7 POISON / PALATE

The culinary Bay Area never tires of trumpeting its gourmet treasures, while the toxic face of the region is rarely mentioned, from the barrels of radioactive waste rusting off the coast of the Farallones to the twenty-nine Superfund sites Silicon Valley created to the tons of pesticides and herbicides that go into winemaking to the mercury from leaking mines and former gold-mining operations that has washed onto the floor of the bay. And even the real foodscape of this place that produces salt, sugar, and mushrooms on a grand scale, along with Rice-A-Roni and artisanal chocolates, is not quite what people think it is. Still, this remains a major food-producing, exporting, and importing region as well as a culinary capital—in part because almost every ethnic group on earth is here, which is why you can buy everything from durians to piroshki to dim sum just in the Richmond District. This map, with Sunaura Taylor's exuberantly mutant mermaids and tree, is here to both whet and ruin your appetite and deepen your appreciation for the contradictions. CARTOGRAPHY: BEN PEASE; ARTWORK: SUNAURA TAYLOR ∞ MAP APPEARS ON PAGES 52–53

WHAT DOESN'T KILL YOU MAKES YOU GOURMET

BY REBECCA SOLNIT

The Bay Area is a tale of two valleys, places that call up very different associations. Napa Valley is the opposite of Silicon Valley, or likes to think so. Napa Valley is how the region is marketed, as upscale, arcadian, sensual, and leisurely; Silicon Valley is its other face, hectic, disembodied, corporate, and geeky, though the sweatshop tech work is now done mostly overseas. Of course, the meaning of each place, and their relationship to each other, is more complicated. Napa is a second-home capital for the wealthy, including those who've made a killing in technology. You make software to engineer the future and buy pseudo-Tuscan nostalgia with the profits.

Visually, the valley in the north is a pastoral vision of green gridded vineyards and rustic architecture—the gigantic wooden fermenting barrels were one of the wondrous sights of my childhood. Making wine is as traditional as making electronics communication technology, new devices, and software is not. And certainly the suburban expanse of Silicon Valley is dystopian: a landscape of workspaces, shopping, and sprawl scattered any which way and connected by a network of highways prone to gridlock. But if you include the farmworkers whose lives in the wine country are not so gracious, you can begin to locate the affinities between the two places.

POISON / PALATE

THE BAY AREA IN YOUR BODY

Legend:
- Palate sites
- Poison sites
- Poison/Palate sites
- EPA Superfund sites
- • Wineries

Map labels:

Socrates mercury mine

Napa County wineries
114,280 tons of wine grapes (2008)
764 tons of chemicals (2007)

Sonoma County wineries
168,208 tons of wine grapes (2008)
1,256 tons of chemicals (2007)

Gravenstein Highway
Gravenstein Apple Fair

French Laundry

Clover Stornetta
Riebli Dairy

Moretti Dairy
Triple C Dairy

Petaluma Poultry

Rancho Veal slaughterhouse

Straus Family Creamery
Kehoe Dairy
Marin French Cheese

Cherry Tree Country Store

Hog Island Oyster Co.
H Ranch/McClure Dairy
Home Ranch

Gambonini mercury mine

Former Hamilton Air Force Base

Former Mare Isl...
Naval Shipyar...

Lafranchi Dairy

D Ranch

Mercury contamination from gold mining

B Ranch
Bivalve Dairy

A Ranch

San Rafael Civic Center
Farmers Market

Chevron's Richmond refi...

General Chemical

Star Route Farms

Farallon murre and seagull eggs

See's Candies factory

Guittard Chocolate

Nuclear waste disposal sites

It's-It factory

Half Moon Bay Pumpkin Festival

Brussels spro...
and artichoke f...

Pie R...

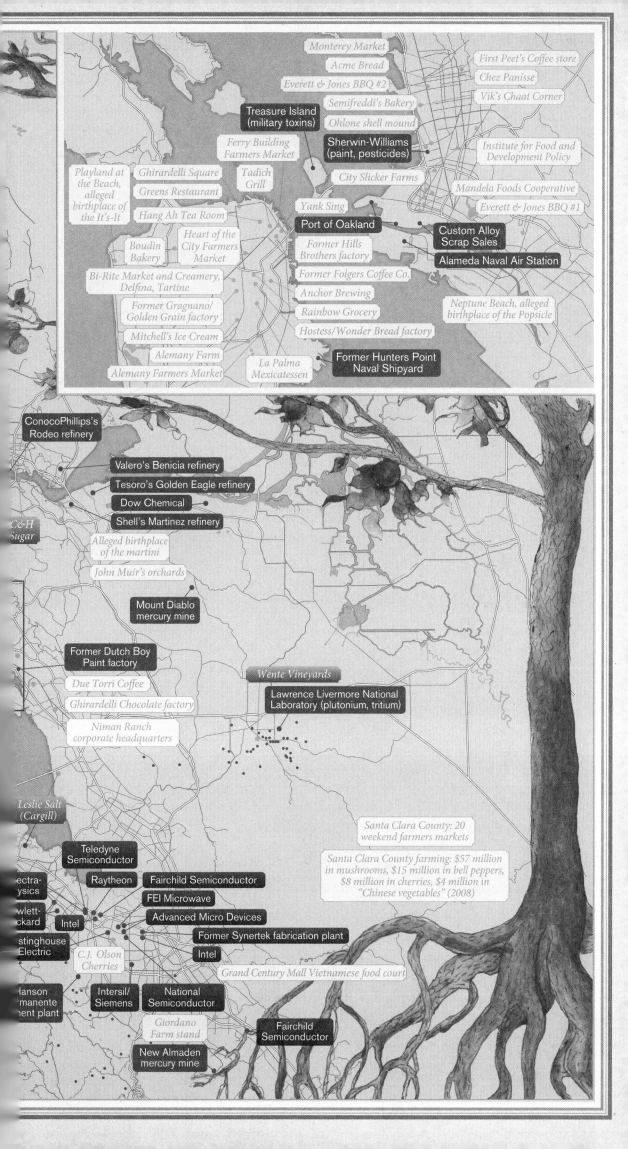

Monterey Market

Acme Bread

Everett & Jones BBQ #2

Semifreddi's Bakery

Ohlone shell mound

First Peet's Coffee store

Chez Panisse

Vik's Chaat Corner

Treasure Island
(military toxins)

Sherwin-Williams
(paint, pesticides)

Ferry Building
Farmers Market

City Slicker Farms

Institute for Food and
Development Policy

Playland at
the Beach,
alleged
birthplace of
the It's-It

Ghirardelli Square

Greens Restaurant

Hang Ah Tea Room

Tadich
Grill

Mandela Foods Cooperative

Everett & Jones BBQ #1

Yank Sing

Port of Oakland

Custom Alloy
Scrap Sales

Boudin
Bakery

Heart of the
City Farmers
Market

Former Hills
Brothers factory

Alameda Naval Air Station

Bi-Rite Market and Creamery,
Delfina, Tartine

Former Folgers Coffee Co.

Anchor Brewing

Neptune Beach, alleged
birthplace of the Popsicle

Former Gragnano/
Golden Grain factory

Rainbow Grocery

Mitchell's Ice Cream

Hostess/Wonder Bread factory

Alemany Farm

La Palma
Mexicatessen

Former Hunters Point
Naval Shipyard

Alemany Farmers Market

ConocoPhillips's
Rodeo refinery

Valero's Benicia refinery

Tesoro's Golden Eagle refinery

Dow Chemical

Shell's Martinez refinery

C&H
Sugar

Alleged birthplace
of the martini

John Muir's orchards

Mount Diablo
mercury mine

Former Dutch Boy
Paint factory

Wente Vineyards

Due Torri Coffee

Lawrence Livermore National
Laboratory (plutonium, tritium)

Ghirardelli Chocolate factory

Niman Ranch
corporate headquarters

Leslie Salt
(Cargill)

Santa Clara County: 20
weekend farmers markets

Teledyne
Semiconductor

Santa Clara County farming: $57 million
in mushrooms, $15 million in bell peppers,
$8 million in cherries, $4 million in
"Chinese vegetables" (2008)

ectra-
ysics

Raytheon

Fairchild Semiconductor

FEI Microwave

wlett-
ckard

Intel

Advanced Micro Devices

stinghouse
Electric

Former Synertek fabrication plant

C.J. Olson
Cherries

Intel

Grand Century Mall Vietnamese food court

Hanson
manente
ent plant

Intersil/
Siemens

National
Semiconductor

Giordano
Farm stand

Fairchild
Semiconductor

New Almaden
mercury mine

Not so long ago, the southern region was the Valley of Heart's Delight, one of the great orchard landscapes of the world, with plums, apricots, and cherries the major crops. The sight and smell of the orchards in bloom were said to be spectacular, though picking apricots, plums, and cherries was not so arcadian a pursuit. Workers' conditions there were part of what inspired Cesar Chavez to take up the struggle for farmworkers' rights (at the outset of his political career, he lived in a San Jose barrio nicknamed Sal Se Puede [Get Out If You Can]). That was when San Francisco was the industrial capital of an agrarian region, when the city had branch railroads feeding ingredients to the big breweries, canneries, food factories, and coffee processors near the waterfront, and when Mission Bay was a railyard, not a biotech campus. Some of this still remains: a significant proportion of the coffee drunk in the United States continues to come through the Golden Gate, though it now comes through the Port of Oakland, not San Francisco.

In many industries, food and poisons are intertwined: C&H Sugar, near the Carquinez Bridge, is both a major sugar refinery and a toxic polluter. Just south of this map, in Watsonville, the strawberry capital of the nation, a major battle has been waged over use of the deadly, ozone-depleting fumigant methyl bromide. And in the Napa Valley vineyards and wineries, vast quantities of chemicals are used in the raising of wine grapes and some more in the production of most wine, although this doesn't compare to the legacy of Silicon Valley, which is home to the greatest concentration of Superfund toxic cleanup sites in the nation—twenty-nine, in various states of toxicity.

The Bay Area is now legendary, and sometimes smugly so, as a culinary capital, home of Chez Panisse and Greens and various other upscale dining emporia, fancy markets, and more. Since the Gold Rush, locals have liked to eat well, though the first famous dish to emerge from the place was hardly genteel in name or taste: the Hangtown Fry—eggs scrambled with oysters and bacon. There were elegant restaurants like the Old Poodle Dog, open from 1849 to 1922, and Jack's, the French restaurant that closed in 2009 after operating since 1864. The city blithely ignored Prohibition, though the wine grown in Napa and home-brewed by the huge Italian population wasn't always so refined. The Bay Area was once a much more rough-and-ready place, and the food it produced was on a grander scale but a less epicurean level before everything changed.

A lot of the local food of yore was funny. The Popsicle is said to have been invented in the 1920s at Neptune Beach, a little Alameda amusement park, since contaminated by the Navy; the martini in refinery capital Martinez; the It's-It ice cream sandwich at the long-gone Playland at the Beach amusement park; and the mai tai at Trader Vic's in Oakland, also gone. Rice-A-Roni, a name hard to say without appending "the San Francisco treat," resulted from the packaging of an Armenian rice-pasta dish by an Italian family whose Gragnano Products bulk pasta factory in the Mission District—around the corner from today's gourmet mini-ghetto of Delfina, Bi-Rite Market and Creamery, and Tartine—eventually became Golden Grain in the 1930s and migrated to Fremont in the 1950s (near where the Ghirardelli Chocolate factory, once in northern San Francisco, also ended up). Rice-A-Roni was invented in the late 1950s, in the golden age of dried parsley flakes, cake mixes, and recipes whose first ingredient was a can of Campbell's Soup. The bricks of hot-pink popcorn

sold in Golden Gate Park and at the zoo were another local treat that hardly merits the term "delicacy," though they are my madeleines. (They're still made at the Wright Popcorn and Nut Company in the Mission.)

The region was both a prolific producer of food—of fish, of wine, of produce, if not of grains—and home to a vast array of cuisines. Chinese food has been cooked here since the first Chinese immigrants arrived, and Mexican food long before. And San Francisco can claim to be one of the coffee capitals of the nation—Italian North Beach was full of espresso machines steaming and Graffeo coffee roasting back in the era when I thought the Central Valley should have a sign for those heading east saying, "Next Good Coffee 3,000 Miles."

Food evolved. Some of the Hangtown Fries must have been made not with chicken eggs but with murre and seagull eggs harvested from the Farallones, those rocky little islands ten miles off the coast—Petaluma had yet to become the Egg Basket of the World, as it did in the teens of the last century, producing more than half a billion eggs per year by 1917. The Egg War on the Farallon Islands was fought to control the commodity in 1863, and two lives were lost. The Farallones are now a bird sanctuary, and Petaluma's chickens are mostly gone, though Clover Stornetta processes milk and dairy products on a large scale at a creamery in the vicinity, and the Petaluma area has seen a small free-range chicken farming revival (in addition to the chickens that can be found in countless urban backyards nowadays). Food is part of the Bay Area you hear about nowadays, exquisite upscale food at famous restaurants and gourmet markets. But it's so boring we couldn't stay focused on it in this map.

More important is the populist and radical foodscape—certainly the burrito has flourished in San Francisco as nowhere else, and these biomass logs sustain many a student and day laborer in the Mission. As does a politics of radical food, from Frances Moore Lappé's 1971 *Diet for a Small Planet*, the first manifesto with recipes (for bean-based protein dishes, mostly), to the Future-farmers' 2008 Victory Gardens and the inner-city farms in San Francisco and

Sunaura Taylor, *Mercury*, 2010

West Oakland. The Black Panthers served breakfast to inner-city children, and the Symbionese Liberation Army forced *Examiner* newspaper mogul Randolph Hearst, father of the kidnapped Patty Hearst, to give away groceries on a grand scale. This place is rife with food as redemption, from Cathy Sneed's food-gardening project at the San Francisco County Jail, begun a few decades ago; to Mission Pie, which connects inner-city youth to jobs in food preparation at a diner in the Mission; to La Cocina, a flexible industrial kitchen that helps poor women set up small food enterprises.

Another landscape of labor poisoned workers and left behind more toxins for the rest of us. The New Almaden mine at the southern end of the region supplied a lot of the mercury used to refine gold during the Gold Rush; the miners ended up putting ten times as much mercury into the water systems of California as the amount of gold they took out of streams and rivers and rock and dirt. The region is still dotted with ancient mercury mines, many of them continuing to leach toxins. The Silicon Valley Toxics Coalition long ago pointed out that the high-tech industry is not nearly as clean as its image.

Bay water, groundwater, soil, food—and then there's the air. Chevron is not only involved in human rights abuses and environmental devastation in other countries; it's also the biggest emitter of greenhouse gases in California and is responsible for more readily detectible emissions such as ammonia and benzene, which affect the seventeen thousand poor people who live within three miles of Chevron's Richmond refinery. In 1999, the refinery suddenly released eighteen thousand pounds of sulfur dioxide and told ten thousand residents to stay inside; those who lived even closer were evacuated. The stuff "killed trees and took the fur off squirrels," a resident reported. The Bay Area is one of the centers of the environmental justice movement in part because it's also a center of environmental injustice, in Richmond and all through the toxic corridors of refineries and chemical plants along the Carquinez Straits, in San Francisco's Hunters Point, in Silicon Valley, and among farmworkers.

The Bay Area is good at containing contradictions: being both the great laboratory for new military technologies and the capital of opposition to militarism, being both Tuscany and the starship *Enterprise*, making both delights for the palate and poison for the body. Behind the latter conundrum lies its constant tension between being more sensual and engaged with place, substance, and pleasure, on the one hand, and more sped-up, technological, profitable, and disembodied, on the other. Such contradictions may never be resolved, but they can at least be recognized. Even tasted ∞

8 SHIPYARDS AND SOUNDS

This map could be imagined as a detail of the map of the Great Migration from the Jim Crow South, which created concentrations of formerly rural African Americans in many northern cities and helped to shape the histories of their new homes. This migration brought a flood of African Americans from the South to the Bay Area for shipyard jobs during the Second World War and then, when the jobs evaporated, left many stranded here in isolated neighborhoods and housing projects—though others from this Great Migration did well afterward and traveled throughout the region and beyond. For the Bay Area, this human tide launched a rich new musical and political era whose impact was felt nationally, and the music and the politics were often intertwined. CARTOGRAPHY: SHIZUE SEIGEL ∞ MAP APPEARS ON PAGES 58–59

HIGH TIDE, LOW EBB BY JOSHUA JELLY-SCHAPIRO

I left my home in Georgia
Headed for the 'Frisco bay . . .

It makes all kinds of sense that the modern soul song most identified with San Francisco should mimic the sound of waves lapping a pier and be voiced by a singer who had washed up from afar. When Otis Redding composed the tune that would become his epitaph—he finished recording "(Sittin' on) The Dock of the Bay" just days before his plane plunged into an icy Wisconsin lake in December 1967—he was not a Bay Area resident but a musician passing through: he penned its first verse on a friend's houseboat in Sausalito, after his storied appearance at the Monterey Pop Festival down the coast that summer, the same festival for which Scott McKenzie recorded that other sixties anthem of questing west: "San Francisco (Be Sure to Wear Flowers in Your Hair)." Released just after the Summer of Love had made San Francisco the center of global hippiedom, and as the Black Panthers were building Oakland's reputation as a font of black revolution, "Dock of the Bay" used a timeless leitmotif of African American culture—sea, ships, and waiting—to offer a timely invocation of this newly hip region. Yet, as with most great pop laments, part of the song's lasting power comes from a story that resonates with a larger social history. In this case, it is the history of thousands of emigrants from the Jim Crow South who'd come west looking not to put daisies in their hair but to build the boats and guns that won World War II—and who then remained, after the shipyards and factories closed, to make the bay their home.

The U.S. effort to defeat the Axis powers during the Second World War brought more profound changes to the Bay Area than to any other region. The larger Bay Area—one of the world's great natural harbors, linked by rail

SHIPYARDS AND SOUNDS

THE BLACK BAY AREA SINCE WORLD WAR II

World War II shipyards

African American political and musical landmarks

North Richmond: Tappers Inn, Savoy Club, Brown Derby, Pink Kitchen, and Minnie Lue's

Singing Shipbuilders Gospel Quartet

Black Panther George Jackson killed, San Quentin Prison, 1971

Rosie the Riveter Memorial opens, October 2000

Richm

First ten female welders hired by Kaiser, July 1942

Otis Redding writes "(Sittin' on) The Dock of the Bay," 1967

MARIN COUNTY

Marinship (Bechtel shipyard)

Kaiser Richmond Shipyards

Home of Tupac Shakur from 1988 to 1992

Bob Marley records "Talkin' Blues" at the Record Plant, 1973

Marin City

Tracy Sims leads anti-discrimination demonstrations, 1964

Sausalito

Sylvester's solo debut at Bimbo's 365 Club, 1972

Black Hawk: Lester Young and Billie Holiday perform their last club dates; Fillmore teen Johnny Mathis performs his first

Fillmore District: Club Alabam, New Orleans Swing Club, Elsie's Breakfast Club, Café Society, Long Bar, Blue Mirror, Ebony Plaza Hotel, Booker T. Washington Hotel, and more

Fillmore District

Bethleh Shipya

KPOO 89.5 FM: oldest black-owned radio station on the West Coast

Black Panther Kathleen Cleaver runs for California State Assembly, 1968

San Francisco

Willie Brown becomes Speaker of the California State Assembly, 1980

Herbie Hancock recor "Head Hunters" at Diffe Fur recording studio, 19

Tower of Power records "East Bay Grease" at Mercury Recording Studios, 1970

Sly and the Family Stone record "Stand!" at Pacific High Recording Studios, 1969

Bayview– Hunters Point

SAN FRANCISCO COUNTY

First four-year U.S. black studies program, San Francisco State College, 1968

James Baldwin visits Bayview, 1963

Hunters Po Naval Shipy

Carlos Santana attends Mission High School

Police shooting of Matthew Johnson sparks Hunters Point Uprising, 1966

Western Pipe Steel Shipya

South San Francisco

SAN MATEO COUNTY

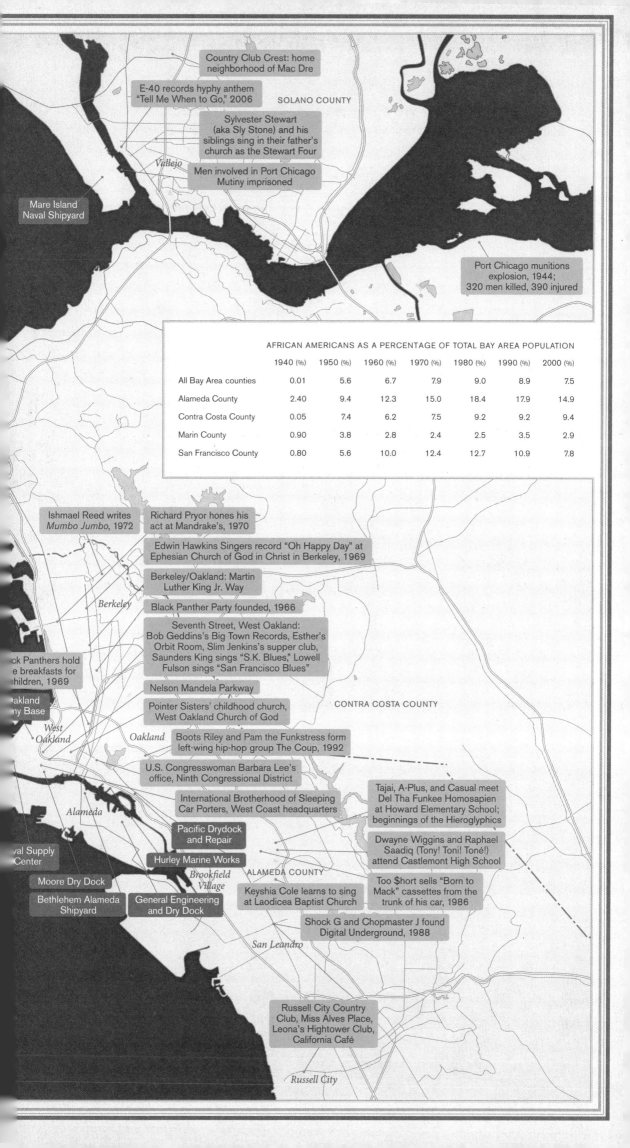

Country Club Crest: home neighborhood of Mac Dre

E-40 records hyphy anthem "Tell Me When to Go," 2006

SOLANO COUNTY

Sylvester Stewart (aka Sly Stone) and his siblings sing in their father's church as the Stewart Four

Men involved in Port Chicago Mutiny imprisoned

Vallejo

Mare Island Naval Shipyard

Port Chicago munitions explosion, 1944; 320 men killed, 390 injured

AFRICAN AMERICANS AS A PERCENTAGE OF TOTAL BAY AREA POPULATION

	1940 (%)	1950 (%)	1960 (%)	1970 (%)	1980 (%)	1990 (%)	2000 (%)
All Bay Area counties	0.01	5.6	6.7	7.9	9.0	8.9	7.5
Alameda County	2.40	9.4	12.3	15.0	18.4	17.9	14.9
Contra Costa County	0.05	7.4	6.2	7.5	9.2	9.2	9.4
Marin County	0.90	3.8	2.8	2.4	2.5	3.5	2.9
San Francisco County	0.80	5.6	10.0	12.4	12.7	10.9	7.8

Ishmael Reed writes *Mumbo Jumbo*, 1972

Richard Pryor hones his act at Mandrake's, 1970

Edwin Hawkins Singers record "Oh Happy Day" at Ephesian Church of God in Christ in Berkeley, 1969

Berkeley/Oakland: Martin Luther King Jr. Way

Berkeley

Black Panther Party founded, 1966

Seventh Street, West Oakland: Bob Geddins's Big Town Records, Esther's Orbit Room, Slim Jenkins's supper club, Saunders King sings "S.K. Blues," Lowell Fulson sings "San Francisco Blues"

ck Panthers hold e breakfasts for hildren, 1969

Nelson Mandela Parkway

akland ny Base

Pointer Sisters' childhood church, West Oakland Church of God

CONTRA COSTA COUNTY

West Oakland

Oakland

Boots Riley and Pam the Funkstress form left-wing hip-hop group The Coup, 1992

U.S. Congresswoman Barbara Lee's office, Ninth Congressional District

Tajai, A-Plus, and Casual meet Del Tha Funkee Homosapien at Howard Elementary School; beginnings of the Hieroglyphics

Alameda

International Brotherhood of Sleeping Car Porters, West Coast headquarters

Pacific Drydock and Repair

Dwayne Wiggins and Raphael Saadiq (Tony! Toni! Toné!) attend Castlemont High School

al Supply Center

Hurley Marine Works

Brookfield Village

ALAMEDA COUNTY

Too $hort sells "Born to Mack" cassettes from the trunk of his car, 1986

Moore Dry Dock

Keyshia Cole learns to sing at Laodicea Baptist Church

Bethlehem Alameda Shipyard

General Engineering and Dry Dock

Shock G and Chopmaster J found Digital Underground, 1988

San Leandro

Russell City Country Club, Miss Alves Place, Leona's Hightower Club, California Café

Russell City

to the midwestern steel needed to build ships, and by water to the war's key Pacific theater once those ships were built—was transformed with astounding speed into what the San Francisco Chamber of Commerce could fairly call, in 1943, "the greatest ship-building center the world has ever seen." It turned out an astonishing fourteen hundred vessels during the three and a half years of the war—more than a ship a day. The flood of federal monies for war-related industries attracted a flood of people, who caused the Bay Area population to grow by half between 1940 and 1945 alone. Their arrival forever altered the region's demographic mix, its politics, its culture, and its music.

With some ten million Americans drawn into military service and leaving the domestic labor force, Bay Area firms who had contracted to build the ships could ill afford to turn away able-bodied workers. What famously held true for women ("Hitler was the one who got us out of the kitchen," as one female worker put it) also applied to racial minorities. During the war, industries long restricted by the prejudiced practices of employers or whites-only unions were opened to new groups of workers (helped along by President Roosevelt's order to end discrimination in war-related hiring)—Asian Americans, who had earlier been excluded from skilled trades; Mexican immigrants, who had previously been prevented from legal employment in California; and, perhaps most significant in terms of how they transformed the area's demography and politics, African Americans from the South. These southern migrants—tenant farmers, laborers, and domestics, still accustomed to earning a quarter a day in Dixie—struck out by bus and train and car from Tupelo, Texarkana, and New Orleans on hearing from recruiters and relatives that jobs paying a dollar an hour were open to all comers; and they didn't stop coming until, by war's end, some half a million had arrived to make new lives in California.

By the time Otis Redding penned "Dock of the Bay" in 1967, the shipyards that had drawn many of those migrants were long gone. But from where he sat, Redding could see many of the places that had been transformed by the arrival of southern black workers. Northeast from where he contemplated the Sausalito tides was Richmond, where industrialist Henry J. Kaiser—an engineering magnate with no previous experience in shipbuilding—built a complex of four "instant shipyards," which by 1945 were employing 100,000 laborers assembling Liberty Ships around the clock. Farther north on the east side of San Pablo Bay was Mare Island Naval Shipyard, where 46,000 workers launched submarines, destroyer escorts, and landing craft by the hundreds from a site hard by the North Bay town of Vallejo. (Following a munitions explosion at nearby Port Chicago in July 1944 that killed 320 sailors, many of them black, who had been loading the explosives onto ships, black sailors at Mare Island a month later refused to continue loading munitions and organized the "Port Chicago Mutiny," a strike protesting the U.S. Navy's practice of assigning its most dangerous jobs to segregated black units.)

Across the water in Oakland, the work force at the old Moore Dry Dock Company—one of the Bay Area's few commercial shipyards before the war—went from 600 workers in 1940 to 30,000 three years later. On the spur of land in San Francisco's southeasternmost corner lay the Hunters Point Naval Shipyard, which during the war employed 17,000 civilians. It was from Hunters Point that the first atomic bombs sailed for Japan in 1945. Even Redding's own

perch, on a houseboat moored on mudflats at Sausalito's north end, had been the site of a major wartime shipyard constructed by Marinship, a short-lived company founded in March 1942 by Kenneth Bechtel to build oil tankers for the navy. An "instant shipyard" like its Kaiser cousins, the Marinship yard was dismantled as soon as the war was over—but it left behind, just across Highway 101, the housing projects that had been built for the wartime work force. Many of the now unemployed African American shipyard workers were unable to find other housing, and the projects became an island of impoverished blackness in the sea of white affluence that is Marin County. That community, Marin City, is best known today as the teenage home of rapper Tupac Shakur.

To list the centers of wartime shipbuilding—Richmond, Vallejo, and Oakland, Hunters Point, Marin City—is to reel off the names of places that today remain centers both of black population and of black poverty. But not all wartime African American immigrants moved into sui generis developments built for war workers. In some cases, they were banned from doing so—in San Francisco, five public housing developments were constructed during the war for new city residents, but the Housing Authority, citing the need to preserve extant "neighborhood patterns," banned blacks from four of them. In the East Bay, many African Americans and other wartime migrants established squatter settlements in places like North Richmond, a marshy bit of land out by the city's dump, and Russell City, an unincorporated parcel south of Oakland, which became home, by 1945, to some ten thousand mostly black residents living in ramshackle wooden homes powered by pirated electricity. (Russell City burned to the ground in 1964; today a Calpine power plant is located at the site, in the town of Hayward.)

Other new arrivals gravitated to areas where the region's small black communities had previously been centered. Best-known of these was San Francisco's Fillmore District, a mixed working-class neighborhood west of downtown, which had long been home to a majority of the city's black citizens (who in 1940 numbered just 4,086 of San Francisco's 635,000 residents). As that black population grew by nearly 700 percent during the war, reaching 32,000 in 1945 (when African Americans officially replaced Asians as the city's largest nonwhite minority), the Fillmore became a black neighborhood. It was able to absorb so many new arrivals—and to do so, moreover, without the racial riots that followed the wartime influx of southern blacks in cities such as Los Angeles and Detroit—in part because the government had forcibly removed and sent to internment camps several thousand Japanese residents from an area of the Fillmore known, until 1941, as Japantown. In the Victorians and storefronts left behind by the Japanese, black immigrants opened dozens of nightclubs and bars that would play host, from the early 1940s to the 1960s, to all the major figures in jazz, making the Fillmore perhaps the key West Coast hub for the evolution of that music.

In Oakland, as in San Francisco, many black newcomers settled in the part of town where the city's black populace—some 8,000 strong in 1940—had previously clustered: the West Oakland area. During the first decades of the twentieth century, a distinctly middle-class black community had grown up around the terminus of the transcontinental railroad and the adjacent West Coast headquarters of the International Brotherhood of Sleeping Car Porters.

As Oakland's black population climbed to over 40,000 by 1945, West Oakland—which had been, like the Fillmore, a mixed neighborhood in the 1930s, with significant numbers of Irish, Italian, and Portuguese longshoremen as well as Mexicans and Chinese—became a majority-black neighborhood. It also became the geographic and emotional heart of black life in the Bay Area: the place where many new southern immigrants first arrived and then later came to cash and spend their paychecks on Friday night. With its main thoroughfare, Seventh Street, lined with rooming houses and restaurants, pool halls and pawnshops, and some forty nightclubs and bars, West Oakland was where the stories of wartime immigrants and the new music they crafted to tell their tales came to shape American music at large.

Like the Fillmore, West Oakland was home to plenty of establishments such as the legendary supper club run by Slim Jenkins, a dapper Louisianan who booked all the top national acts in black pop (also known as jazz and blues); everyone from Count Basie and Billie Holiday to Bobby "Blue" Bland and a young Ray Charles put in time at Slim's Seventh Street place. Perhaps what most distinguished the neighborhood scene, though, was the seedbed it supplied for locals—which is to say, for transplanted southern blacks—to elaborate a new musical idiom. In 1942, West Oakland legend Saunders King (birthplace: Staple, Louisiana) scored a nationwide hit with "S. K. Blues," one of the first blues songs to feature electric guitar. From there, the scene was nurtured and shaped by figures such as Lowell Fulson (birthplace: Tulsa, Oklahoma), who learned to play guitar on Seventh Street while he was a navy conscript stationed nearby and who, after making his name in its clubs with tunes like "San Francisco Blues" (*"Ohh, San Francisco/Please make room for me"*), became a seminal influence on B. B. King; by Bob Geddins (birthplace: Highbank, Texas), "the Godfather of Oakland blues," who first recorded Fulson and dozens of others in his small studio at the corner of Seventh and Center and delivered their records by hand to radio stations across the South from the trunk of his car during yearly drives back to the "old country"; and by sometime Oakland resident Big Mama Thornton (birthplace: Ariton, Alabama), who made a hit of "Hound Dog" in the barrooms of Seventh Street and Russell City years before Elvis Presley got near it.

Such figures made the bay's eastern shore the most crucial site for the birth of what came to be known as the West Coast blues. Joining the feel and structure of Texas blues to the propulsive harmonies of swing jazz, the groups who played this style employed full horn sections rather than a lone harmonica, forging a music that at once recalled the rural past of ancestors brought to America in wooden slave boats and spoke to the urbane lifeways of people building steel warships in modern cities. The West Coast blues became, during the 1940s and early 1950s, one of the key forerunners of rock 'n' roll.

Even as war-related jobs disappeared in the Bay Area, both Seventh Street and the Fillmore—fed by a steady if slowing stream of black migrants joining their friends and family members in the Golden State—continued to thrive as centers of black culture and commerce well into the 1950s. Newer areas of black habitation near the shipyards themselves fared less well. In his 1946 hit "Shipyard Woman Blues," blues shouter Jimmy Witherspoon may have had his reasons for hailing the return of slacks-wearing women from the factory to the home (*"You better put on some of those fine dresses/And give us men our privilege*

back"), but for most black workers in the region, the flight of thousands of jobs from Oakland, Hunters Point, and Vallejo was nothing to cheer. In Richmond, the pain of the Kaiser yards' closing was eased somewhat by the presence of a Ford factory, which transitioned, after the war, from churning out jeeps for the army to assembling pickup trucks for returning GIs. But even the Ford factory closed in 1955, pushing the economy of Richmond, whose unemployment rate today stands at 16 percent, into a crater from which it has yet to emerge.

And soon enough, in the Fillmore and West Oakland too, what the free market left alone the state attacked. From the late 1950s on, the black residents of the Fillmore fell victim to "redevelopment," which entailed tearing down dozens of square blocks of the district's fine Victorian houses. (Many of the displaced black residents moved into housing projects elsewhere in the city from which they'd been banned during the war.) West Oakland, like many other black neighborhoods in cities across America in the 1960s, was decimated by "urban renewal" and large-scale infrastructure projects afforded by America's postwar prosperity and hubris. The first big blow to the neighborhood arrived in 1958 with the new I-880 overpass that cut off West Oakland from the rest of the city. (Thirty-one years later, the Loma Prieta earthquake flattened the elevated freeway; the resultant surface road is named Nelson Mandela Parkway.) The demise of Seventh Street as a thriving thoroughfare began in 1960 when the city razed some four hundred homes and businesses along twelve blocks of the street, to make way for a huge U.S. Postal Service distribution center; the death knell came later that decade with the building of the BART rail system, whose track in West Oakland—unlike those laid beneath main drags in downtown Oakland, Berkeley, and San Francisco, which left intact the street life above—was built on elevated tracks, right down Seventh Street's heart, in order to save money.

In the decades before World War II, as today, San Francisco's political classes nurtured a self-image of their city—fed by its having officially desegregated its public transit and schools as early as the 1860s—as a racially progressive place. After the war, the presence of an actual black population—and a largely unemployed and underemployed one, at that—put that myth of progressivism to a severe test. The likelihood that the city would pass that test was never high, given electoral laws mandating that San Francisco's Board of Supervisors be elected not by district but rather in citywide contests—with the net effect that as San Francisco (and Oakland as well) became an increasingly diverse city, its municipal government and police force remained almost entirely white. (In 1977, a temporary change in the election laws allowed district elections; one of the San Francisco supervisors elected that year was Harvey Milk, representing the Castro District.)

In September 1966, the riots that San Francisco had avoided during the war came to pass. When a white police officer shot and killed an unarmed sixteen-year-old car-theft suspect in Hunters Point, the resultant unrest lasted five days, and it took twelve hundred National Guard troops to finally tamp it down. A few weeks later, at West Oakland's Merritt Community College, where the nation's first black studies program had just been born, two sons of wartime immigrants—Bobby Seale and Huey Newton (places of birth: Dallas, Texas, and Monroe, Louisiana)—founded the Black Panther Party for Self Defense. Built around a ten-point program whose demands included full employment

and "an immediate end to police brutality and murder of black people," their fast-growing organization conjoined high Marxist rhetoric to streetwise style, introducing the iconography of the black militant to New Left culture in the Bay Area and worldwide. (One of the Panthers' early members, Afeni Shakur, named her son Tupac after the insurgent Incan emperor Tupac Amaru.)

That the Panthers came to prominence just as the Summer of Love kicked off distills much about the vivifying "ball of confusion" that was the counter-culture of those years, with its utopian dreams of reconciling peace and militancy, bliss and rage, and its hippies on their communes growing food for the Panthers' breakfast program in the ghetto. Of course, in the counterculture at least as much as in the mainstream, there was little place for blacks who didn't wish to play the role of musician or militant. But no matter: in the Bay Area and elsewhere, the erotic specter of integration (not to mention inter-racial love) suffused the era's best music—perhaps most notably in the work of Sly Stone, the Vallejo-raised son of a Texas preacher, who became, after James Brown, the key architect of the music we know as funk. With his self-consciously integrated group, the Family Stone (whose white members the Panthers repeatedly urged him to expel), it was Sly, above all, who forged the bass-heavy grooves in which the freaks of all San Francisco's nations could get down and be whatever they wanted to be. The scene he scored was the same one in which Richard Pryor, for example, found his voice as a performer in a Berkeley bar where he shared bills with Country Joe and the Fish, and in which Carlos Santana, for another, decided to show the world that Chicano kids could play electric guitar too—and, as if to underscore the point, married the daughter of Seventh Street guitar legend Saunders King. (Santana would record a duet with the old man on his *Oneness* album in 1979.)

Today, the stretch of Seventh Street where Saunders King once reigned is a desolate strip of liquor stores and vacant lots, its soundscape provided not by music but by the rumble of BART trains overhead. Only one establishment still standing recalls West Oakland's heyday. Proprietor Esther Mabry (birthplace: Palestine, Texas), who got her start on Seventh Street as a waitress at Slim Jenkins's Place, is eighty-nine now, but she can still sometimes be found at Esther's Orbit Room, holding court beneath a dark bar-ceiling bedecked with white Christmas lights to resemble the night sky. Her bar no longer plays host to stars like the Pointer Sisters (who grew up singing in West Oakland's Church of God a few blocks away). But I was glad to find, on a recent visit, that it still boasts the best jukebox in the Bay Area, with a selection of offerings by figures who made their name among wartime immigrants on nearby streets. In the jukebox museum at Esther's, the musical legacies of the great black migration to the bay are plainly audible. But even in the hip-hop music to which many of the Bay Area's young people now live and move, the fact and legacies of that migration have a way of cropping up: the "Brookfield Slide," one of the signature dance moves of the "hyphy" hip-hop that is perhaps Oakland's signal contribution to our national soundscape today, carries the name of Brookfield Village—a housing project for war workers, carved out of East Oakland orchard land in 1943.

Since the end of the Great War—and before—what has always drawn many black migrants to the Bay Area is the same promise vested in San Francisco by all its newcomers: the possibility of imagining a world different from the

one left behind (perhaps, for instance, a world—it bears mentioning here—in which black people are no longer associated solely with music and woe). That the Golden State's promise proves hollow as often as it is real is no small part of the California epic. But absent the old utopian tint, it is hard to imagine much of what those broken promises have uniquely yielded here: from a pair of students at an Oakland community college (in the state where the community college was invented) imagining world revolution; to a comic, Pryor, who changed how Americans think (and laugh) about race; to a drag queen, Sylvester, whose brilliant performances with the Cockettes and as a solo act (produced by the Pointer Sisters' producer, David Ferguson) helped shape the disco era; to a congressional district, Oakland's Ninth, long known for sending to Washington dissenting representatives such as Barbara Lee (birthplace: El Paso, Texas), whose solitary vote in Congress against authorizing the War on Terror prompted a spate of bumper stickers nationwide reading "Barbara Lee speaks for me." "It's like that old song from the Gold Rush—'Oh, what was your name in the States?'" says longtime Oakland resident Ishmael Reed, the celebrated author of *Mumbo Jumbo*, who visited the Bay Area in 1968, looking for a place to write away from New York's noise, and never went back. "You can disappear here, be whatever you want to be."

Today, the Bay Area's ever-growing and more diverse populace is fed less by immigrants from Texas and Mississippi than by those from Afghanistan and Guatemala. Since 1980, each decennial census has revealed fewer African Americans in the region's main cities: the ceaseless march of gentrification and the skyscraper-high cost of living continue to push blacks and other members of the old working classes to cheaper towns inland. In San Francisco and its surrounding area, too many of those who remain are confined to ghettoes made only more monolithic and marginal across the years by the state's determination to defund its once-vaunted public schools in favor of building up the huge state prison system, with which no family in such neighborhoods is unfamiliar. In places like Hunters Point, one can still vividly feel what James Baldwin meant when he declared, during a visit to the neighborhood at the height of the civil rights ferment in 1963, that "there is no moral distance between the facts of life in Birmingham and the facts of life in San Francisco." Speaking to a group of local youths above the old shipyard where their parents once worked, Baldwin sagely inveighed that "there will be a Negro president of this country, but it will not be the country we are sitting in now."

Around the famously liberal San Francisco Bay Area in 2008, the election of that "Negro president" was met by many with a sense of joy befitting what felt like the vindication of old struggles and, in this region that is home to more multiethnic families per capita than anywhere else in the country, also with a visceral sense that in a mixed-race son of the Pacific, America had sent to the White House one of its own. Whether and how we are sitting in a country different from the one we had in 1963 is a question with many answers. But, as the descendants of those once lured to the docks of the bay by the promise of jobs paying a buck an hour can attest, what the integration of elite institutions and many of our families perhaps too often elides is that—in the Bay Area as much as anywhere—to be born black in America still means, for too many, learning too young what it is to feel, as Redding sang, "like nothin's gonna come my way" ∞

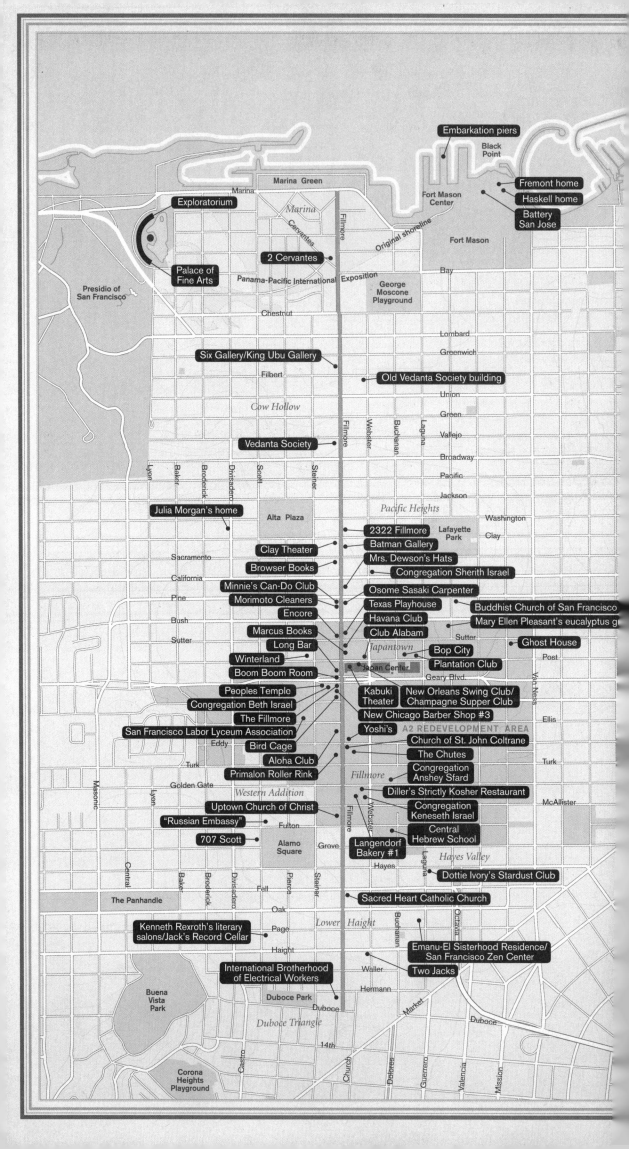

Embarkation piers

Black Point

Fremont home

Haskell home

Battery San Jose

Marina Green

Marina

Fort Mason Center

Exploratorium

Marina

Cervantes

Fort Mason

2 Cervantes

Palace of Fine Arts

Panama-Pacific International Exposition

George Moscone Playground

Bay

Presidio of San Francisco

Chestnut

Lombard

Greenwich

Six Gallery/King Ubu Gallery

Filbert

Old Vedanta Society building

Union

Cow Hollow

Green

Vallejo

Broadway

Vedanta Society

Pacific

Jackson

Lyon · Baker · Broderick · Divisadero · Scott · Steiner · Fillmore · Webster · Buchanan · Laguna

Washington

Julia Morgan's home

Alta Plaza

Pacific Heights

Clay

Lafayette Park

2322 Fillmore

Sacramento

Clay Theater

Batman Gallery

Mrs. Dewson's Hats

Browser Books

Congregation Sherith Israel

California

Minnie's Can-Do Club

Osome Sasaki Carpenter

Pine

Morimoto Cleaners

Texas Playhouse

Buddhist Church of San Francisco

Bush

Encore

Havana Club

Mary Ellen Pleasant's eucalyptus g

Marcus Books

Club Alabam

Sutter

Long Bar

Japantown

Sutter

Ghost House

Winterland

Bop City

Post

Boom Boom Room

Japan Center

Plantation Club

Van Ness

Peoples Temple

Kabuki Theater

New Orleans Swing Club/ Champagne Supper Club

Geary Blvd.

Ellis

Congregation Beth Israel

New Chicago Barber Shop #3

The Fillmore

Yoshi's

A2 REDEVELOPMENT AREA

San Francisco Labor Lyceum Association

Church of St. John Coltrane

Turk

Eddy

Bird Cage

The Chutes

Turk

Aloha Club

Congregation Anshey Sfard

Primalon Roller Rink

Fillmore

Golden Gate

Western Addition

Diller's Strictly Kosher Restaurant

McAllister

Uptown Church of Christ

Congregation Keneseth Israel

"Russian Embassy"

Fulton

Central Hebrew School

707 Scott

Alamo Square

Grove

Langendorf Bakery #1

Hayes Valley

Hayes

Dottie Ivory's Stardust Club

Central · Baker · Broderick · Divisadero · Pierce · Steiner

Fell

Laguna

Octavia

The Panhandle

Oak

Sacred Heart Catholic Church

Page

Lower Haight

Kenneth Rexroth's literary salons/Jack's Record Cellar

Haight

Emanu-El Sisterhood Residence/ San Francisco Zen Center

Buena Vista Park

International Brotherhood of Electrical Workers

Waller

Two Jacks

Hermann

Duboce Park

Duboce

Market

Duboce

Duboce Triangle

14th

Corona Heights Playground

Castro · Church · Dolores · Guerrero · Valencia · Mission

FILLMORE

PROMENADING THE BOULEVARD OF GONE

9 FILLMORE

Maps usually focus on a coherent region, but it was the metamorphosis of this street, which goes from a couple of wealthy white neighborhoods through a poor African American one into other zones and past vanished worlds of Jewish and Japanese immigrants, that made it interesting to us. It is a map of collisions, geographical and cultural. Gent Sturgeon supplied the marvelous Rorschach blot of faces and gestures that parallels the boulevard, itself an enigma that can be read many ways and a street that has been blotted out again and again. CARTOGRAPHY: BEN PEASE; ARTWORK: GENT STURGEON ∞ MAP APPEARS ON PAGES 66–67

LITTLE PIECES OF MANY WARS BY REBECCA SOLNIT

Some streets function like a core sample through their cities. Fillmore Street runs through San Francisco's wealthiest neighborhood, Pacific Heights; drops into the gritty, African American Western Addition, known as the Fillmore District or just the Fillmore in its heyday; and then continues onward through the lower Haight, to end not far from upper Market Street and the Castro. Pacific Heights is sometimes called Specific Whites, but the 22 Fillmore bus line that traverses the 2.5-mile street and then goes on to cut through the Mission on its way to the Bayview has been nicknamed the 22-to-Life. The war between the states left its traces here, as did the Second World War, and the war on poverty, the war on drugs, the stale and ancient war that is racism, and various forms of freelance violence. As did a lot of potent music and spirituality that mostly went right, though at the Peoples Temple at Fillmore and Geary, it went terribly wrong.

"(Weird John Brown)/The meteor of the war" novelist Herman Melville called the just-executed abolitionist in an 1859 poem, but the outbreak of the Civil War and the failure of his own work depressed Melville enough that he rode another *Meteor*, the clipper ship of that name captained by his brother, on a planned trip around the world that ended in San Francisco, where he turned back in homesickness. On October 19, 1860, at the end of what was then Black Point and is now the grassy portion of Fort Mason Center, in the home of Jessie Benton Fremont, Melville had dinner with her and Unitarian minister Thomas Starr King, an abolitionist. Her husband, John C. Fremont, was a conundrum, the explorer who helped steal Mexico's northern half for the United States in the war on Mexico of 1846–1848 and a Civil War general who was in and out of scandals much of his life. His name was given to a downtown street and to a Silicon Valley town that now has the greatest concentration of Afghan residents in the United States, refugees from endless wars there.

A year before Melville's visit, another opponent of slavery had died in Leonard Haskell's pretty house next door, which still stands, though Jessie Fremont's cottage was torn down long ago.

On Tuesday, the 13th of September, 1859, out at Lake Merced in San Francisco County's sandy western wilderness, a pro-slavery California State Supreme Court judge named David killed a Free-Soiler California senator also named David. It was a duel, and Senator Broderick shot at Judge Terry too, but his gun misfired, while the judge's bullet went right into his chest. Broderick lives on as a street that runs parallel to Fillmore Street.

Over in the other direction, on Octavia Street at Bush, is a less overt memorial to a more charismatic San Francisco character: Mary Ellen Pleasant, the former slave become Underground Railroad guerrilla become political powerhouse, who integrated San Francisco's public transit in the 1860s and also planted a row of eucalyptus trees that still stands. The writer George Orwell once said, "The planting of a tree, especially one of the long-living hardwood trees, is a gift which you can make to posterity at almost no cost and with almost no trouble, and if the tree takes root it will far outlive the visible effect of any of your other actions, good or evil." In Jasper O'Farrell's layout of the streets, in street names and architecture and trees, the long-gone characters of that era live on, influential but unseen.

Black Point had been militarized since 1797, when Spain built Battery San Jose there to defend the Golden Gate. In 1850, Millard Fillmore, a forgettable president who compromised fruitlessly on slavery in an effort to avoid the rupture of the war, designated the site as U.S. military land. It is in his dubious honor that the street is named. The anti-slavery squatters, including the Fremonts and Haskell, were forced out by the Civil War. Thereafter, the commander of the Army of the West, in charge of the Indian wars, resided at Black Point; the panicked General Funston, who did so much to destroy San Francisco in the wake of the 1906 earthquake, had his headquarters there; and during the Second World War more than a million soldiers embarked from Fort Mason for the Pacific.

Fillmore Street got a little longer after rubble from the ruins of the 1906 earthquake was dumped at its northern end. Landfill liquefies in an earthquake, and the Marina District was badly shaken in the 1989 Loma Prieta earthquake. Several buildings collapsed, including one at Cervantes and Fillmore, where a baby died. Gas mains broke, creating a conflagration fought from land by firefighters and hundreds of volunteers and from the sea with the city's fireboat pumping seawater to the blaze. A new building stands there today, at 2 Cervantes.

The landfill area had been the site of the Panama-Pacific International Exposition of 1915, a big World's Fair celebrating the city's resurrection and the completion of the Panama Canal, which brought the city and the West Coast so much closer to the Atlantic world. The neoclassical fantasia of the Palace of Fine Arts is the last remnant of that fair. As of 2010, some of its buildings still housed the Exploratorium, the innovative science museum started by Frank Oppenheimer. He was the younger brother of nuclear physicist Robert Oppenheimer, who oversaw the Manhattan Project and the making of the bombs dropped on Hiroshima and Nagasaki. Frank worked on the bomb too, but he was branded

a communist and driven out of physics. He found redemption by establishing the populist science museum in 1969 (soon to move to a downtown pier).

"Angelheaded hipsters burning for the ancient heavenly connection to the starry dynamo in the machinery of night" sounds a little like the Exploratorium's mission statement, but it was Allen Ginsberg, a little farther up Fillmore Street at the Six Gallery, at 3119, reading aloud for the first time his epic poem "Howl," on October 7, 1955, seven blocks west of Jessie Fremont's dinner for Melville and ninety-five years later. Ginsberg's hipsters "sat up . . . contemplating jazz" and "saw Mohammedan angels staggering on tenement roofs," a New York nightscape surely, but those hipsters "reappeared on the West Coast investigating the F.B.I. in beards and shorts with big pacifist eyes sexy in their dark skin."

"Song of the rattlesnake/Coiled in the boulder's groin": these were among the opening lines read that night by the much more deeply West Coast poet Gary Snyder. The reading at the Six Gallery, which was founded by five artists and the very out, very gay poet Jack Spicer, is considered a great landmark in American liberation from Eurocentrism, from repression, and a step toward a language and imagination that could embrace erotic, urban, mystical, and radical experience. For decades after the Six was gone, the former carriage house structure was a kind of oriental bazaar, full of carpets and crafts, still a little magical. But no more. Even the address of the Six Gallery, which was briefly the King Ubu Gallery in 1953–1954, no longer quite exists. Next door to it in 2009 was PlumpJack, a wine business founded by Gavin Newsom, elected mayor of San Francisco in 2004, backed by his patron, Pacific Heights resident and oil billionaire Gordon Getty.

"Who is he who became all this glory?" asks one of the Upanishads. In the form of the Vedanta Society, non-European mysticism has long had a home in the neighborhood. Its fantastic 1905 temple, with lacy Moorish balconies topped by rows of onion domes, is a block off Fillmore, at Webster and Filbert; and its new temple is a little way up the hill, at 2323 Vallejo Street at Fillmore. Vedanta, as founded by the Indian mystic Ramakrishna in the nineteenth century, mixes elements of Islam, Christianity, and Hinduism and claims to be the world's most ancient religion, drawing from the Upanishads.

There was another artists' gallery over the hill that is Pacific Heights and up the street, at 2222 Fillmore: the Batman Gallery, which became a Starbucks toward the end of the 1990s. Two of the six founders of the Six Gallery, Jay DeFeo and Wally Hedrick, lived at 2322 Fillmore Street for several years, as did beat poet Michael McClure (who also read at that famous 1955 reading) and various other artists over the years, including the Bay Area Figurative painter Joan Brown. In that building, DeFeo worked on her monumental and mystical painting *The Rose*, until she was evicted in 1965. The painting, several inches thick and weighing one ton, was removed by a crane and by Bekins moving men, whom artist and experimental filmmaker Bruce Conner saw as "angelic hosts" when he filmed the event in 1965 for his black-and-white film *The White Rose*, with its Miles Davis soundtrack. Other beat-era figures in the neighborhood include Wallace Berman and John Wieners at 707 Scott Street, around the corner from Conner on Oak Street, and Kenneth Rexroth and his literary salon at Scott and Page.

Members of the congregation of the Church of St. John Coltrane, 2000. Photo by Susan Schwartzenberg.

"'Fuck you!' sang Coyote/and ran" were the last lines of Snyder's poem at the Six Gallery reading. The wealthy sometimes claim to bring civilization to rough neighborhoods, but the Upper Fillmore neighborhood that was so culturally rich when it was the property of poor people in the 1950s is smoothed over into insignificance now, except perhaps for the Clay movie theater at 2261 (built in 1910 as a nickelodeon) and Browser Books, the excellent bookstore a few doors away at 2225 Fillmore. It does have a lot of places to eat and buy clothes, and it does have Mrs. Dewson's Hats, one of the last Afrocentric businesses in the upper end of Fillmore. Dewson, who sells churchgoing hats as well as hats to former mayor Willie Brown, sponsors the Western Addition Foundation for Girls scholarship program. Marcus Books, at 1712, possibly the oldest African American bookstore in the country, is a little farther away from Pacific Heights; at the party there for *Harlem of the West*, the book by Elizabeth Pepin and Lewis Watts that documents what has been destroyed on Fillmore Street over the years, people dressed up and pretended they were at Jimbo's Bop City.

"I'll be glad when you're dead," sang Louis Armstrong. Miles Davis himself played at the Fillmore, which is still a concert hall at Fillmore and Geary, in 1970; and almost everyone in jazz paraded through the neighborhood at one point or another. Charlie Parker played at Bop City, just off Fillmore at 1690 Post. So did Duke Ellington, Armstrong, and Ella Fitzgerald. Chet Baker came to listen there. In the post–World War II years, Minnie's Can-Do Club at 1915 Fillmore, the Encore at 1805, the Havana Club at 1718, the Club Alabam around the corner at 1820A Post, the Long Bar at 1633 Fillmore, the New Orleans Swing Club (later the Champagne Supper Club) at 1849 Post, the Plantation Club at 1628 Post, the Bird Cage at 1505 Fillmore, the Aloha Club at 1345 Fillmore, to say nothing of the Primalon Roller Rink at 1223 Fillmore and Dottie Ivory's Stardust Club on Hayes made the neighborhood sing. All those clubs are gone, though blues singer John Lee Hooker opened up his Boom Boom Room at 1601 Fillmore in the 1990s, and the East Bay jazz and sushi club Yoshi's opened up a branch in late 2007, at 1330 Fillmore, right after embarrassing itself by releasing a celebratory anniversary CD that failed to include any black jazz artists. But Yoshi's serves sushi, and it belongs in this neighborhood, which used to be a whole lot more Japanese.

"San Francisco's Japantown, the oldest in the continental United States, celebrated its 100th birthday in 2006, but it's a ghost-haunted shadow of itself," writes Shizue Seigel, one of the cartographers for this atlas. "The first-gener-

71

ation Issei planted roots in the face of laws denying them naturalized citizenship or the right to own land. They were a communal, collaborative group that soon founded newspapers, temples, schools and shops. For instance, Issei women saved and fundraised for years to build a Japanese YWCA at 1830 Sutter to serve as a community center and as a residence for single women and runaway wives. They persuaded Julia Morgan to donate a handsome design and the San Francisco YWCA to hold the deed. But the Japanese YWCA only used the building for ten years. A few months after Pearl Harbor, they were forced to gather in front of Kinmon Taken on Bush Street to board busses headed for the unknown. Each was allowed only two suitcases and an armload of bedding."

And she remembers what the neighborhood was like after the Japanese American community returned: "As a shy kid of twelve riding the 4 Sutter to the Buddhist Church, I stared out the windows at life happening in the street. Church ladies in full regalia sailing into the Macedonian Baptist Church, families sitting on their stoops enjoying a rare warm afternoon, young men with hairnets and sherbet-colored outfits singing impromptu quartets on the street corner. Fried fish church suppers, junk stores and washing machine repair shops jutting out of makeshift storefronts. And church basketball, teriyaki chicken fundraisers and dancing in the street in my kimono at the annual Obon festival. But Japanese Americans and African Americans alike were forced into a second migration by redevelopment."

"But baby, it's cold outside," sang Ella Fitzgerald. The neighborhood that had hosted a heyday for African Americans was then gutted by redevelopment that literally ripped out its heart and displaced thousands. Hundreds of Victorian houses were described as "blighted" and smashed into splinters (in the A2 redevelopment area on the map here). Instead of the promised better homes, the neighborhood got bunker-like housing projects, mostly demolished in the years since, and on Fillmore itself lots lay vacant for decades and then were badly rebuilt. Shiz's husband, *Infinite City* cartographer Ben Pease, remarked, "What amazes me about Fillmore is how the Redevelopment Agency and the city can walk away and say 'we're done' with A2 when the land use is so anti-urban, and sometimes downright stupid."

African Americans had come here to escape Jim Crow and take shipbuilding jobs during the Second World War, and the African American scene had flourished, on the site of what had been a flourishing Japanese community until almost all its residents were incarcerated during that war solely on account of their race. Japantown was rebuilt as a modernist island-complex of shops whose slow failure has led to various plans for revamping it yet again. The Kabuki Theater is the most successful enterprise there, now part of Robert Redford's Sundance empire, and the San Francisco Film Society often screens documentaries and non-mainstream films there. But its big blank wall facing Fillmore is an attempt to turn its back on the street.

Duke Ellington sang to a black butterfly with its "wings frayed and torn," "laughter's yours, so is scorn." Despair over redevelopment's scorched-earth policy was said to have been what pushed some locals into Jim Jones's Peoples Temple cult, housed in 1971 in the former Albert Pike Memorial Scottish Rite Temple (named after a newspaperman, trapper, and Confederate brigadier

general who later became a prominent Freemason), located at Geary just west of Fillmore. As media and government investigations of the cult stepped up, Jones led his congregation to Guyana, in South America, where almost a thousand members were eventually forced to drink cyanide in the jungle complex called Jonestown. Punk bands played at the former San Francisco temple for a few years after the mass suicide/massacre in late 1978, including the Clash on their first American tour, until the building was torn down and replaced by a post office. The Sex Pistols' last concert was held around the corner earlier that year, January 14, 1978, at Winterland, a former ice-skating rink at Post and Steiner. Jimi Hendrix had played there several times in 1968, once with bluesman Albert King—"the velvet bulldozer"—opening.

From Billie Holiday singing "Strange Fruit" to the Clash singing, "When they kick at your front door/how you gonna come?" the Fillmore district has hosted some of America's most turbulent culture, and behind it has been the violence that most of the artists resisted. "Strange Fruit" was written for Holiday by a radical Jew, Abel Meeropol, who adopted the children of Julius and Ethel Rosenberg after the couple's execution for leaking nuclear secrets in 1953. Immigrant Jews had been the dominant population of the lower Fillmore early in the twentieth century; the center of their ghetto was between Golden Gate and Fulton, but little trace of them remains on the street now.

Theaters, synagogues, and an amusement park called the Chutes are all long gone, as are the arches of light that stretched across Fillmore Street for decades before they were turned into scrap for the war effort in the early 1940s. The handsome golden brick Sacred Heart Catholic Church at Fillmore and Fell was a shelter during the 1906 earthquake, employed the city's first African American parish priest, and was the site of a food program run by the Black Panthers, but it was shuttered for good after a last mass in 2004, doomed on account of a dwindling congregation and seismic safety issues. A better fate awaited the Emanu-El Sisterhood Residence for Jewish women a few blocks east of Fillmore, at Laguna and Page, a handsome brick complex that is now San Francisco Zen Center. The building was designed by Pacific Heights dweller and pioneering female architect Julia Morgan, as was the Japantown YWCA and a few other buildings in the neighborhood.

The sprawling Uptown Church of Christ is in the middle of that stretch of redevelopment, at 949 Fillmore Street. The utilitarian replacement architecture of redevelopment that begins above Geary ends below Fulton Street, where ornate Victorian houses again line the street, with an occasional church or new building interposed. But at that point, the street is in transition once again. In the early 1980s, white kids moved into what had been a black neighborhood. Two Jacks Seafood at 401 Haight remains from the earlier era, but the storefront church at Haight and Steiner became Edo Hair Salon, Nickie's went Irish, and the neighborhood is now tattoo parlors and cafés, giving way to boutiques and bistros. It is at least a convivial section of street, and maybe here you can imagine all the jazz stars and fancy dressers, all the abolitionists and angels, scruffy poets, investigators with big pacifist eyes, kids in kimonos, all the sharp-toothed idealists and the soul-stirrers and ghost dancers together under the sign of Coyote, the scientist whose experiment North America is, and maybe imagine Fillmore Street as a swizzle stick with which he stirred the volatile mix ∞

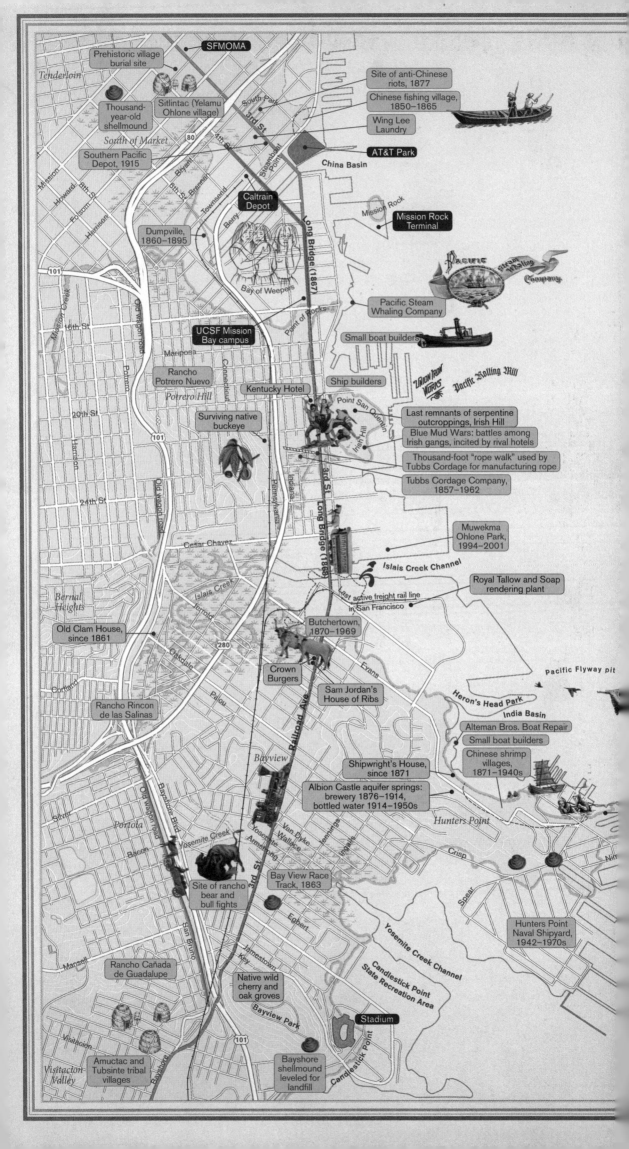

Tenderloin

Prehistoric village burial site

Thousand-year-old shellmound

Sitlintac (Yelamu Ohlone village)

SFMOMA

South of Market

Southern Pacific Depot, 1915

Dumpville, 1860–1895

Caltrain Depot

Site of anti-Chinese riots, 1877

Chinese fishing village, 1850–1865

Wing Lee Laundry

AT&T Park

China Basin

Mission Rock

Mission Rock Terminal

Pacific Steam Whaling Company

Pacific Steam Whaling Company

Small boat builders

UCSF Mission Bay campus

Bay of Weepers

Point of Rocks

Long Bridge (1867)

Rancho Potrero Nuevo

Kentucky Hotel

Potrero Hill

Surviving native buckeye

Ship builders

Point San Quentin

Union Iron Works *Pacific Rolling Mill*

Last remnants of serpentine outcroppings, Irish Hill

Blue Mud Wars: battles among Irish gangs, incited by rival hotels

Thousand-foot "rope walk" used by Tubbs Cordage for manufacturing rope

Tubbs Cordage Company, 1857–1962

Irish Hill

Muwekma Ohlone Park, 1994–2001

Islais Creek Channel

Royal Tallow and Soap rendering plant

Last active freight rail line in San Francisco

Bernal Heights

Old Clam House, since 1861

Islais Creek

Butchertown, 1870–1969

Crown Burgers

Sam Jordan's House of Ribs

Evans

Pacific Flyway pit

Heron's Head Park

India Basin

Alteman Bros. Boat Repair

Small boat builders

Chinese shrimp villages, 1871–1940s

Rancho Rincon de las Salinas

Palou

Bayview

Shipwright's House, since 1871

Albion Castle aquifer springs: brewery 1876–1914, bottled water 1914–1950s

Hunters Point

Portola

Yosemite Creek

Site of rancho bear and bull fights

Bay View Race Track, 1863

Crisp

Spear

Rancho Cañada de Guadalupe

Native wild cherry and oak groves

Hunters Point Naval Shipyard, 1942–1970s

Yosemite Creek Channel

Candlestick Point State Recreation Area

Bayview Park

Stadium

Candlestick Point

Visitation Valley

Amuctac and Tubsinte tribal villages

Bayshore shellmound leveled for landfill

THIRD STREET PHANTOM COAST

San

Francisco

Bay

American conquest, 1846–1851

Mexican rancho era, 1821–1849

Colonization, 1776–1821

Spanish expeditions, 1769–1775

Coastal tribes, 4000 B.C.–1776

ump house, since 1867

st Pacific Coast dry dock,
1867–1970s

Historical site

Surviving historical remnant

Modern site

 Known shellmound

 Pre-1849 landmass and shoreline

 2010 shoreline

 Historical marshes

10 THIRD STREET PHANTOM COAST

With its layering of histories from the heyday of the Ohlone Indians to the early twentieth century along the industrialized east coast of San Francisco, this map literally lays the groundwork for the maps that follow, "Graveyard Shift" and "The Lost World." It shows the many lost populations—Ohlones in reed boats, Chinese fisherfolk at Hunters Point and elsewhere—and the early years of industrialization that preceded both the era of "Graveyard Shift" and the era of redevelopment, when the industrial city began to fall away and the old workers who had been a part of it were pushed out. The map predates this atlas project: originally it was a painting by artist Alison Pebworth, which she graciously allowed us to remake as the map you see here with her iconography. Phantom Coast, she called it, because even the original coastline was lost amid the development. Every city is full of ghosts, and learning to see some of them is one of the arts of becoming a true local. CARTOGRAPHY: BEN PEASE; ARTWORK: ALISON PEBWORTH ∞ MAP APPEARS ON PAGES 74–75

11 GRAVEYARD SHIFT

That San Francisco was once a great port city, that there were far more fishermen than tourists at Fisherman's Wharf and a bustling produce district where the Embarcadero Center now stands, that there were industrial railroads and factories and industrial workers laboring around the clock, are largely forgotten. Paul Yamazaki, chief book buyer for City Lights Books, pointed out to me that the bars that continue to open at 6 A.M. may be the last relic of this bygone realm when workers stopped off for a drink on their way home from working the graveyard shift. By 1980, when I moved to San Francisco, it was a rapidly deindustrializing city, though the dramatic loss of jobs and workplaces was obscured for many by the rise of new, less muscular industries, mostly having to do with information, technology, and finance, as well as tourism. This map is an attempt to represent that earlier industrial city, as it functioned in 1960, with a scattering of the remnant 6 A.M. bars that still exist today. CARTOGRAPHY: SHIZUE SEIGEL ∞ MAP APPEARS ON PAGES 78–79

Flows and successions are the invisible but necessary ligaments and tendons of any urban area. As I gaze at the shoreline map of San Francisco, I can't help but think of all the different foods that were shipped through those old finger piers, long before refrigeration or containerization altered oceanic trade forever. The most fundamental food that came into San Francisco well into the twentieth century, sustaining the transportation system, was, in fact, hay. The tens of thousands of horses that pulled carts, wagons, and street cars stuffed with goods and people made it possible for San Francisco to slowly spread itself across the windswept, flea-ridden hills. That hay was grown all around the bay and, eventually, farther upstream in the Central Valley. It was brought to San Francisco on steam-powered scows, one of several dozen types of ships that once plied the bay waters, the economic lifeblood of the city and the region.

Pre-urban San Francisco was covered in scrub and in sand dunes, often between one hundred and two hundred feet tall, with freshwater ponds at the bottom of the ridges. As the city expanded, Irish laborers used shovels and picks to begin flattening stretches of land such as today's museum zone around Third and Mission or the area where the factories settled around Eighth and Harrison. (There is a great old photo from the early 1850s of a steam shovel, identified in the photo as a "steam paddy," leveling the dunes in the factory area, next to the early Gordon sugar factory—"paddy," in this case, being a derogatory term referring to the Irish.) In a comforting ecological circle, the horse manure that dropped on city streets in profusion, mixed with mud and sand, was also the crucial resource used by the early park builders in the "outside lands" to build soil on the dunes that eventually became today's flourishing Golden Gate Park.

Another harmonious cycle that is lost to most memories is also food-related. The Italians who dominated the old Produce Market area just north of today's Embarcadero Center, where the fresh produce feeding the city arrived from the nearby piers, would take wagonloads of fruits and vegetables through the city, calling out their wares in the streets. Later many of them established corner groceries, which served as the backbone of food distribution before the invention of the supermarket. Meanwhile, other Italian clans set themselves up as scavengers throughout the city, slowly amalgamating during the early twentieth century into two great cooperative associations, Sunset Scavenger Company and the Scavengers Protective Association. Few recall that in these co-ops the men on the wagons and trucks (who are said to have sung opera in top hats while picking up the pre-dawn garbage) were paid the same as the executives in the offices until 1972. After that, the co-ops were convinced to become ESOPs (Employee Stock Ownership Plans), which allowed corporate control to pass to the behemoth Norcal Waste (recently renamed Recology), leaving the egalitarian roots of the Italian clans far behind.

At that same Channel Street dock area (aka Mission Creek, aka Shit Creek) where most of the hay was imported, the Del Monte Company built a large

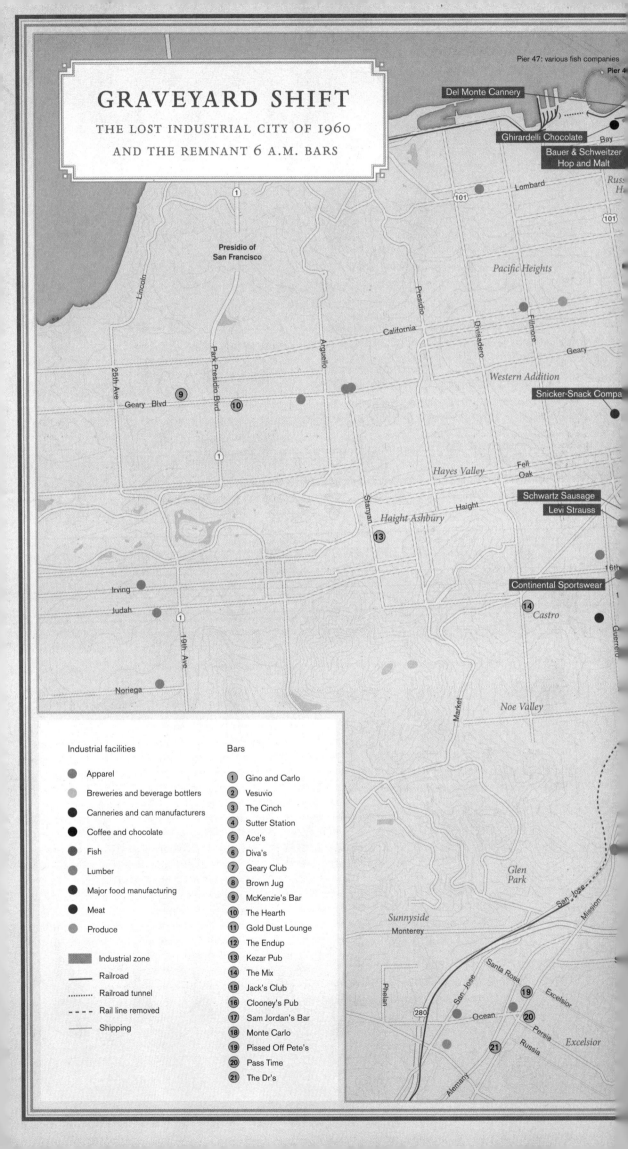

GRAVEYARD SHIFT

THE LOST INDUSTRIAL CITY OF 1960
AND THE REMNANT 6 A.M. BARS

Pier 47: various fish companies

Pier 4

Del Monte Cannery

Ghirardelli Chocolate Bay

Bauer & Schweitzer
Hop and Malt

Russ
H

Lombard

101

101

Presidio of
San Francisco

Pacific Heights

Lincoln

Presidio

California

Divisadero

Fillmore

Geary

Park Presidio Blvd

Arguello

Western Addition

25th Ave

9

Geary Blvd

10

Snicker-Snack Compa

1

Hayes Valley

Fell
Oak

Stanyan

Haight

Schwartz Sausage
Levi Strauss

Haight Ashbury

13

16th

Continental Sportswear

Irving

Judah

1

14 Castro

19th Ave

Noriega

Market

Noe Valley

Guerrero

Industrial facilities

- Apparel
- Breweries and beverage bottlers
- Canneries and can manufacturers
- Coffee and chocolate
- Fish
- Lumber
- Major food manufacturing
- Meat
- Produce

Industrial zone
Railroad
Railroad tunnel
Rail line removed
Shipping

Bars

1. Gino and Carlo
2. Vesuvio
3. The Cinch
4. Sutter Station
5. Ace's
6. Diva's
7. Geary Club
8. Brown Jug
9. McKenzie's Bar
10. The Hearth
11. Gold Dust Lounge
12. The Endup
13. Kezar Pub
14. The Mix
15. Jack's Club
16. Clooney's Pub
17. Sam Jordan's Bar
18. Monte Carlo
19. Pissed Off Pete's
20. Pass Time
21. The Dr's

Glen
Park

Sunnyside
Monterey

San Jose

Mission

Phelan

280

San Jose

Santa Rosa

Excelsior

19

Ocean

20

Persia

Excelsior

21

Russia

Alemany

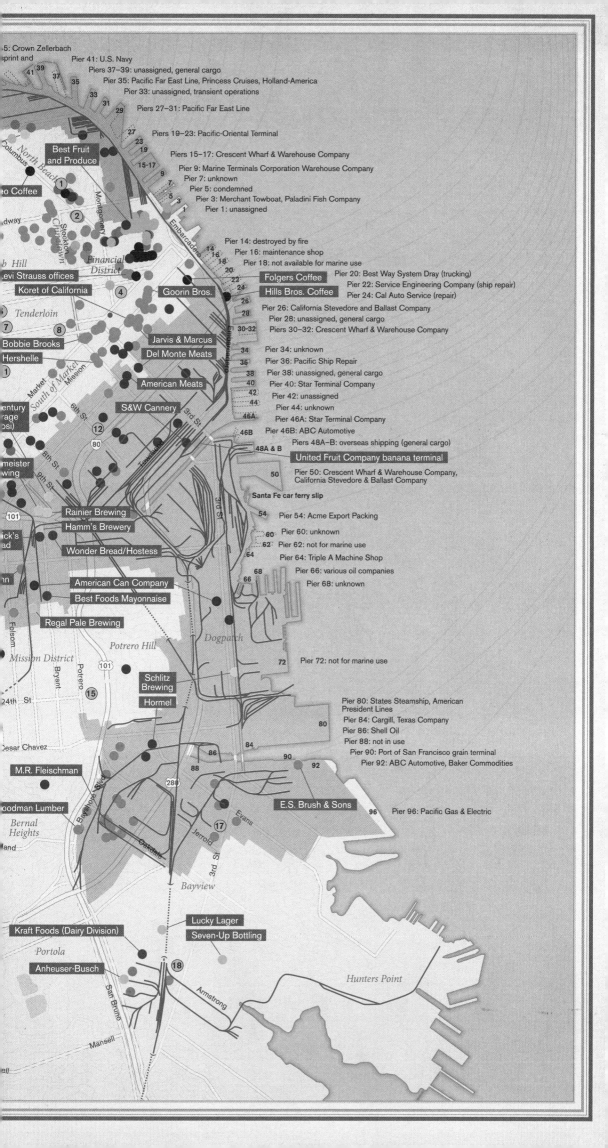

California produce labels, 1940s (Pacific Pride, Frisco) and 1970s (Nob Hill)

building that still sits between the drawbridges on the north shore, now converted into another office building. This is where the United Fruit Company off-loaded Central American bananas for decades, the same company that gave rise to the term "banana republic" in reference to the corrupt puppet regimes it controlled in Honduras and elsewhere in Central America. It's one of those weirdly amnesiac cultural artifacts that when most people under thirty-five hear the term, they're likely to first think of a clothing chain store, the bloody history of United Fruit obscured by stonewashed denim jeans and slender models in snug cotton. (And it's a chain also born in San Francisco, founded as an actual military surplus boutique and snapped up by the Gap, with world headquarters here, along with Levi's and Esprit.)

The Cannery—once owned by Del Monte, which ran the largest peach cannery in the world there—is a mall, as is Ghirardelli Square, the former Ghirardelli Chocolate factory, to its west, both adjoining Fisherman's Wharf. The food industry that was centered in this part of town is largely buried and forgotten under an avalanche of imported tschotschkes and tourist-trap kitsch. Where Italian women once packed the South Bay's abundant peaches, plums, and apricots in cans to ship to the world, today unknowing tourists bump through trendy boutiques and fast-food joints. The cans that were stuffed with that agricultural abundance were made here too, first at the American Can Company factory at Florida and Seventeenth, and later at Twentieth and Third Streets. The first factory is now the much-beloved Project Artaud, one of the first artists' live/work conversions of old factories in San Francisco; and the

other, larger structure has been leased by the San Francisco Art Institute along with several dozen small businesses and working artists.

A block east at Twentieth and Illinois sat one of the biggest ironworks on the West Coast (and still sits the oldest industrial building west of the Mississippi), where many ships of the Great White Fleet of Teddy Roosevelt's "Big Stick" ("speak softly and carry a big stick") were constructed. Earlier still, just a few blocks farther south, sat the Arctic Oil Works, once the West Coast's biggest whale processing facility, of key importance because the spoils of this first oil war (between humans and the biggest creatures in the sea) were essential to lubricate and illuminate the early stages of the Industrial Revolution. Even the quintessential technology of the twentieth century used to be produced right here in San Francisco. At Twenty-first and Harrison, the Ford Motor Company made Model Ts and later models, rolling them onto the freight trains that once dominated Harrison Street from Twenty-second to Fourth, passing a cluster of steel and ironworks factories around Eighth and Harrison.

The old white, blue-collar San Francisco loved baseball, and just up the hill at Sixteenth and Bryant, Seals Stadium was built and opened in 1931. You could hop off the long-forgotten H-line at Potrero and Sixteenth, grab a drink at the Double Play across from the main gate (amazingly, it's still there), and then sit in the right field bleachers, allowing your thirst to grow as you watched the giant beer glass made of lightbulbs atop the Hamm's Brewery on Bryant fill and empty, fill and empty, incessantly. I remember that beer glass with a child's enthusiasm for strange sights, as it was a regular landmark of my family's rare drives through San Francisco in the late 1960s. Herb Mills, former secretary-treasurer of Local 10 of the International Longshore and Warehouse Union, told me about the life on the piers that characterized the golden era of longshoring: "Used to be a bar or café at the head of every pier. . . . Ain't none of that no more. . . . That's all gone now, it's like . . . gone with the wind!"

What happened to the Port of San Francisco? In a word, the shipping container, which Mills described to me as "the technological underpinning of the global economy. . . . the container has been the physical means of exploiting cheap labor throughout the world." Of course, it also increased the quantity of goods shipped through coastal ports by more than 400 percent, while keeping the absolute number of workers from growing much. This technological revolution in shipping happened with the agreement of the ILWU, led by Harry Bridges, codified in the Mechanization & Modernization Agreement of 1960 (renewed in 1966 and again in subsequent years). Given San Francisco's peninsular location and lack of expansive flat areas to store stacks of containers, not to mention the absence of direct rail lines heading north and east, the once vibrant waterfront shriveled in little over a decade, as shipping moved to the quickly automating and expanding Port of Oakland (and, as the huge expansion in global trade continued from the 1970s to the present, the ports of Los Angeles, Long Beach, and Seattle superseded Oakland).

Inadvertently, this seminal M&M Agreement, while beneficial to the specific longshore workers employed at its signing (boosting pensions, raises, job security), damaged the broader working class by creating the conditions that allowed manufacturing industries to leave the Bay Area, and even North America. Just as manufacturing had moved out of San Francisco during and after

World War II to less union-dominated areas around the bay and in other parts of California, during the 1960s this process began to take shape on a global scale, even if it wasn't commonly referred to as "globalization" until the late 1980s and after.

San Francisco is a quintessential example of what happened to cities in the United States and, to some extent, in Europe in the latter half of the twentieth century. More broadly, it underwent in microcosm a process that altered the role of the United States in the world economy. To make sense of it, we have to go beyond the limits of one urban story to the metropolitan region at whose center San Francisco sits brashly and arrogantly (in spite of its small geographic size). The process that unfolded in the Bay Area was writ large across the country during the last twenty-five years of globalization, wherein the United States sent most of its manufacturing to new locations (without relinquishing control over technology, labor processes, or, crucially, capital) while building a "new economy" based on information and tourism. Using a combination of debt and a strangely hollow but widely distributed abundance, the U.S. working class was reconfigured as the vast middle class, situated between shopping-cart pushers on the streets and Lear Jet commuters soaring overhead.

San Francisco had been home to a savvy, well-organized working class that in the 1930s staged a general strike and overturned the class relations dominated by business that had made the 1920s the era of the "American Plan" (open shops, low wages, frantic stock market speculation). In the midst of the Great Depression, San Franciscans organized themselves based on solidarity and mutual aid and saw trade unions as the vehicle for their collective defense and self-improvement. By the dawn of the Second World War, nearly 100 percent of the city's restaurants (to cite just one example) were unionized, including lunch counters and coffeehouses. The patrons were largely union workers in the factories, warehouses, and waterfront industries that made up the blue-collar (and mostly white) city.

By the end of World War II, members of the local business elite were chafing at the impediments to their control and profitability that the local working class represented. But things were already changing, and those changes were to get a significant push from both local power brokers and the national government. The war itself had already completely altered the conditions underlying working-class confidence and ruling-class acquiescence. The war effort had radically expanded industrial production in the Bay Area, opening major shipyards in San Francisco, Marin, and Richmond, while materiel was being produced in factories from north to south. White working-class men had been shipped off to fight in two theaters of the war, so women were rushed into production work, and some forty thousand black working men and women from the South were recruited into the war industries in San Francisco.

The great northward migration during the war changed the face of many industrial cities, San Francisco included. The black population continued to grow until the late 1960s; by 1970, there were around one hundred thousand black residents, nearly one in seven San Franciscans. Today, however, the black population is under forty-five thousand, and shrinking steadily. After the war, city leaders designated the largest black neighborhood, the Fillmore

(once known across black America as "the Harlem of the West"), as "blighted" and implemented a federally supported "urban renewal" program (derisively renamed "negro removal" in the community). The heart of black San Francisco became a desert of vacant lots slated for upscale "redevelopment."

But the Fillmore was only one of several areas singled out for destruction by elite planners. The first neighborhood they'd targeted had been the old Produce Market district, slated to become an eastward extension of the Financial District. The Genoese and Ticinese Italian immigrants who dominated the food industries in San Francisco, giving rise to such well-known names as Del Monte, Martinelli, and Italian Swiss Colony, had controlled the neighborhood a few blocks inland from the finger piers through which so much food came and went. At the northern edge of North Beach, Italian women had worked in the canneries and other food processing facilities, while Italian fishermen plied the waters of the bay and the Pacific. But urban renewal moved the food warehouses and wholesalers south to the old swamplands east of Bernal Heights and Highway 101, gutting the economic and cultural heart of the Italian neighborhood by the end of the 1950s. Italians in San Francisco joined the national exodus of whites from the inner cities and moved to the suburban west side of the city or beyond city limits altogether in the southern, northern, and eastern cities of the Bay Area.

I remember well the roasting coffee smells at the foot of the Bay Bridge, the same coffee that longshoremen used to off-load in two-hundred-pound sacks on pallets with slings and cranes. (I learned later that no longshoreman ever lacked for coffee, and that most of them preferred a dark, bitter brew made from green beans roasted over the stove, with hot water poured over them once they were darkened. Those two-hundred-pound sacks had the misfortune of breaking pretty easily, so "spillage" was always a customary benefit of waterfront work.)

I can conjure up an olfactory tour of the more industrial city quite easily, from the raw sewage that poured into the bay during rainstorms, to the piercing odor of ammonia emitted by the Best Foods Mayonnaise factory at Florida and Eighteenth, to the pungent sweet smell of baking that wafted from the Kilpatrick's Bread factory and the Hostess bakery that turned out Wonder Bread and Twinkies. You can still peer into sweatshops from the Central Freeway and watch the female Chinese garment workers trudge home up most of the streets in South of Market at the end of the workday. Edwin Klockars Blacksmithing is still operating much as it has for the past century, off First and Folsom, now dwarfed by the massive condominium complex built over it by, of all things, AFL-CIO pension money.

Construction, the quintessential blue-collar activity, has ebbed and flowed with the real estate and financial services business in past decades, providing one of the few lasting sources of blue-collar employment. We're taller, denser, and have more dwellings and offices and buildings than ever. But the printing industry, though it still exists in pockets, is nothing like it used to be, especially when the city had three or even eight competing daily newspapers. Typesetting, once a highly skilled job requiring access to extremely capital-intensive technology, has disappeared with the rise of the personal computer and desktop publishing. Skills that the working class used to vault into the middle

class during the past half-century have been systematically eliminated by the inexorable "progress" of capitalism: the substitution of technology for human labor and the deskilling of the workers who remain, all while the system's proponents claim that we need more education and training to function in the high-tech world of today.

The truth is that we're drowning in busywork, nonproductive work, everything from "creative" banking and insurance bureaucracies to the pointless shuffling of data and the manufacturing of products designed to be obsolescent almost immediately—and I would argue that a great deal of what we're doing should just stop. Interestingly, people of all sorts are beginning to reconnect to skills and sensibilities that were bulldozed in the frenzy of "development" that remade our world during the past two generations. Those orchards and fields that once covered the lands of the peninsula, the East Bay, and Silicon Valley are haunting us now, as we seek to relocalize our food sources and our economy more generally. People are relearning how to reuse things, how to fix broken items, and even how to make new things from the scraps of industrial waste. The world shaped by capitalist modernization is not good for human life and is certainly rough on the health of the planet. The hollowing out of communities whose lives were once anchored in the old Produce Market area or who shared life along the vibrant Fillmore blues corridor is precisely what people are trying to overcome.

The modernization and progress that gave this soul-destroying process a certain inevitability did indeed affect the whole country, and even most of the world. It was not invented in the Bay Area, but San Francisco was one of its earliest epicenters. The heads of the biggest corporations here tried out things regionally that later became models for how they would manage the global economy that had come under their control, as their companies escaped the bounds of a national economy to become global behemoths (Bank of America, Chevron, Bechtel, Wells Fargo, Del Monte, and many more). As this process unfolded, the white working class lost its identity as workers, mostly fled the cities, sent the kids to college, and took full advantage (by going into massive debt) of the wealth that U.S. militarism and multinational business poured into U.S. coffers.

San Francisco is at the cusp of another transformative cycle. The practical acts of thousands of people embody an agenda of reinvention, regeneration, but it's mostly happening outside the logic of business, wage labor, money, and markets. Can these efforts find their political voice? Can human communities reinvent public life and subordinate corporations to their social choices? The foods that world cultures brought here have erupted into something new in the past generation or two. The proliferation of gourmet ghettoes and the folks who work in them indicate that a new kind of craft production has emerged, one that harkens back to the best of human ingenuity celebrated in the nineteenth century by the likes of William Morris and John Ruskin, writers who understood the difference between quality work and useless toil. Did we need to pass through all these stages to get to a new renaissance, in which we are finally starting to ask about what we do and why we do it? Might we finally be ready to enthusiastically jettison all the useless work that this mad world has heaped upon us? That's what I'd like to see "gone with the wind"! ∞

12 THE LOST WORLD

To understand a place is to know its past, which suggests that few really comprehend the strange limbo that is the commercial–cultural–convention center complex south of Market Street, which was made by demolishing most of the buildings and banishing most of the people who were there well into the 1970s. Ira Nowinski's photographs are that lost place's greatest memorial; the two that appear on this map help flesh out what all the tiny print tells you about this dense 1960 neighborhood of residential hotels, pawnshops, small shops and manufactories, diners, and taverns, which served a population long rooted in the city but since replaced by streams of tourists, museum-goers, shoppers, and conventioneers. The place now is a slice of nowhere or anywhere, with little identity and some great cultural institutions, as well as some not-so-great ones, such as the meta-mall anchored by the multiplex movie theater that is forever changing its name from that of one corporation to another. The convention center and luxury hotels are built for outsiders, though a largely invisible elderly population survives in the high-rise residences that are the slim margin of victory for the largely defeated and evicted low-income residents. Maybe the antithesis of the bland Yerba Buena Gardens is the paradisiacal community garden tended by some of these seniors behind Mendelsohn House, on the poetic little street called Lapu Lapu at the intersection of Rizal—both named after great Filipino independence heroes. The latter also stayed in the Palace Hotel in 1888 and later had a residential hotel on Third named after him. Neither of these streets existed in 1960, the era this map represents, and some of the alleys it shows have since been eradicated.

CARTOGRAPHY: BEN PEASE; PHOTOGRAPHS: IRA NOWINSKI © 2010 ∞ MAP APPEARS ON PAGES 86–87

PILED UP, SCRAPED AWAY BY REBECCA SOLNIT

Cities approach immortality while everything within them rises, falls, is erased and transformed and replaced. San Francisco, which burned down six times in its first decade and lost its urban core in the 1906 earthquake and fire, is a city of change, but not all change is a natural force. There are little wars, and even the rise of a city can be considered a war against the original landscape, one that the great disasters reverse. This map is about the lay of the land before a fierce war began, one in which blood was shed and fires were set, in which bullies with fists and financial plans were held off by determined old men who

Market St

Market St

Pacific Building

State Theatre
Humboldt Bank Bldg
Sweet Spot restaurant
Keefe Typewriter Co.
Joseph Torrano shoe shiner
Bernie's Liquor & Cigar
State Theatre Barber Shop
Cozy Corner Restaurant

Portola Theater

Bancroft Building
Hub Theater

Central Tower Building

Holmes Book Co.
Jay Hurley's Sportorium cocktail lounge
Joe's Tamale Parlor

Walter Alini Watch Repair

The Emporium

Pioneer Pl

Atchison, Topeka & Santa Fe Railway

Keystone Hotel
Keystone Grill
Keystone Room tavern

Fourth St

Stevenson St

Veterans Administration Building

Joe's Cigars

PG&E Garage

PG&E Jessie St Substation

Leonard's Barber Shop
King Hotel
Barrel House tavern

Owen Hotel
Capitol Clothing Co.
United Loan Office pawnbrokers
Bavarian Ski Shop
The Kentucky Tavern
Golden Gate News Agency
Westchester Hotel

Third St

Jessie St

Jessie St

Red Scissors Premium Store
Belding-Heminway-Corticelli fabrics and threads
News Building
News Coffee Shop

Star Book Shop
Fred's Barber Shop
Fox Hardware
Quality Hat Works
Argonaut Gun Mart
Starlight Cafe
Gallagher's tavern
Gay's Coffee Shop
The Artist Tailors

The Emporium Warehouse

McCarthy's tavern
Margaret Hotel
Fourth St Loan pawnbroker
Cairo Restaurant
The News Room tavern
Graystone Wine & Liquor Store
St. Regis Hotel
Fourth Street Lunch
Jack & Ralph's cigars
Sanitary Barber Shop
George Soran shoe shiner
West Coast Beauty Supplies

SF Cash Register Co.

Benziger Brothers Inc. church supplies
St. Patricks Roman Catholic Church
Rectory

Universal Merchandise
Carnival Goods
Trude of California
Martin District Co.
household appliances
Halco Light Co. Inc.
J. Jacobs & Co. men's clothing wholesale

Knox Hotel Knox Cafe
Kurant's Western Outfitters
Old Waldorf Tavern
Mercantile Center Building
Harry A. Reif photo supplies
Stop & Shop Gen'l Mdse.
Gus Dunn watch repair
Garo Basmajian Coffee Shop
Bea's Coffee Shop

Harry's Barber Shop
Ryan Borneman Book Shop

Mission St

Mission St

Heidelberg tavern
Hotel Irwin
Hot Dog
Palace No. 2

Silver & Co importers
Advertising Building

Fifth and Mission Parking Garage

Henry M. Zais Furniture Co.
Melvin Goldberg novelty mfg.
128 Fourth St Barber Shop
Su-Z-Q Club
Alpine Lodge Hotel

Saroyan's Office Repair and Service
Castle Coffee Shop
Milner Hotel
Long Horn Tavern
Veterans Hand Laundry
Wong's men's clothing

Troy Sportswear

Gay-Teens of California clothing manufacturers

Mission Auto Park

Pacific Outdoor Sales Co.

Kearny Wholesale Drugs

Saltzman Brothers Furniture

Rochester Clothing for Men
Union Liquor Store
Zenith Club Tavern
Colorado Hotel
Mad's Loan Co.
Square Deal Jewelers
Carmel Barber Shop
Hotel Carmel
Max's Shop for Men

Minna St

Minna St

Chuck's Grocery Store
Hotel Imperial
Western Cleaners and Laundry
San Francisco Belt Co. mfg.
System Auto Park
Panama Barber Shop

Green Frog tavern
Henry's Locksmith
Golden Harbor Restaurant
Bridge Way Garage
Goldfield Hotel
Moler Barber College

Roxy's Tavern
Francisca T. Harvey, accountant
Aron C. Rogoff used clothes
Majestic Lunch
Peerless Theater
Rose Cleaners & Laundry
Dr. Jerome P. Gludkfeld/Penn Drug Co.
West Hotel
Marine Cafe
Favorite Store

Old Friends Coffee Shop
Hotel Panama
Fay Laundry and Dry Cleaners
Mars Liquor and Grocery Store
184 Fourth St Rooms & Lodgings
Wing's Coffee Shop
Mars Hotel
Till Two Club
Howard St Laundry
Manifold Trade Bindery

Howard-Holland Service Gas Station

Workingman's Headquarters used goods
Sidney Rosenthal used clothing
Paul's Place used merchandise

Johnson's Shoe Shine stand

SF Bottle King

Chicago Clothing Co.

American Hotel

Natoma St

Victory Club tavern
New York Cafe
Sequoia Hotel
Calif State Hotel
The Mother Lode tavern
The Chicago tavern

Mike's Cafe
Pete's Liquor

Howard St

Howard St

Dettner Building
Floralart Products
novelty mfg.
Kampco wholesale toys
Banner Hotel
Saint Anthony Hotel
Chu-Wong Inc. food broker
Duncan McGregor contractor

West Coast Engraving Co.

Hal's Automotive Services

Jim's Tavern
Netherlands Hotel
Independent Grocery
Chicago Clothing
Avondale Hotel
American Hotel

Henry's Cafe
Nellie's Club
Hotel Niagara

The Economy Store
Advanced Steam Laundry
Stratton & Young Hardware

Sapero's Bargain Center

Del Monte Meat Co. Inc. wholesale

Schwabacher-Frey wholesale

Larsson's Tavern

Davitt's Richfield Station

Tehama St

Fred's Sportswear Cleaners

Francis Valentine Co. printers/ Ogden Printing Co.

Rock Hotel
Bing's Laundry & Cleaners
Cooper's Liquor Store

Gen Gen Cafe
Al's Place used clothing
Hotel Rex
Pacific Cleaners
Hollywood Barber Shop

Mallett Hotel

Salvation Army

S E Massengill pharmaceuticals

Metropolitan Parking Corp.

Clementina St

Clementina St

Carlenton Hotel
Pilgrim Rest Church
Welcome Mission
Venice Hotel
Dobre Beauty Supplies

Victor Equipment welders equipment
ABSCO welding equipment
Simonds Machinery Co.
Union Oil Service Station

Copple Bus and Truck Service
John G. Lipp watch repairs

Hotel Albert
Maragos Cafe

American Meat Co.

San Francisco Plating

Blutman's Stationery

Atlas Paper wholesale

Kay's Jewelers
Russell's Auto Repair

Folsom St

Folsom St

Golden State Meat Co. wholesale

California Casket Co.

Peterbilt Motors Co. truck parts

California Wafer wholesale bakery

Pacific Telephone & Telegraph

Sperry Gyroscope scientific instruments

Rincon Hill Market
United Meat Co.
G. Varetakis & Son shoe repair
Sparta Hotel
Cosmopolitan Market

Shipley St

Tintan Cafe
Helen's Club
Hotel Montana
Sunset Grill
Third St. Cleaners & Laundry
Bob Whitman Salvage
Nevada Hotel

Lert Hagemeister Inc. sporting goods mfg.

Crankshaft Exchange Inc.
Olivier Printing Co. badges & buttons

Clara St

Nevada Club tavern
Gold Crest Meat Co.
Faire Hotel
Deliverance Mission
Young Chun Laundrette
Hotel Lodge
Lillie's Place Restaurant
Whiteway Barber Shop

Robinson-Coney Co. Contractors

Charles Lowe Industrial Equipment

Harrison Hotel
Gray Club Tavern

Louie's Market

Harrison St

Locations in 1960

Wong's — Business

Troy — Industrial and warehouse

Pilgrim — Civic and community

Argus Hotel
Argus Cafe — Hotel over businesses

Mallett — Hotel only

Flats and dwellings

...aneman's
...ars & Liquors
...arst Building/
... Examiner | Monadnock
...curity Loan Co. | Building
...wnbroker
... Magnet, restaurant
...gnet Cocktail Lounge

Annie St
Palace Hotel

SF Examiner
(plant)

Jessie St
Hotel Jessie

...en's Cafe
...vles Printing Co.
...aranty Loan Office
...y and Johnny tavern
... Sporting Goods pawnbroker
...ce Bath
...t James Hotel
...'s Men's Store
... Liquor & Cigar

... Cafe
...e Loan Co.
...town tavern
...able Mercantile & Loan
...shine Cafeteria
...er & Shea shoes
...e Loan Office and
...rting Goods pawnbroker

...ential Loan Office pawnbrokers
...el Argus
...el Andelis
... Fifty-Five Club tavern
...s Market

Massett/Sherwood St
...Loan Office pawnbrokers
...Barber Shop
...Boat Tavern
...Hotel
...n Hotel
...Ben Mercantile & Loan

Hunt St
Fire station
Seinwel Paper Co. wholesale

...nal Cleaners
...t Albany
...Albany Bar
...ny Barber Shop
...al Loan Office
...brokers

Durham Meat Co.

...on
...t
...e
...et
...ery

Tehama St
...onse Logan Billiards and Pool
...n Hotel
...ield Hotel
...s Market
...bul Pastries

... & Clementina Auto Park

Clementina St
...'s Remedies
...ioma Barber Shop
...nix Rooms
...odgings
...Eighty-Three
...avern
...s Bar-B-Q

...kes Speedy Press
... Cafe

...o Cafe
...no Caffe whole coffee
...o Missionary
...t Church
...o-Nut King

Verona St
...Pentecostal Church of Christ
...Cleaners
...nes Spiritual Temple
...tic Barber Shop
... J. Yee Laundry
...o Hotel
... Cafe

NO VACANCY

THE LOST WORLD

SOUTH OF MARKET, 1960,

BEFORE REDEVELOPMENT

lost much and won a little, about the total annihilation policy that created the opening for the Yerba Buena Center and Moscone Center complex south of Market Street in downtown San Francisco.

But before we plunge into the war over urban renewal south of Market Street, it's worth remembering that the neighborhood had arisen on the site of marshes and sand dunes. William Heath Davis, one of the first Yankees to settle in Mexican California, remembers hunting deer not far away: "We would start at about nine o'clock and go over to a place called Rincon, a flat between Rincon Hill and Mission Bay and a resort for deer, the place being covered with a thick growth of scrub oak and willows, which afforded them good shelter." As the sand filled up with settlement, the stretch along Mission from First to Third was called Happy Valley. By the second year of the Gold Rush, it was full of dysentery and cholera, its name a farce. But then an affluent neighborhood began to arise. South Park was laid out in the mode of an English square some years later, and Rincon Hill (where the pier of the Bay Bridge now comes down) was a fashionable district before the Second Street cut in 1869 undermined the foundations of the mansions built on sand. The cut, made to speed traffic from the ports to the central city, was part of the transformation of the region that included filling in Mission Bay (which became the railyard for the Central Pacific and then the Southern Pacific Railroad, fell into disrepair in the last third of the twentieth century, and was reborn as a biotech campus at the millennium).

By late in the nineteenth century, everything on that side of Market Street was known as South of the Slot. Jack London, who was born there (at 615 Third Street near Brannan), named a short story after it: "Old San Francisco, which is the San Francisco of only the other day, the day before the Earthquake, was divided midway by the Slot. The Slot was an iron crack that ran along the center of Market Street, and from the Slot arose the burr of the ceaseless, endless cable that was hitched at will to the cars it dragged up and down…. North of the Slot were the theaters, hotels, and shopping district, the banks and the staid, respectable business houses. South of the Slot were the factories, slums, laundries, machine-shops, boiler works, and the abodes of the working class. The Slot was the metaphor that expressed the class cleavage of Society."

Urban historian Chester Hartman describes, in *Yerba Buena: Land Grab and Community Resistance in San Francisco*, what replaced the old slum that burned down in 1906: "By 1907, 58 new hotels and 80 new lodging houses had been built. Small manufacturing, wholesaling, and warehousing concerns gradually rose again among these residences. The Irish and Germans who returned to their old neighborhood were joined by a large Greek community. This settlement, which occurred between 1910 and 1920, was at first largely composed of men who had worked their way across the country on railroad crews. They often opened tea or coffee houses and inexpensive restaurants, serving the Greek and other single men's community. Other immigrants opened pawnshops and new and secondhand clothing stores. The formerly genteel South Park neighborhood just to the south became a mixed area of warehouses, machine shops, and flats housing a Japanese community. South of Market thus became a neighborhood of every nationality. Two 'main stems' grew up after 1906 and remained for over 50 years. Along Third Street men came to gamble in the many saloons with their special back rooms that doubled as 'bookie

joints,' legal until 1938. On Howard Street, the men spent most of their time on the street, looking at the blackboards advertising work, drinking, or pitching pennies on the sidewalk. The Howard Street area became known as the 'slave market' due to the extraordinary exploitation and suffering that migratory and unskilled workers were subject to."

It was still rough territory when Jack Kerouac walked through it several times a week to the trainyard at Fourth and Townsend, which still sends commuter trains down the peninsula, though the big railyard in Mission Bay is long gone. He packed a lot of what he saw into a sentence that rumbles on like a freight train in "The Railroad Earth," his great essay about the place: "Blue sky above with stars hanging high over old hotel roofs and blowers of hotels moaning out dusts of interior, the grime inside the word in mouths falling out tooth by tooth, the reading rooms tick tock bigclock with creak chair and slant-boards and old faces looking up over rimless spectacles bought in some West Virginia or Florida or Liverpool England pawnshop long before I was born and across rains they've come to the end of the land sadness end of the world gladness all you San Franciscos will have to fall eventually and burn again."

It was a rough neighborhood, but it well served the old and infirm work-ingmen who could live there on savings, small pensions, and Social Security, a neighborhood of residential hotels, taverns, diners, pawnshops, and small businesses dissolving into the industrial zone of much of the rest of what's now called SoMA, or South of Market. Many of these men—and they were mostly men, though some women lived there as well—had worked on the waterfront in earlier decades. Some of them still bore the stamp of the radical politics and great labor battles of the 1930s and earlier.

When San Francisco's business interests set out to destroy the architecture in order to build a new commercial complex, the residents fought back with the skill and ferocity they'd learned during the General Strike of 1934, which began on San Francisco's docks and shut down the city for more than two months. The strike led to the unionization of all the ports of the West Coast of the United States, to a few deaths from police bullets, and to the loss of George Woolf's front teeth. Woolf had been president of the Ship Scalers Union and then the Alaska Cannery Workers Union, which was based in San Francisco. "I've lived my life so that I can look any man in the eye and tell him to go to hell," he remarked late in life, and when the city's redevelopment agency and business interests came after Woolf's neighborhood, the eighty-year-old didn't back down, and neither did dozens of the other residents. In 1969, they formed

Ira Nowinski, *Last Resident, West Hotel*, 1974. No Vacancy Archive, Bancroft Library.

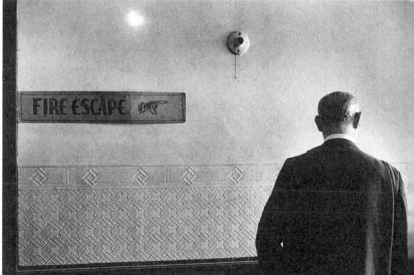

TOOR, Tenants and Owners in Opposition to Redevelopment, and they fought one of the bloodiest battles in American redevelopment history.

The tenants of the area were evicted, threatened, beaten, driven out by arson, and forced to live in buildings that the city took over and turned into slums. But they were tenacious. One disabled man hung on in a building whose elevator had been immobilized, and another elderly man, the pugilist Eddie Heider, stayed alone for two years in a hotel from which all the other tenants had been driven (now the site of the big parking garage at Fourth and Mission). It was a class war, a war to move the wealthy and the middle class across the line that Market Street had been, into blue-collar territory.

Another combatant, Peter Mendelsohn, cofounder of TOOR, said, "I've lived on this block for forty years. I know everyone here and they know me. To move me even five blocks away would be the same as moving me to another city. It'll take years for me to build up new relationships, and years off my life in the process." Another resident explained in 1965, "Most people don't understand but let me tell you a man can enjoy freedom here. All of us have many friends. To us, this has been a home for years. We enjoy life. . . . Most of all there is something spiritual about all of this. . . . We have something that couldn't be replaced with all the money our federal government could put in here."

Although many were driven out, some were able to stay because of the work of TOOR and other groups. Seldom noticed nowadays amid the conference center and cultural facilities are the eight apartment blocks built since 1977 by TOOR's successor, TODCO (Tenants and Owners Development Corporation), including Woolf House Apartments, 801 Howard Street at Fourth; and Mendelsohn House, at 737 Folsom near Third. A war was fought, alleys and small enterprises disappeared, lots were scraped clean, and an amnesiac white-collar slice of anywhere sprang up, but these eight buildings housing more than twelve hundred vulnerable people—seniors, the disabled, the formerly homeless—are monuments to valor and refuges for what remains of the old neighborhood.

So are Ira Nowinski's extraordinary photographs. He was a graduate student at the San Francisco Art Institute in 1972 when he wandered by the neighborhood to see what was going on and found it so compelling that he stayed for seven years and took hundreds of strong photographs of the people and the place, as it was and as it was being knocked down. They are pictures of poverty, of dignity, of the small details of bygone lives—a medicine cabinet with whiskey bottles and goldfish food, a wall with an American flag from a newspaper— of the ecology of community, its places to eat, to gather, to sleep.

The map here, with two of Nowinski's 1970s photographs, reconstructs the neighborhood as it stood in 1960, when the waterfront was still thriving and redevelopment had not yet begun to gnaw away at the place. It is a lost world, not only because these diners and hat blockers and watch repair shops were scraped off the earth long ago but also because something of the dignity of these old laborers in their hats and suspenders, their modest pleasures and fierce commitments, will never exist in the same form again. "All you San Franciscos will have to fall eventually and burn again," said Kerouac. Earthquakes or new versions of urbanism or something else in the course of time will transform the neighborhood again, and perhaps someday deer will be hunted again in Happy Valley. But for now it's important to see what was lost most recently ∞

13 THE MISSION

The juxtaposition of inner-city kids who've hardly left their neighborhood to cross a bridge or go to the country and day laborers who've survived extraordinary odysseys to come here from other worlds—surviving ordeals at the hands of coyotes and border patrols, walking days across deserts, leaving villages to become lost and anonymous in strange cities—always strikes me as extraordinary: in the Mission, these two different cosmologies coexist, and often both are called Latino as though the geographical particulars don't matter. Adriana Camarena, herself an immigrant from Mexico City now living in the neighborhood of this map, investigated both populations, finding stories of stasis and displacement, hope and loss, gang life and economic hardship. The decision to abut Cesar Chavez Street with the Mexican border was mine. Leaving out the gentrified Mission of restaurants and boutiques, so visible on Google maps, leaving out retail life altogether, was one of the pleasures of making this version of the place. CARTOGRAPHY: SHIZUE SEIGEL ∞ MAP APPEARS ON PAGES 92–93

THE GEOGRAPHY OF THE UNSEEN BY ADRIANA CAMARENA

MY CORNER AT 24TH AND FOLSOM

I walk from my home at 24th and Folsom to the men who stand at two corners only four blocks apart in the Mission District: the day laborers at South Van Ness and Cesar Chavez Street, and the gang guys at Shotwell and 24th.

Being a light-skinned Mexican national with a PhD from a U.S. university who migrated into a Mission apartment with cheap rent, I am arguably closer to the culture of the white bohemian radicals and young hipsters of the Mission—the latter fueled by expensive organic coffee and cheap burritos—than to that of the day laborers from an imagined Macondo or the gang guys posting on the block. In recent years, cafés have gained ground on local shop space in the Mission, providing sanctuary spaces for the hipsters. When I look into the cafés, I see the hip sip liberally on Fair Trade roasts, while their laptop screens suction their brains into the ether-web. Concurrently, the other Mission residents bobble past the café windows, towing their children like cannons. I bobble on toward the cornerlands.

DAY LABORERS–JORNALEROS

On Cesar Chavez Street and onto Bayshore Boulevard, day laborers line the walls. They wait every day for *el patrón* (the boss) to arrive. There are many empty metered parking spaces where drivers seeking to pick up labor can quickly and discreetly pull over, inquire about particular skills, negotiate a fee (or not), and take off with one or more human beings in their vehicles.

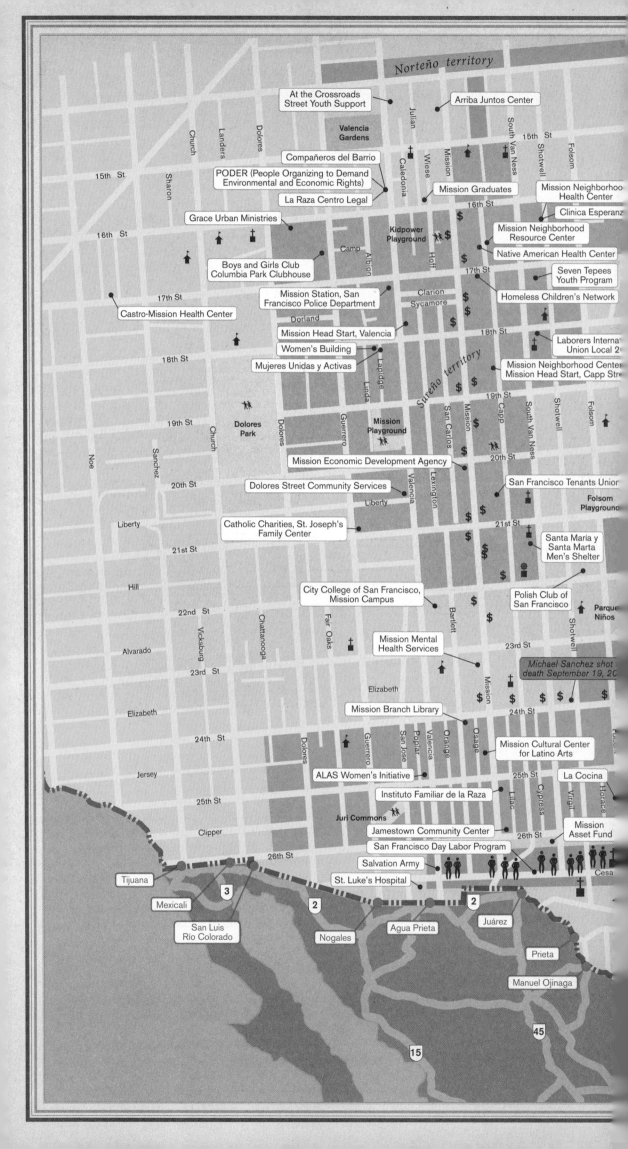

THE MISSION

NORTH OF HOME, SOUTH OF SAFE

14th St

15th St

Girl Source

St. Martin de Porres House of Hospitality

16th St

Franklin Square

17th St

Horizons Unlimited

Mariposa

Homeless Prenatal Program

18th St

Bike Kitchen

Mission Language and Vocational School

Latino Cuisine Culinary Academy

Florida Street Café (training site)

101

21st St

Norteño territory

Mission Recreation Center

22nd St

22nd St

San Francisco General Hospital

23rd St

Francisco Peña and Francisco Cornejo murdered September 20, 2009

Mission Girls Services

El Tecolote

24th and York Mini Park

24th St

Good Samaritan Family Resource Center

Galería de La Raza

Santa Ana Men's Shelter

Central American Resource Center (CARECEN)

La Raza Park (Potrero del Sol Park)

Teenage Pregnancy and Parenting Project (TAPP)

Rolph Playground

Precita Valley Community Center

Bayshore Blvd

Florida, Bryant, York, Hampshire, Potrero, Alabama, Florida, Bryant, Utah

57

Piedras Negras

Nuevo Laredo

Reynosa

Matamoros

"Communities are made by people who go through the same situations. They bond through the same struggles. It's about the people you grow up with and the place in which you feel comfortable. . . . I kinda want to be here forever, in the Mission. It is sunny sometimes, the warmest place in the city. I do want to go to other countries to help people. I do want to travel. I like learning in order to satisfy that hunger within myself. I also want to work with homeless people, and poverty—with something we can fix."
—ELSA, age nineteen, City College student, born at San Francisco General to Mexican nationals

"The Mission—this madness—there weren't gangs like this when I was growing up. It was just about neighborhoods. You had Shotwell and 24th; Capp to Mission on 24th; Precita Park; Little Time Mission, which were the junior high kids; and Mission, which were the older guys; Happy Homes on 20th and Mission; 22nd Hogs; York and Hampshire at 24th. . . . Sure, we'd have fights, but we used to play each other in football. It was more a sports thing. It was friendly but physical. After the game, we'd drink together. . . . These days, people don't fight, they shoot. It's silly."
—FRANK PEÑA, age forty-one, Mission homie, born in 1968 at San Francisco General to Nicaraguan nationals, died at the same hospital in 2009

"It's like the story: A Gringo goes to a town and asks an Indio, 'Hey, Indio, do you know how to get to this street?' The Indio says, 'No, mister, I don't know.' The Gringo insults him, 'Hey, stupid ignorant Indio, how can you not know?' The Indio responds, 'Hey, mister, I may not know where I am, but I never get lost.'"
—SILVANO, age fifty-two, day laborer from Durango, Mexico

Community service

Mexican city

Border

South of the border

Sureño territory*

Norteño territory*

Public housing

Park

Day laborer site

Remittance shop

Child development center or playground

School

Church

Temple

* Source: Gang Task Force, Special Investigations Division, San Francisco Police Department

At the intersection of Cesar Chavez and South Van Ness Avenue, I met four Mexican workers who shared their stories with me. On the street, the men call each other by their place of origin. I call them by their names, but if I miss them, I might ask for El Chilango, Puebla, Durango, and Guadalajara.

MARCOS—EL CHILANGO

Marcos is a Chilango—a citizen of Mexico City—just like me, though not truly the same as me, since he is from a jumbled metropolitan outskirt of *la capital* called Ecatepec, and I am from an overly gentrified residential Art Deco quarter called La Condesa (The Countess). He is a *moreno* (dark-skinned), and I am a *güerita* (light-skinned). Together we draw a pigmentocratic caricature of the worker and the bourgeois of Mexico. He is my friend.

The *jornaleros* on the corner remind me of *ruleteros*—the word comes from *ruleta* (roulette), a slang name for cabbies in Mexico who draw the luck of the day. One slow day at the corner, I tell Marcos, "I love playing lotería. When I am in Mexico, I play the Mexican National Lottery, and I play Lotto here." Marcos responds that he used to play bingo with the old folks at 18th and Capp. "Once I won the big two-hundred-fifty-dollar bingo prize, and with that I bought my daughter's *quinceañera* dress."

Marcos last went to Mexico at the end of 2004 for his daughter's fifteenth birthday celebration. By May 2005, he had begun crossing the border again. "One of the times I got caught on that trip was June 14, my birthday. I got searched and my ID was pulled out. A border patrol guard took it and then huddled with his colleagues, and they all came back to sing me 'Las mañanitas' [the traditional Mexican happy birthday song]." I ask Marcos how he felt. "It made me feel good, that they cared."

On my last trip to Mexico City, I met his wife and daughters, along with the grandson Marcos has not yet met, in an underground tunnel of the Metro. I was their mule. I carried back letters, photos, and medicine for Marcos's bum soccer knee.

Marcos plays soccer on the cement field near 19th and Valencia, where he continues to bust his bad knee.

HUGO—PUEBLA

Hugo is reserved: a loner, a cowboy. I call him El Ranchero. He has the stamp of a young country gentleman. He never crowds around or joins in mocking others, including me. Hugo stands well at the parking meter—legs apart, back straight. He looks sturdy, physical, with good moral character. His clothes are clean. Hugo is a competent worker. "I know how to pour cement, do roofing, shingling, chimneys, painting, construction, carpentry, window sealing, gardening, everything."

He is from a ranching family in Puebla. "We own and work several hectares of land in Puebla. I have cattle, swine, turkeys, goats, dogs, chickens. I sow lettuce, carrots, potatoes, apples, corn, peaches, alfalfa." Despite his family's holdings, he comes to San Francisco, where he finds the fog beautiful, to increase his savings. At twenty-eight years of age, he is the youngest son in the family, but he is not interested in settling down with a wife yet. "I tell my mother, 'Don't worry. . . . If I die, let the nephews have my share.'"

El Ranchero migrates between Puebla and San Francisco. He last came back in 2009, crossing the border from the municipality of Altar, Sonora, into Arizona. "There are many places to cross around there. Wherever the drugs cross, people cross." He prefers to cross alone with a gallon of water and some fruits and vegetables. For him, it is an affair of two days and two nights.

He describes the desert for me. "It is hell. Corpses lying everywhere, skeletons hanging off of trees." I ask who dies in the desert. "The city folk. Many start out in a bad way, already hungry and dehydrated. They head straight to the canyons, as if intent on dying."

I ask who comes. "This is like a thread. A friend or family member tells you there is work here. They pull you in, and you pull in the next guy, and the next guy pulls in the next one. It's a thread that winds onto itself."

Hugo rents a room near Mission and 19th for $250 a month. He likes to hang out in the parks near La Rusia (Russia Avenue, in the Excelsior District) or walk to Dolores Park sometimes.

I've been invited to visit his ranch. "I'll pick you up at the bus depot, just as friends." One morning he calls my cell phone, saying that it could be a good day to take that walk up Bernal Heights. Another day and then another, he offers to treat me to a coffee down the street. These invitations throw me off. This is the borderland called friendship between women and men. I decline his invitations, and for a long time afterward Hugo avoids me.

Then one day he calls again and invites me out to coffee, "just as friends." I accept. I finally understand that this competent young man wants to be seen as someone and not just another body on Cesar Chavez and Van Ness.

SILVANO—DURANGO

Silvano is fifty-two years old and a twenty-seven-year veteran of migrant day labor. Philosophically inclined, he quotes popular wisdom for every situation we talk about. He ponders the existential questions of his life, beginning with why his wife won't have more sex with him. He yearns for things lost and never had: youth, love, home, safety, and acknowledgment.

I ask how he became a migrant laborer, when he is so attached to home. "Well," he lets go a long sigh, "you see, I am a slave to sex. After about eight years of being married, my wife and I stopped understanding each other. She suggested that perhaps I should start selling clothes in the city [Durango]. I began working weekdays in the city and returning home on weekends, in the hope that things would be better between us. After a while, my wife suggested again that perhaps I should go find my brother in the U.S."

Silvano first crossed in 1982. After a stint in L.A., he lived and worked in Miami with his brother for fifteen years, and even got a green card. In 2000, he moved out to San Francisco and worked at the Divisadero car wash for six years.

With migrant wages, Silvano built a house in Durango and put his three daughters through college. But despite his efforts to establish a home in Mexico, he had been back for barely six months in 2008 when they ran out of money. Tension rose between him and his wife. "No money, no honey!" he exclaims in English. "*Sin dinero, no hay amor,*" he repeats in Spanish. After a pause, he adds, "Woman and horse suffer from neglect" (*A la mujer y al caballo les hace daño el olvido*).

Silvano lives on the streets of the Mission, tucked in between cars and curbs. I ask what street he sleeps on. He shrugs his shoulders and says, "It's like the story: A Gringo goes to a town and asks an Indio, 'Hey, Indio, do you know how to get to this street?' The Indio says, 'No, mister, I don't know.' The Gringo insults him, 'Hey, stupid ignorant Indio, how can you not know?' The Indio responds, 'Hey, mister, I may not know where I am, but I never get lost.'"

I stopped finding Silvano after November 2009. I ask Marcos about him. He raises his eyebrows. "Ah, you don't know what happened. I think he went back home. . . . One day, we were out here—you know me—I was sitting by the wall. That day I was wearing my Cruz Azul cap. Durango, he always wore his blue t-shirt, and there was another guy wearing blue jeans. A car drove by, and some guys shot at us, some local *cholitos*. After that, I didn't see Durango again."

EL CABE—GUADALAJARA

El Cabe is a thirty-two-year-old man from Guadalajara who can make his way into any place, any time, anyhow for the purpose of stealing; hence his nickname, "El Cabe," from the verb *caber*, "to fit." He says his real name is Jorge, but he has used other aliases before. El Cabe had twelve *caídas* (falls) with the border patrol near Tijuana, in which he was booked variously as Pedro Infante and José Alfredo Jiménez—names of famed Mexican ranchero singers—and also as Arnold Schwarzenegger and Steven Seagal. This was over a period of several weeks in 1994, when he was being paid by *coyotes* to be caught by the border patrol—he was a *conejo* (rabbit) or *corredor* (runner). The distraction caused by these rabbits allows the coyotes to pass their clients through La Línea.

El Cabe tells many stories. His last crossing starts on Cinco de Mayo of 2009, through a tunnel that exits at the back of a hospital in Arizona. "Everyone walks in silence through the tunnel in the dark. Mothers with children, men carrying bundles of drugs, single men like myself. There is pestilence, there are dead dogs, and corpses." On the other side, he is confronted by mystical obstacles in the desert, but El Cabe beats death and crosses over.

When I met El Cabe, he had been standing for two weeks on Cesar Chavez Street, looking for work. He slept at the Santa María y Santa Marta Men's Shelter at 1050 South Van Ness Avenue, took his breakfast at St. Anthony of Padua Church (Cesar Chavez between Shotwell and Folsom), and ate his dinner at St. Martin de Porres House of Hospitality at 225 Potrero.

I spend Memorial Day sitting on the sidewalk listening to his storytelling. As the sun begins to set on Cesar Chavez Street, I ask El Cabe for one more story.

"Do you know who Cesar Chavez was?" Without hesitation, he announces: "I'm going to tell you the story of Cesar Chavez. Cesar Chavez was a crop picker just like many of us. In those times, *los patrones* wouldn't let you have water while working in the fields. You would get beaten if you drank water while on the job. It was after *la jornada* (the workday) was over that you would be allowed to drink water. Cesar Chavez brought his son to work in the strawberry fields with him. In those times, children also worked the fields. The boy saw a puddle of water in the middle of the field, and just like you or I would do now, he dove for the water. As he was drinking, the foreman saw him and meant to fire a warning shot to scare him, but instead he hit the kid square on

the head. That is how Cesar Chavez began. After that, he began organizing workers and created every labor law existing to protect migrant farmworkers."

I nod at this wonderful oral history: the Legend of Cesar Chavez, as told on Cesar Chavez Street by El Cabe. El Cabe is a trickster, but he just may also be one of the great contemporary troubadours of migrant lore.

I have not seen El Cabe since that day. Silvano says he came around another day, dressed as a *cholo* (a Chicano gang guy).

GANGS

Frank remembers how it used to be. "The Mission—this madness—there weren't gangs like this when I was growing up. It was just about neighborhoods. You had Shotwell and 24th; Capp to Mission on 24th; Precita Park; Little Time Mission, which were the junior high kids; and Mission, which were the older guys; Happy Homes on 20th and Mission; 22nd Hogs; York and Hampshire at 24th. . . . Sure, we'd have fights, but we used to play each other in football. It was more a sports thing. It was friendly but physical. After the game, we'd drink together. . . . These days, people don't fight, they shoot. It's silly."

Today, the Norteños claim territory roughly between Mission Street and Potrero, from 20th to 26th, with an extension to just past Dolores on 24th, 25th and 26th streets. To the north, the Sureños carved out a niche for themselves approximately between Dolores and South Van Ness, from 16th Street to 22nd Street, with an extension to Potrero Street (Jackson Park) on 16th and 17th. In the Mission, the Sureños joined forces with the MS-13, a Central American gang, to increase their land holding. On a map, Sureño territory is north of Norteño territory. The magnetic poles are inverted in ganglands.

I meet Smiley and Luis over at Bernal Dwellings, low-income housing on 26th and Folsom, near Garfield Park. This is a multicultural enclave of black, Asian, and Latino families. I ask if there are gangs on those public housing blocks. Smiley and Luis shake their heads: "We won't allow it." Nonetheless, Luis points out some scratchings on the sidewalk that say "XVIII" for 18th Street. The 18th Street Gang arose from the streets of Pico Union in L.A. This scratching is a critical clue to the history of Sureños and Norteños, now the dominant Mission gangs. Smiley remembers that there used to be only "the Mexicans," without distinctions, but the Mission gangs changed because the prison gangs changed.

In the beginning, there was a powerful prison gang known as the Mexican Mafia, whose members originally came from L.A. The gang consolidated in the 1950s within the California prison system. With the articulation of Chicano pride, the Mexican Mafia became "La eMe" (*eme* is Spanish for the letter m) and picked up, as their symbol, the eagle poised on a nopal from the Mexican flag. The gang also claimed the number 13 (*m* being the thirteenth letter in the alphabet) and the color blue. La eMe protected Mexican prisoners, in exchange for taxing the distribution of drugs, alcohol, weapons, prostitution, and safety. The prison tax systems are not new, but La eMe recomposed the prison power blocs.

In the 1960s, inmates from rural farming areas of Northern California splintered from La eMe and formed Nuestra Familia. Nuestra Familia provided special protection to imprisoned rural northerners, who were allegedly abused by La eMe. However, it is not difficult to imagine that distance contributed to La

eMe losing control of street gangs in rural Northern California. The identity of Nuestra Familia was informed by Cesar Chavez's farmworker movement of the period. Nuestra Familia, or the Norteños, proudly bear the symbol of a sombrero struck by a machete with dripping blood. Their color is red for the blood spilled by workers and their own, and their number is 14 (*n* is the fourteenth letter in the alphabet). In juxtaposition to the Norteños, La eMe became known as the Sureños.

One day, I meet a young man I call Ponytail Boy. He tells me to go away, because he is drinking with his friends near the corner at 24th and Shotwell. We end up comparing the Aztec tattoo on his leg with the Mayan butterfly tattoo on my back. He asks me to tell him more about Aztecs and Mayans. I ask him to explain Norteños.

"Norteños are about Latin American pride, about the workers, about Northern Mexicans. The Norteños originated as the bodyguards of Cesar Chavez." He explains that they started out as protectors of immigrant workers. "The Originals worked on farms; we respect his cause, believe in his cause. That's how we connect. When you go to prison, you'll be asked, 'Are you with the Cause?' It's 'family over everything.' . . .

"In jail, it's like a military regime; we are all soldiers. The upper ranks insist we represent our culture well: educate ourselves, do exercise, read and learn about the Aztecs and the workers, represent for those who don't know about our culture. When the gang goes negative, the higher ranks expect you to be positive."

In the 1970s, with the rise of the cocaine and heroin trade in Mexico, La eMe took its profitable jail business to the streets by working through parolees. La eMe negotiated with existing street gangs—such as the 11th Street Gang (browns) and the 18th Street Gang—to join in an extended tax system, whereby street gangs were given monopoly rights over their territory in exchange for fairly priced and steady drug supplies. La eMe received a kickback from sales. The novelty is the reach of gang generals from the prison cell to the street corner to across the border, an amazing triple feat of intrepid capitalism, military discipline, and identity construction. Today, the prison system has spilled over, and now San Quentin and Pelican Bay inmates control franchises on a street corner near you.

The tremendous flow of young people into the juvenile justice system in California also means that juvie jails are training grounds for gang life. Public schools are the site for first initiations. In neighborhoods such as the Mission, a kid will be "checked" on the street as early as elementary school and asked to claim a gang. Children have died on Mission streets as a result of mistaken identity. Carlos, now nineteen years old, witnessed his best friend gunned down next to him at the age of eleven for wearing the wrong color clothes, in a little alley near 19th and Valencia.

24TH AND SHOTWELL: GANG ADDICTION

Frank Peña says he will always be a Shotwell boy. I met Frank because the gang kids congregate around his front stoop, close to the corner of 24th and Shotwell. He gives them a place to talk, just like once upon a time older guys gave him safe haven on their front stoop and knocked his head about to get some street smarts into him. Open, friendly, and curious, he invited me back to talk on a Sunday about what his life in the Mission had been like.

I sit with Frank and his friend Cisco in the living room of his apartment to watch a pre-season game, Chicago versus Denver. Frank is uncomfortable with me asking how he got in the gangs, but he finally relents: "Just the crowd you hang out with. Just like in school. You had your geeks, smart people . . . just the people you hang out with." For Frank, gangs are about "respect for your fellow Latinos, respect for your neighbors, but bigger like that. . . . Kids who get mistreated at home reach out to their friends. We always did stuff together."

Frank started cutting classes in high school and "getting high on powder" with his crew. "Around 1986, crack got me real bad. . . ."

I ask Frank, "Do you think gangs are related to poverty?"

"When both parents work, what's the kid going to do? As Latinos, both parents are working. And one or two of the kids are going to start hanging out. My mom, she was up at three or four A.M. and wouldn't come back until three or four P.M. I would get home, and there'd be nobody here. I went to the streets. If you go talking to people in the Mission, I guarantee a lot of parents are going to say that it's the same for them."

Cisco, who has been quiet all along, interjects, "It wasn't like that for me."

"What do you mean?" I inquire.

"My mom was on drugs. My dad worked. I would just go to friends' houses."

Frank's and Cisco's stories are repeated in younger generations today. Carlos and Elsa (also nineteen years old)—whom I met at the Seven Tepees after-school program—share their experience with me.

When he was in eighth grade, Carlos got into drugs and drinking by hanging out with gang kids, some of them family members. His drug consumption increased, his grades declined, and he began to steal to buy drugs. He attended three days of his freshman year of high school.

"I would get home, and I would be alone. I lived with my auntie, but she had her own dilemmas. She had two kids, and my uncle is an alcoholic. . . . My mom used to be an alcoholic, but she has now been sober for six months, just like me. . . . The majority of my family are immigrants working double shifts. I barely saw my mom. . . . I once went with her to the Avenues and saw people riding bikes and driving fancy cars like there was no care in the world."

Elsa's teenage sisters are perilously close to the experiences of Carlos and Frank. "They like the excitement of the streets. My parents suffer a lot from it. In the last two years, it's gotten worse. Sometimes they don't come home; they stay out. I go out looking for them. I accompany my mom, because I am afraid that something might happen to her, that she might faint, and there would be no one to help her." Her sisters have been checked at knifepoint, to force them to claim a gang, but so far they've managed to run away.

Elsa gives me further insight into the life of working-class families in the Mission. For most of her life, her Mexican parents worked as housecleaners. Today her dad is incapacitated with diabetes and requires daily dialysis. Her mom works as a caretaker for an elderly woman and still cleans houses on the weekends. "If you think about it, kids' parents are busy working. They can't be there for guidance, to tell their kids what to do and what not to do. My mom took me to clean houses so I would know what it was like. . . . Nobody should clean any houses but their own."

From 1991 to 1993, Frank left the Mission to live with his sister in Phila-delphia, hoping he could get his addiction under control. After relapsing into drugs and getting assaulted on the street, he returned to the Mission. He tried several programs, but it was the Salvation Army on Valencia and Cesar Chavez that helped him. "It hit a switch in here, and I couldn't do it no more."

Frank went back to the neighborhood and started hanging out with the homies, doing illegal stuff but not getting high. "We had stuff under control. Different neighborhoods couldn't come through. That's the Mission, since we've been born. For me, it was a step up, selling drugs but not doing drugs."

Like all homies who know something about the gang business, Frank won't speak about it. In 1999, Frank got arrested for drug dealing and was sent to prison at Susanville. He was released in 2000. For two years after that, all Frank did was work and go home, work and go home.

"I had three years of parole to cover. One afternoon, after I come home from work, I stop to talk to my neighbors, who are sitting on their front stoop. Cops arrive and jump out of a car. I recognize one of them. . . . I knew, I knew, they were going to mess with me. They check me, call my parole officer. My parole officer tells them I'm okay. They had already given me back my ID, when one of the cops comes back and arrests me for 'hanging out with gang members' and breaking the terms of my parole. I was just saying hello to my neighbors, not even hanging out!"

Frank went back for six more months.

Victor, over by 22nd and Harrison, tells me he has been in and out of jail six times for "petty shit"—he is only twenty-one. He is tired of the harassment. He held down a job in Daly City, as a waiter serving sushi. When I went looking for him again, his brother told me Victor was back in prison. They had returned from a 49ers game and were hanging outside their building when a neigh-bor called the cops on them because she saw Victor wearing the color red (a 49ers t-shirt). The cops arrested him for breaking the terms of his parole. That cements a young man's life in the gang system and as a second-class citizen.

Frank tells me about another friend on parole. He is restricted from hang-ing out with gang members. "He can't even have a burrito on 24th Street with-out the risk of getting arrested."

"Can you ever leave a gang?"

"I'll never stop being part of a gang in the cops' eyes. . . . In my own eyes, this is my neighborhood. If I see a friend getting beat up at the corner, I'll get in it, but I am not going to get in the car and go find some guy. . . . Even if you let it go, you always going to have that little title from back in the days. . . . When I go out on the street, I have to be aware. Maybe you're just going down the street and a car passes by, and you say, 'Here we go,' and they jump out on you. But it's not like before, when it's all about me. Now, got to think about them: her and him. It's a beautiful thing . . ."

During his telling, Frank's partner—M—comes in from the street with their baby. Frank immediately takes his son and places him on a Giants' fleece blan-ket on the floor. His heavily tattooed arms belie the parental expertise with which he changes a diaper. Little Frank is a happy, healthy, and handsome six-month-old child. Frank and M met five years ago at the Thirsty Bear club,

down by Howard and 3rd. They've been together ever since. Frank is putting M through nursing school. Frank now works a daily shift delivering electronic equipment around the city in a van.

"I got my van, I got my music. That is all I need." Frank is an affectionate son, father, and partner. He says of his son, "I want the very best for him. I don't want him to join a gang."

THE FELLOWSHIPS OF A WORKING-CLASS COMMUNITY

Elsa's parents tell her to go to school and get a job, but they don't have time to help her figure out what that means. Nonetheless she had help.

"I had a lot of positive images, so I didn't turn to drugs or violence or gangs. I like seeing all the programs in the neighborhood like the Boys and Girls Club, Seven Tepees, afterschool programs at Everett and Marshall, PODER [People Organizing to Demand Environmental and Economic Rights], and H.O.M.E.Y. [Homies Organizing the Mission to Empower Youth]. I got one of my sisters into the Mission Credit Union as a teller, where I used to work. My other sister is working at the Boys and Girls Club. One of my little brothers is in the after-school program at Marshall. I want my other brother to enter Seven Tepees.

"Seven Tepees got me into camping. I river rafted on the American River and went to the salmon lake and the waterfalls near Lake Tahoe. I went to summer camp in Hidden Villa two years ago, and we backpacked from Los Altos to Santa Cruz, a total of sixty miles."

Although Carlos skipped school, he kept showing up at Seven Tepees. Kim at Seven Tepees finally got through to him. She had lived the same life and was able to redirect his attention. Today Carlos is close to graduating with good grades from the Life Learning Academy at Treasure Island, where he holds leadership roles on student boards and as a peer counselor. He responds to his school principal's admonishments by calling her "mother."

My wanderings open my eyes to undiluted poverty in the Mission. Poverty is a calamity, a blight upon the land. That's "the Struggle" that the Mission kids and gang kids talk about, and it's from that experience that their pride about their heritage arises. Their parents are the day laborers, and the migrants, and the second-class citizens. There is no border here. In this country, immigrants and their children pass through a trial by fire of assimilation, which keeps them close to street culture and marginal to mainstream culture, until miraculously one of them wiggles through the fence. The Struggle is about not being there for your kids because you are out working to feed them, or because you are afflicted with a terrible addiction. The Struggle is relying on neighbors and friends and well-intentioned volunteers to step in and help out. The Mission kids have seen the Struggle of the working-class immigrant families.

This is community, and Elsa, now in her first year at City College of San Francisco, explains it best to me: "Communities are made by people who go through the same situations. They bond through the same struggles. It's about the people you grow up with and the place in which you feel comfortable. . . . I kinda want to be here forever, in the Mission. It is sunny sometimes, the warmest place in the city. I do want to go to other countries to help people. I do want to travel. I like learning in order to satisfy that hunger within myself. I also want to work with homeless people, and poverty—with something we can fix."

WHO AM I WHERE? ¿QUIÉN SOY DÓNDE?
A MAP OF CONTINGENT IDENTITIES AND CIRCUMSTANTIAL MEMORIES

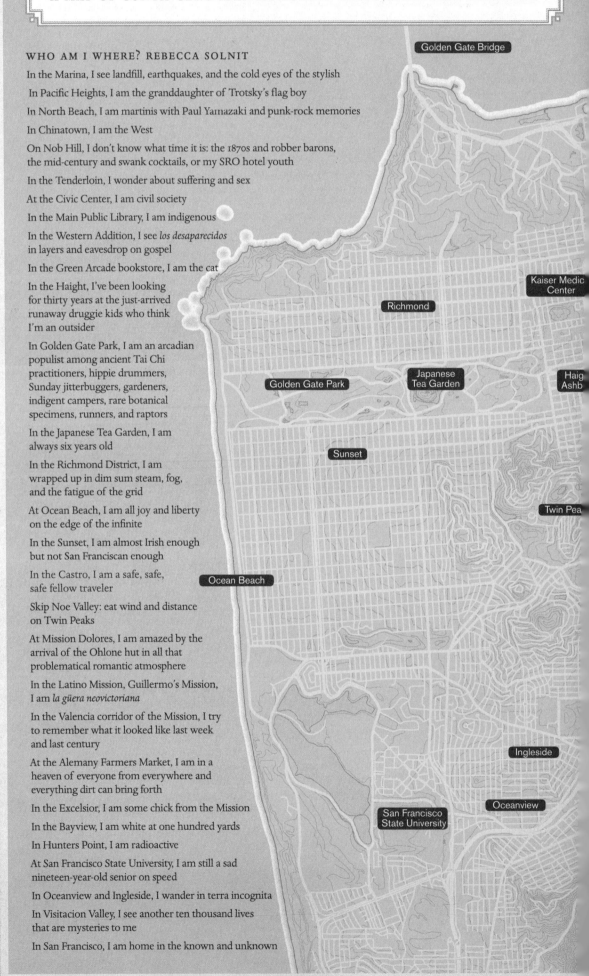

WHO AM I WHERE? REBECCA SOLNIT

In the Marina, I see landfill, earthquakes, and the cold eyes of the stylish

In Pacific Heights, I am the granddaughter of Trotsky's flag boy

In North Beach, I am martinis with Paul Yamazaki and punk-rock memories

In Chinatown, I am the West

On Nob Hill, I don't know what time it is: the 1870s and robber barons, the mid-century and swank cocktails, or my SRO hotel youth

In the Tenderloin, I wonder about suffering and sex

At the Civic Center, I am civil society

In the Main Public Library, I am indigenous

In the Western Addition, I see *los desaparecidos* in layers and eavesdrop on gospel

In the Green Arcade bookstore, I am the cat

In the Haight, I've been looking for thirty years at the just-arrived runaway druggie kids who think I'm an outsider

In Golden Gate Park, I am an arcadian populist among ancient Tai Chi practitioners, hippie drummers, Sunday jitterbuggers, gardeners, indigent campers, rare botanical specimens, runners, and raptors

In the Japanese Tea Garden, I am always six years old

In the Richmond District, I am wrapped up in dim sum steam, fog, and the fatigue of the grid

At Ocean Beach, I am all joy and liberty on the edge of the infinite

In the Sunset, I am almost Irish enough but not San Franciscan enough

In the Castro, I am a safe, safe, safe fellow traveler

Skip Noe Valley: eat wind and distance on Twin Peaks

At Mission Dolores, I am amazed by the arrival of the Ohlone hut in all that problematical romantic atmosphere

In the Latino Mission, Guillermo's Mission, I am *la güera neovictoriana*

In the Valencia corridor of the Mission, I try to remember what it looked like last week and last century

At the Alemany Farmers Market, I am in a heaven of everyone from everywhere and everything dirt can bring forth

In the Excelsior, I am some chick from the Mission

In the Bayview, I am white at one hundred yards

In Hunters Point, I am radioactive

At San Francisco State University, I am still a sad nineteen-year-old senior on speed

In Oceanview and Ingleside, I wander in terra incognita

In Visitacion Valley, I see another ten thousand lives that are mysteries to me

In San Francisco, I am home in the known and unknown

Golden Gate Bridge

Kaiser Medic Center

Richmond

Japanese Tea Garden

Haig Ashb

Golden Gate Park

Sunset

Twin Pea

Ocean Beach

Ingleside

Oceanview

San Francisco State University

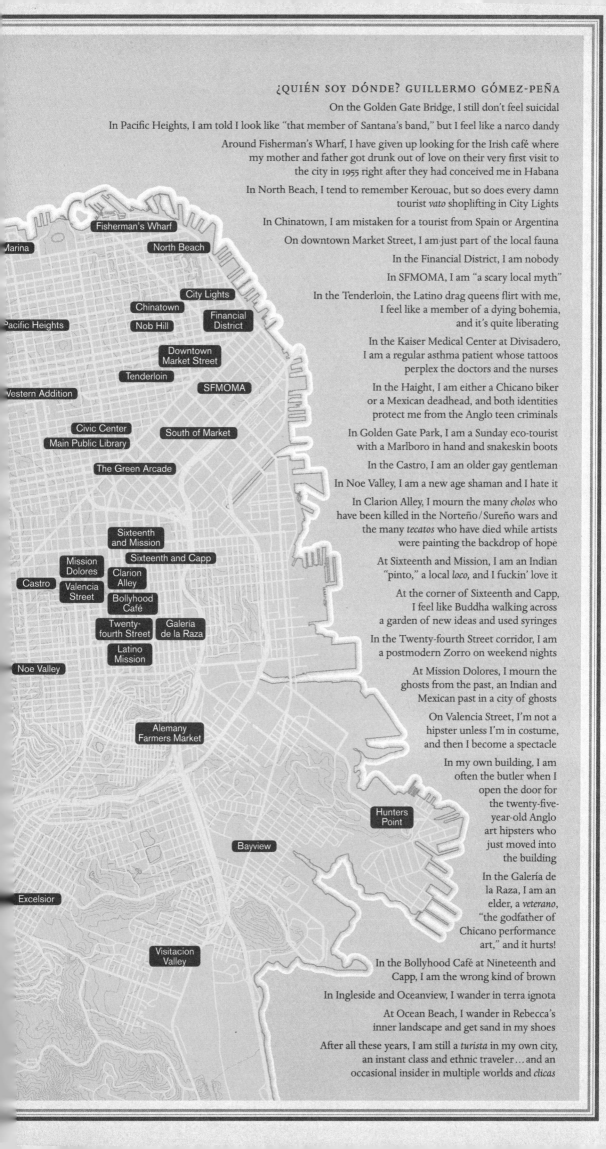

¿QUIÉN SOY DÓNDE? GUILLERMO GÓMEZ-PEÑA

On the Golden Gate Bridge, I still don't feel suicidal

In Pacific Heights, I am told I look like "that member of Santana's band," but I feel like a narco dandy

Around Fisherman's Wharf, I have given up looking for the Irish café where my mother and father got drunk out of love on their very first visit to the city in 1955 right after they had conceived me in Habana

In North Beach, I tend to remember Kerouac, but so does every damn tourist *vato* shoplifting in City Lights

In Chinatown, I am mistaken for a tourist from Spain or Argentina

On downtown Market Street, I am just part of the local fauna

In the Financial District, I am nobody

In SFMOMA, I am "a scary local myth"

In the Tenderloin, the Latino drag queens flirt with me, I feel like a member of a dying bohemia, and it's quite liberating

In the Kaiser Medical Center at Divisadero, I am a regular asthma patient whose tattoos perplex the doctors and the nurses

In the Haight, I am either a Chicano biker or a Mexican deadhead, and both identities protect me from the Anglo teen criminals

In Golden Gate Park, I am a Sunday eco-tourist with a Marlboro in hand and snakeskin boots

In the Castro, I am an older gay gentleman

In Noe Valley, I am a new age shaman and I hate it

In Clarion Alley, I mourn the many *cholos* who have been killed in the Norteño / Sureño wars and the many *tecatos* who have died while artists were painting the backdrop of hope

At Sixteenth and Mission, I am an Indian "pinto," a local *loco,* and I fuckin' love it

At the corner of Sixteenth and Capp, I feel like Buddha walking across a garden of new ideas and used syringes

In the Twenty-fourth Street corridor, I am a postmodern Zorro on weekend nights

At Mission Dolores, I mourn the ghosts from the past, an Indian and Mexican past in a city of ghosts

On Valencia Street, I'm not a hipster unless I'm in costume, and then I become a spectacle

In my own building, I am often the butler when I open the door for the twenty-five-year-old Anglo art hipsters who just moved into the building

In the Galería de la Raza, I am an elder, a *veterano,* "the godfather of Chicano performance art," and it hurts!

In the Bollyhood Café at Nineteenth and Capp, I am the wrong kind of brown

In Ingleside and Oceanview, I wander in terra ignota

At Ocean Beach, I wander in Rebecca's inner landscape and get sand in my shoes

After all these years, I am still a *turista* in my own city, an instant class and ethnic traveler…and an occasional insider in multiple worlds and *clicas*

All gang kids of working age that I talked to are holding down jobs: construction workers, union members, waiters, social workers, painters, barbers, janitors—all living the dream of surviving the Mission, getting a better job, moving out, and in their maturity coming back to check up on the "little kids."

DÍA DE LOS MUERTOS

Frank was born in San Francisco General Hospital on February 3, 1968, and died there on September 22, 2009. He and Cisco were allegedly shot by Andres Siordia, a nineteen-year-old kid, accompanied by an unnamed sixteen-year-old, at the Potrero Papa's Pizzeria on 24th and Potrero. The *San Francisco Chronicle* quoted the cops, who stated that the killings were about gang retaliation. It was, and it wasn't. This was not about Frank and Cisco. This was about a corner. Their death was retaliation against the clique at Shotwell and 24th.

Several days earlier, one of Andres's friends—Michael Sanchez—was killed at 24th and Shotwell. At the time, Frank was in his apartment watching a movie with M, while their baby slept under his grandmother's watchful eye.

The bereaved gang kids down by Hampshire and 24th struck back. When Frank and Cisco stepped into their territory to get pizza, these beloved older homies—older guys on the fringes of the gang life, yet representative of their block—were taken down. In the weeks after Frank and Cisco died, an altar for them stayed up on the corner of Shotwell and 24th with candles and photos and writings and t-shirts. A DPW (Department of Public Works) yellow vest was placed there by friends and co-workers to memorialize Cisco.

I went to Frank's wake. Next to his open coffin stood a wreath in the shape of a street sign, made of white and red carnations and inscribed with the text "Shotwell 24th." I am sorry for Frank and Cisco, for those who love them, and for the young boys who killed them, who are now in the prison system. Andres Siordia was being raised by his grandmother.

I am grateful to Frank for allowing me into his house and guiding me through a tunnel into home life in the Mission. Inside the tunnel, homies and their families walk unheard: mothers with children, men carrying drugs, and men like Frank and Cisco. There are corpses.

A CONCLUSION ON COLONIZING CORNERS

Relationships modify your landscape. They disrupt your sense of boundaries and personal space. My Mission District is thicker now, and bulges at the seams of previously flat corners.

This book will move the subjects of this essay innumerable latitudes and longitudes and time away from their corners, their communities, and the fullness and complexities of their lives. I make their words travel beyond their capacity to enforce their self-perception and identities. In so doing, I become a corner colonizer. On this paper, the Mission is more mine than theirs.

For my misinterpretations, I might get "checked" next time I pass their corner, but you—the reader—won't. Next time you pass men on a corner and find yourself stricken with great curiosity, you might be emboldened by the thought that you know them better, but you do not. For you must travel that distance on your own ∞

14 WHO AM I WHERE? ¿QUIÉN SOY DÓNDE?

The title of this map is an interrogation—or an invitation to consider your own geographic identity—and a reminder that identity fluctuates on the scale of neighborhoods and individual institutions, not just on the scale of nations and regions. This is also a map of friendships and personal histories, origins and transformations. The subject of geographically contingent identities is one to which Guillermo Gómez-Peña, who coauthored this map project, has devoted much of his work as a writer and performance artist, so he was the ideal collaborator for exploring the notion, as well as a counterpoise to my own gender and ethnicity and near-lifetime here. CARTOGRAPHY: BEN PEASE ∞ MAP APPEARS ON PAGES 102–103

15 TRIBES OF SAN FRANCISCO

Jaime Cortez proposed and created this map of the city's subcultures, whether they are ethnic, historical, occupational, socioeconomic, sexual, age-related, or recreational. The finished product is his homage to the ephemerality and variety of human life in San Francisco, made a little more poignant by the fact that he drew this from Oakland. CARTOGRAPHY: BEN PEASE; ARTWORK: JAIME CORTEZ ∞ MAP APPEARS ON PAGES 106–107

WHO WASHED UP ON THESE SHORES AND WHO THE TIDES TOOK AWAY BY REBECCA SOLNIT

"What feels really beautiful," Jaime Cortez says one afternoon in his musical voice, "is the restlessness of the city. It's a restless organism; individuals are being moved in and out, processed, but this also happens to whole communities. They arrive, arise, fluctuate, diminish. It's very fitting that the city has all around it the restlessness of the ocean, that constant shifting of tide that's echoed in the shifting of populations." Jaime chose to document the tribes of San Francisco in the mode of the great illustrator José Miguel Covarrubias, whose great mid-twentieth-century maps of Mexico, Latin America, and the Pacific were crowded with images of culture, industry, ecology, and entertainment, a playful modernist take on the old maps with natives and sea monsters scattered across their expanses.

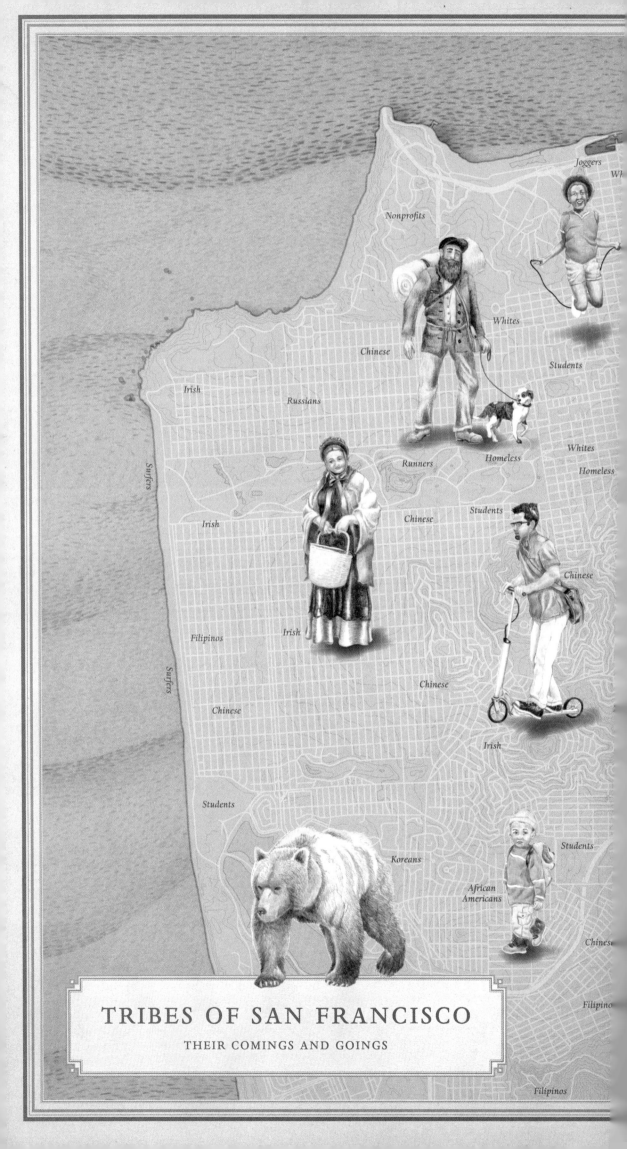

TRIBES OF SAN FRANCISCO

THEIR COMINGS AND GOINGS

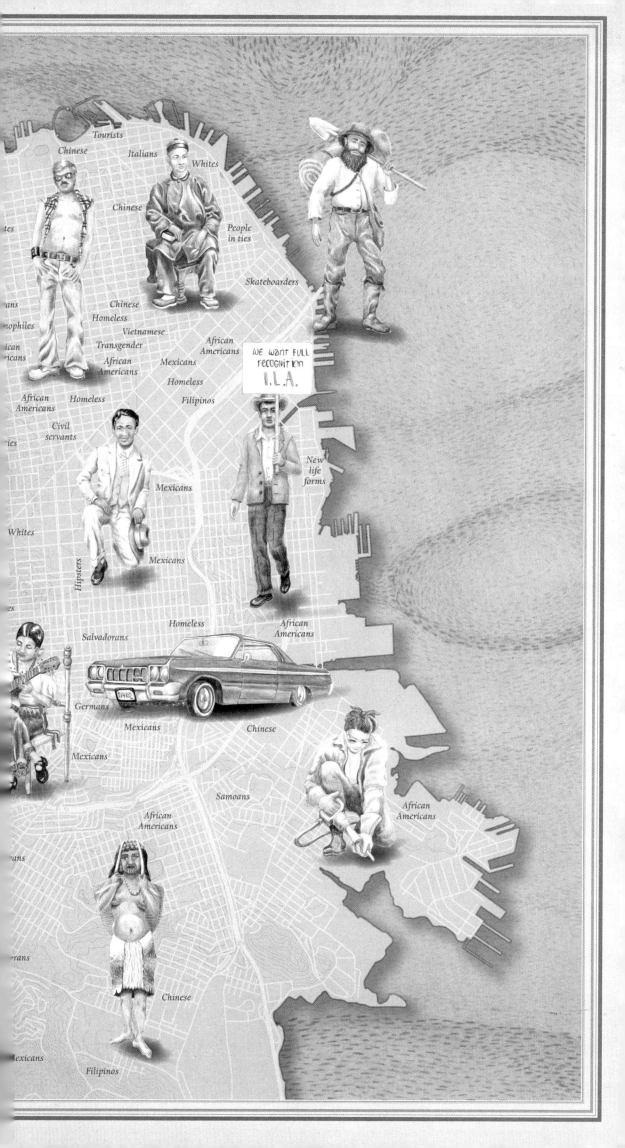

For San Francisco the tribes range from those who arrived with an ethnic identity—a nineteenth-century Irishwoman, a courtly Filipino man—to those who took up roles here—from a striking longshoreman from the 1930s, during the pinnacle of the city's labor history, to a Polk Street hustler in that street's gay male heyday of the 1970s, before the scene moved to the Castro and AIDS and meth otherwise altered the commercial sexual landscape. The male hustler is, Jaime remarks, "a way to name San Francisco as a center of sexual exploration and sexual liberation for a lot of people." And that hustler is also an aspect of one of San Francisco's most consistent economic niches, sex work, from the brutal cribs and elegant bordellos of the Gold Rush to the armies of Internet-based prostitutes and the outliers on the streets today. Other fields of employment—the shipyard welding of Rosie the Riveter, the waterfront work of the longshoreman in Jaime's drawings—have vanished, for this fickle city's economic shift breeds and eradicates types. There's even a dot-commer here, one of the invaders of 1999, smug on his scooter, a latecomer brother to the gold miner. Jaime remarked, "I wanted to situate the dot-com character within the history of San Francisco booms and busts, the kind of money fever that afflicts San Francisco whether that's a gold rush or real-estate boom or the whole bioengineering boom."

Some tribes came and went; other groups stayed in place while their status and style changed—Jaime points out that the Chinese went from a hated outside group against whom much legislation was passed and some violence brought to bear to a "model minority." The Californios—as represented by the woman with the guitar—ruled the state until 1848 and never went away but became invisible, unseen during the eras when Latinos were imagined as immigrants. Invisible but not inaudible, since they exist every time we say Noe, Bernal, Castro, Potrero. Even the low-riders of the 1970s Mission were driven out by legislation, though cars and riders still survive in various ways. The Ohlone were here first and are here still, often forgotten, but not gone.

Others are immortal: in Cortez's rendering to the left, Emperor Norton (the self-proclaimed Emperor of the United States and Protector of Mexico who wandered the streets and lived off kindness in the decades before his death in 1880) stands in for one San Francisco subspecies with a thousand faces: the crazies. And Jaime recalls "the mysterious Red Man of the Mission, with his red clothes and red painted face, seen around Sixteenth and Valencia for years before he mysteriously disappeared, or just took off his makeup and went civilian," as do I.

But the most poignant and unexpected of the threatened species in this map of tribes is that of children. In 2005, the *New York Times* reported, "San Francisco ... had the lowest percentage of people under 18 of any large city in the nation, 14.5 percent, compared with 25.7 percent nationwide, the 2000 census reported. Officials say that the very things that attract people who revitalize a city ... are driving out children by making the neighborhoods too expensive for young families." The brown-skinned boy with the knapsack could just be going to school but looks like he's setting off on an exodus in a city where everyone arrives, departs, mutates, self-liberates, and is erased or extinguished, each a drop of life in a city whose citizens wash over it like crashing tides ∞

16 DEATH AND BEAUTY

Every January, the *San Francisco Chronicle* publishes a map of the previous year's murders, from which it is clear that violent death has a geography—a sort of Milky Way of murders spreads across the east side of town, while only a few are scattered across the west side. It's not a widely observed divide, but measured in murders it's a clear one. To counterbalance and complicate this mapping of death, I considered many things and settled on beauty, before I realized how complicated a question beauty is—what is it, who has it, how do you map it?

Eventually I chose Monterey cypress trees, which, in contrast to the swath of murders, are all over San Francisco, as monumental in McLaren Park (in the city's southeast) as they are at Lands End and the Presidio. The species is a local one, found naturally only on the central California coast—thus the *Monterey* in its name. It has been propagated widely—so widely in San Francisco that it seems like the city tree, visible in dramatic silhouette from great distances on the crests of hilltop parks and ridgelines, with its strong trunk and jagged dark crown of evergreen foliage. There are about seven hundred thousand trees of all species in San Francisco (and a little over eight hundred thousand people). It was the calmness of this parallel population of trees, their stable, silent lives, that made them the right counterweight to violent death. CARTOGRAPHY: SHIZUE SEIGEL; PHOTOGRAPHS: JIM HERRINGTON ∞ MAP APPEARS ON PAGES 110–111

RED SINKING, GREEN SOARING BY SUMMER BRENNER

> *It is difficult*
> *to get the news from poems*
> *yet men die miserably every day*
> *for lack*
> *of what is found there.*

WILLIAM CARLOS WILLIAMS, "ASPHODEL, THAT GREENY FLOWER"

In 2008, there were six thousand twenty-five deaths in San Francisco—some painful and untimely, many caused by aging and disease, others accidental. In most cases, there were reasons, an etiology, an explanation that possibly offered solace to the bereaved.

Murder rarely offers solace. Murder is the ultimate crime, not the first or

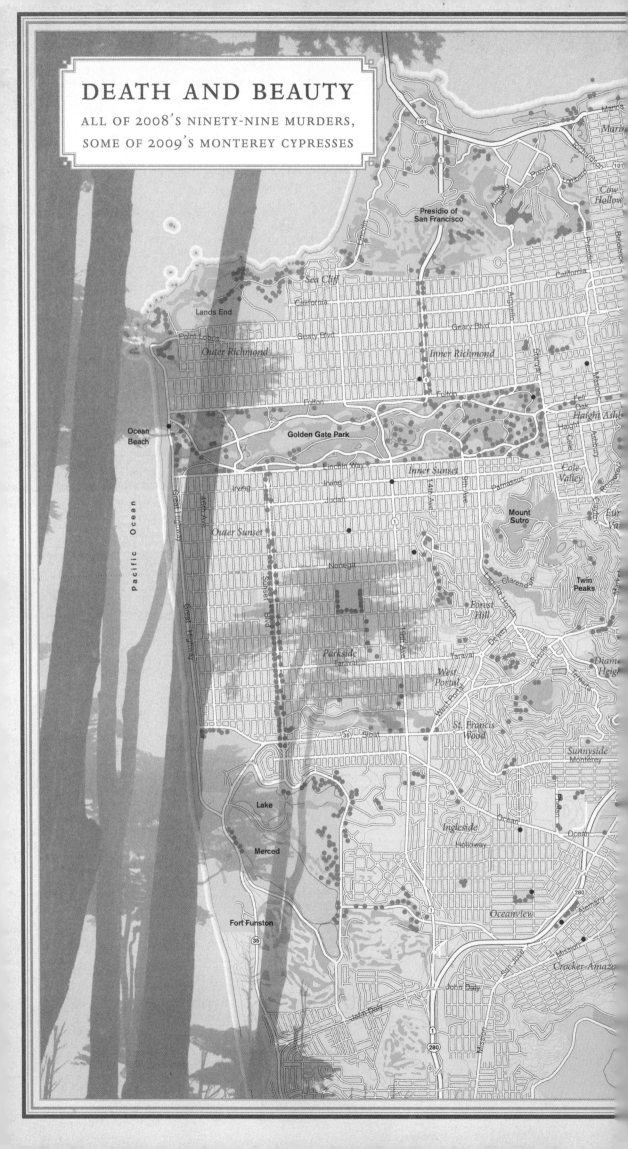

DEATH AND BEAUTY

ALL OF 2008'S NINETY-NINE MURDERS,
SOME OF 2009'S MONTEREY CYPRESSES

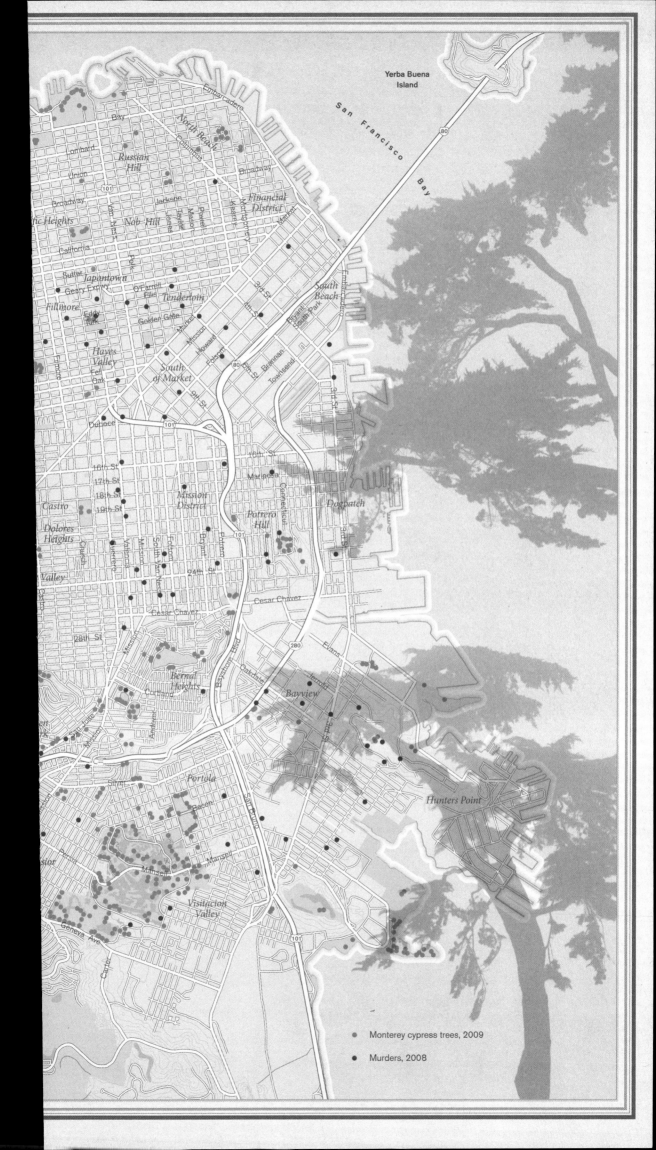

Yerba Buena
Island

San Francisco Bay

Embarcadero

Bay

North Beach

Columbus

Russian
Hill

Lombard

Union

Broadway

Broadway

Jackson

Van Ness

Polk

Mason

Taylor

Keary

Montgomery

Financial
District

Market

ic Heights

Nob Hill

California

Sutter

Japantown

Geary Expwy

O'Farrell

Filli

Tenderloin

South
Beach

Fillmore

Eddy

Turk

Golden Gate

Market

Mission

Howard

Folsom

3rd St

4th St

Bryant

South Park

Brannan

Embarcadero

Townsend

Hayes
Valley

Fell

Oak

South
of Market

9th St

80

5th St

6th St

3rd St

Duboce

101

16th St

18th St

Mariposa

Connecticut

Dogpatch

17th St

18th St

Mission
District

19th St

Castro

Potrero
Hill

3rd St

Dolores
Heights

Church

Valencia

Mission

South Van Ness

Folsom

Bryant

Potrero

24th St

Valley

Cesar Chavez

Cesar Chavez

28th St

280

Evans

San Jose

Mission

Bernal
Heights

Bayshore Blvd

Oakdale

Jerrold

Cortland

Andover

Bayview

3rd St

Silver

Portola

Bacon

San Bruno

Hunters Point

isor

Persia

Mansell

Mansell

Mansell

Visitacion
Valley

Geneva Ave

101

Carter

• Monterey cypress trees, 2009

• Murders, 2008

Shizue Seigel, *Sudden Death 2008: In Memory of Jordan McKay*, 2010

last of the Ten Commandments but the most powerful: *Thou shalt not kill.*
The greatest interdiction.

Here on a map of San Francisco, ninety-nine red dots disperse scattershot
on a golden wash of green. Regard each dot as a life and be mindful.

Know that for each location marked, that's where contact between mur-
dered and murderer occurred. That's where life was taken and death delivered.
That's where the ambulance, fire trucks, and police cars arrived, sirens blast-
ing, lights whirling, rushing from elsewhere in the city to attend the victim,
dying or already dead.

That's where the body was removed.

Afterward, that's where the yellow tape was unwound, signaling a police
investigation: interviews, files, case numbers, reports, evidence boxes, war-
rants, newspaper accounts, possibly confessions, arrests, trials, witnesses, tes-
timonies, possibly sentences and prison terms. Innocent and guilty, everyone
pays heavily for the infrastructure of murder.

That's where the cleanup took place. If blood spilled on the sidewalk or
steps, splattered on a wall or windshield, soaked into a carpet, it was scrubbed
away there.

That's where the murderer fled. By car or truck, bus or foot, across roofs
or through alleys, the murderer took off. Filled with dread or satisfaction,
shocked that it went so poorly or so well, giddy, high, unnerved, anxious to
ditch bloody or identifiable items, the murderer moved as quickly as possible
from that red dot.

Ninety-nine murder weapons traveled from the red dots to their places of
disposal. Guns, knives, razors, broken bottles, whatever, pitched in a Dumpster
or thrown from a dock. Or later discovered as incriminating evidence.

From each red dot, news spread. Family and friends came there to cry. Tears
flooded the spot. Flowers surrounded it. Simple bouquets and formal arrange-
ments drowned it in beauty, fragrance, and color. Sometimes there were can-

dles, balloons, teddy bears, love letters, religious icons, t-shirts with smiling photos and R.I.P. in Gothic lettering.

Memorial, marker, shrine, curse.

That's where children heard a shot or siren, or saw a body, or watched police helicopters hovering overhead. Thereafter, it was a haunted place. They changed their route to school to avoid it. Or they raced past, shutting their eyes, crossing their fingers, holding their breath to avoid the taint. Some had nightmares. Some couldn't sleep for weeks. It became a form of punishment and terror, the spot where children learned that extinguishing a life was as easy as flushing a toilet.

That's where the souls of the murdered rose and floated through the city: bloodless shadows, ghosts of estranged lovers, night-shift cashiers, cabbies, gang bangers, tourists, drifters, and bystanders. The work of maniacs and mayhem of boys.

In neighborhoods where red dots cluster, concentric circles spread from dot to dot, pulsing, intersecting, overlapping. Within those multiples, everyone becomes a target, especially young men of warrior age. As in war, their past and future shrink; surviving the present is paramount. Often, they stay inside. Generally, they don't walk to the store or play ball in the street. Outside lies trouble; inside offers a modicum of protection. They wonder if their own future will be summarized by something like a red dot. Their loved ones wonder, too. They are the red dots in waiting. Tens of thousands of them, enough to make the map run red.

By the end of 2008, there was a festoon of red dots. An aggregate. A curiosity. A tableau of grief. A scorecard of failure. A city of wealth, beauty, and resources marred by murder almost every three days. Time for politicians to fulminate, police budgets to increase, and fearfulness to rise.

> *thank you . . . for*
> *pulling my hair when I*
> *pulled the leaves off the trees so I'd*
> *know how it feels*

DIANE DI PRIMA, "APRIL FOOL BIRTHDAY POEM FOR GRANDPA"

The Monterey cypress, *Cupressus macrocarpa*, is magnificent, an evergreen that soars as tall as a hundred feet. These trees grow in clay and loam. They tolerate drought. They can live as long as 150 years. They are so huge and occupy their place so completely, they look as if they will never die. They promise to grace future generations with their presence. They share their beauty with all of us. They sing and sough with the wind. They shade and shelter us: we kiss beneath them and hide behind them and sit beside them on blankets, watching children and dogs. They break the monotony of concrete. They shimmer over roofs and sidewalks. Their branches weave the sky. They harbor birds. They do no harm. Bless them!

Of all living things, trees speak most to longevity. Old trees attest to the past, young trees affirm the future. Like grandparents and babies, they bookend the present. They give us assurance that life was and life will be. They are the ongoing fixtures of harmony, reverence, even worship.

When a tree is felled before our eyes, we cry out. They're cutting down trees! They're murdering trees! Brave, fierce people climb into endangered trees and refuse to come down. They defy laws and risk their own safety to defend them. For almost two years, a group of tree protectors resided in ninety-year-old oaks in the Berkeley hills to challenge the University of California's misplaced priorities. *Harass me! Starve me! Ridicule me! Imprison me! BUT SAVE THE TREES!* The tree-sitters lost. Most of the trees were cut down. Nearly a century to grow and in hours, to the high whine and low grind of chainsaws, gone.

On August 6, 1970, a few of us set out from Albuquerque, traveling northwest by car to the Los Alamos Laboratory in the Jemez Mountains. Security at the laboratory was minimal. We parked next to the main facility and carried a small tree, a couple of shovels, and a watering can to the lawn. Unhampered, we dug a hole and loosened the soil. We unwrapped the root ball and planted it, while lab workers watched from every window, taking pictures. However, no one interfered. After the tree was in the ground and watered, we said words to honor those who died from the A-bombs dropped on Hiroshima and Nagasaki. It was the twenty-fifth anniversary. A single tree was our commemoration. A living thing to mark the death toll of war.

In my small yard is a small orchard. The Fuji apple and Meyer lemons are established; every year they flower and bear fruit. We do nothing but reap the benefits of sun, rain, and the trees' beauty and delicious generosity. There's a new Palestinian lime in a large pot and three saplings on the south side of the house. I watch them attentively. The fig tree has eighteen leaves. It should produce a fig or two by the time my grandchild is a toddler. In ten years, there will be enough for us to make pies and preserves. The trees give me a picture of our future together. Bless them!

> *Death is the mother of beauty. . . .*
> WALLACE STEVENS, "SUNDAY MORNING"

The map of Death and Beauty is a flat surface. A finite, colored square with a delineation of coastline, inlets, ocean, bay, a grid of streets dotted with place names, and green swaths of parks. We can read the surface right to left, north to south, reversed, backward, upside down. Turn it in any direction, it's a map.

At the edges, the silhouettes of trees lift and spill beyond it. While we gaze down, the limbs and branches vault and groin above us, expanding up and soaring out. The map transforms into a cathedral of foliage, flowers, needles, and crowns. The undersides of trees—thousands of them. With our heads thrown back, they guide us through the city beneath their green canopy. Arboreal navigation.

On the map of Death and Beauty, the cardinal directions expand to six. Up and down are added, the polar opposites of one axis. Green dots rise, red dots sink. Bodies buried in the great underground network commingle with the roots of trees. Life and death busy themselves unseen.

In the commotion of rising and sinking, the map begins to shudder. Ah! It's Death and Beauty dancing. They've danced together forever. They're each other's favorite, fatal partner. They wrestle and fly, tangle and cry until they are ground to dust. Then the ecstatic frenzy passes. We wonder, has anyone else seen or heard? We stare down at the flat surface. The map is still ∞

17 400 YEARS AND 500 EVICTIONS

This map attempts to illustrate the notion that a city is not merely a single lineage of years—about 160 for San Francisco—but an accumulation of all the years all its residents have spent here, which even for a small, young city like this adds up to millions. Inspired in part by Add Bonn's remark, over sweet vermouth, that she didn't like the Golden Gate Bridge, visible from her window these past six decades or so, because it ruined the view—she remembers how dramatic the Golden Gate was when it was untouched—the map traces four lives that have unfolded largely within the confines of this seven-mile-square city over the past century.

This map also provides evidence of the coexistences that make up cities. The four hundred years of the centenarians' residence (drawn from interviews conducted by Heather Smith) are counterbalanced with five hundred Ellis Act evictions (borrowed from a map by designer Mike Kuniavsky) that took place between 2000 and 2005, only a small portion of the overall number of evictions in recent years that have made San Francisco literally unlivable for so many in this era of gentrification and greed. This, then, is a map of continuity and disruption, of settling in and being forced out.

CARTOGRAPHY: SHIZUE SEIGEL; ELLIS ACT MAP DATA COPYRIGHT 2006 MIKE KUNIAVSKY, LICENSED UNDER CREATIVE COMMONS ATTRIBUTION NONCOMMERCIAL-SHARE ALIKE 2. ∞ MAP APPEARS ON PAGES 116–117

DWELLERS AND DRIFTERS IN THE SHAKY CITY

BY HEATHER SMITH

The bartender in Cambodia tells me stories of the Endup, the notorious gay bar at Sixth and Harrison. The elderly couples in Minnesota tell me of the ballrooms: a San Francisco full of teenagers in snappy uniforms, temporarily liberated from parents, hometowns, and the concept that their own existence might last more than the next few months and handling this mental reshuffling via the lindy hop, swing, the foxtrot. In the Midwest, a woman in her eighties tells me about the Kodak plant, where women developed film for eight-hour shifts in pitch darkness and recognized each other by the sound of footfalls as one or another walked by. I begin to suspect that if I travel to every corner of the world, I will find it full of San Franciscans, past, present, and future.

When I first arrived, the city echoed with the sound of luggage snapping shut. The dot-com era was finished, and when people talked about the city that I had newly met, the unspoken assumption was that it was a trend that had played out completely, like legwarmers. Bags were being packed for Seattle,

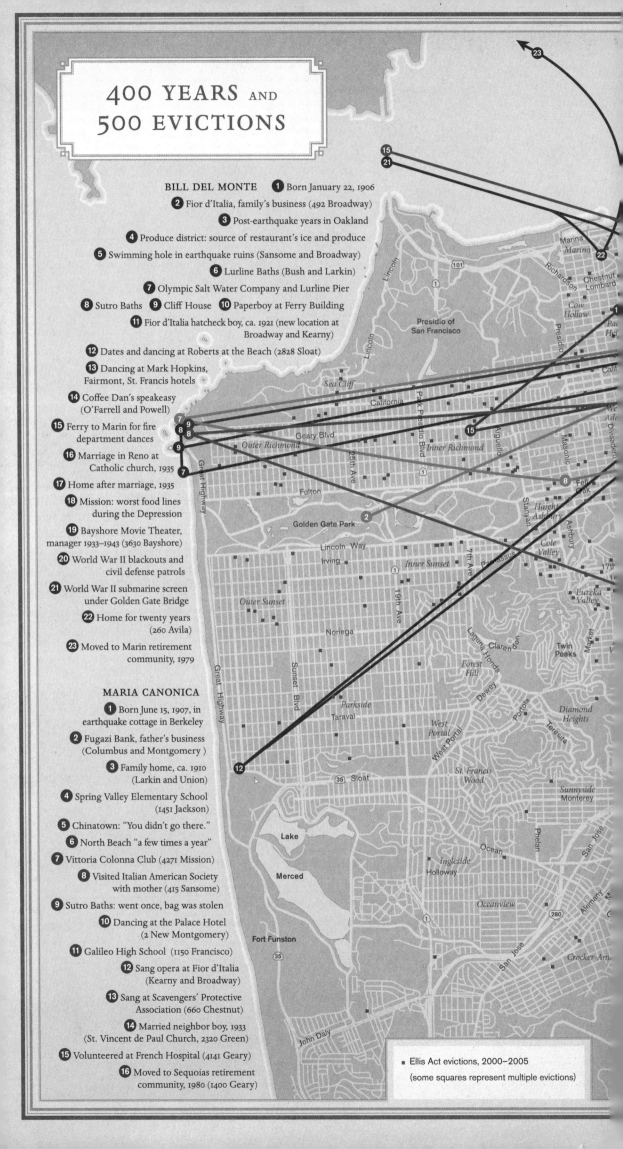

400 YEARS AND 500 EVICTIONS

BILL DEL MONTE
1 Born January 22, 1906
2 Fior d'Italia, family's business (492 Broadway)
3 Post-earthquake years in Oakland
4 Produce district: source of restaurant's ice and produce
5 Swimming hole in earthquake ruins (Sansome and Broadway)
6 Lurline Baths (Bush and Larkin)
7 Olympic Salt Water Company and Lurline Pier
8 Sutro Baths 9 Cliff House 10 Paperboy at Ferry Building
11 Fior d'Italia hatcheck boy, ca. 1921 (new location at Broadway and Kearny)
12 Dates and dancing at Roberts at the Beach (2828 Sloat)
13 Dancing at Mark Hopkins, Fairmont, St. Francis hotels
14 Coffee Dan's speakeasy (O'Farrell and Powell)
15 Ferry to Marin for fire department dances
16 Marriage in Reno at Catholic church, 1935
17 Home after marriage, 1935
18 Mission: worst food lines during the Depression
19 Bayshore Movie Theater, manager 1933–1943 (3630 Bayshore)
20 World War II blackouts and civil defense patrols
21 World War II submarine screen under Golden Gate Bridge
22 Home for twenty years (260 Avila)
23 Moved to Marin retirement community, 1979

MARIA CANONICA
1 Born June 15, 1907, in earthquake cottage in Berkeley
2 Fugazi Bank, father's business (Columbus and Montgomery)
3 Family home, ca. 1910 (Larkin and Union)
4 Spring Valley Elementary School (1451 Jackson)
5 Chinatown: "You didn't go there."
6 North Beach "a few times a year"
7 Vittoria Colonna Club (4271 Mission)
8 Visited Italian American Society with mother (415 Sansome)
9 Sutro Baths: went once, bag was stolen
10 Dancing at the Palace Hotel (2 New Montgomery)
11 Galileo High School (1150 Francisco)
12 Sang opera at Fior d'Italia (Kearny and Broadway)
13 Sang at Scavengers' Protective Association (660 Chestnut)
14 Married neighbor boy, 1933 (St. Vincent de Paul Church, 2320 Green)
15 Volunteered at French Hospital (4141 Geary)
16 Moved to Sequoias retirement community, 1980 (1400 Geary)

■ Ellis Act evictions, 2000–2005
(some squares represent multiple evictions)

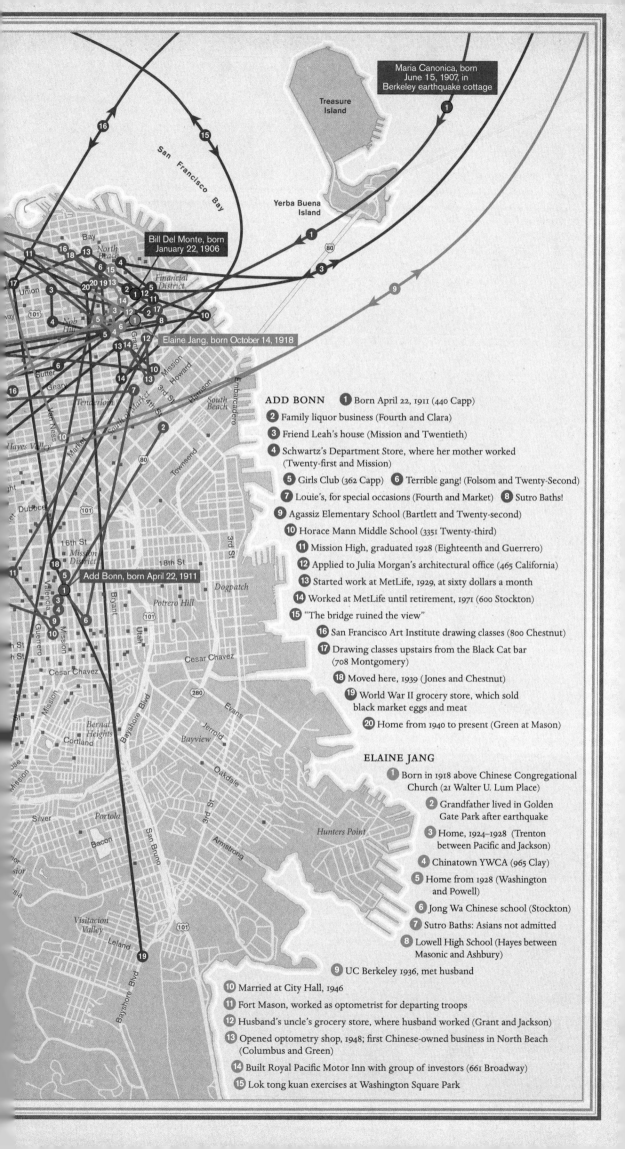

Maria Canonica, born June 15, 1907, in Berkeley earthquake cottage

Treasure Island

Yerba Buena Island

San Francisco Bay

Bill Del Monte, born January 22, 1906

Elaine Jang, born October 14, 1918

Add Bonn, born April 22, 1911

ADD BONN

1. Born April 22, 1911 (440 Capp)
2. Family liquor business (Fourth and Clara)
3. Friend Leah's house (Mission and Twentieth)
4. Schwartz's Department Store, where her mother worked (Twenty-first and Mission)
5. Girls Club (362 Capp)
6. Terrible gang! (Folsom and Twenty-Second)
7. Louie's, for special occasions (Fourth and Market)
8. Sutro Baths!
9. Agassiz Elementary School (Bartlett and Twenty-second)
10. Horace Mann Middle School (3351 Twenty-third)
11. Mission High, graduated 1928 (Eighteenth and Guerrero)
12. Applied to Julia Morgan's architectural office (465 California)
13. Started work at MetLife, 1929, at sixty dollars a month
14. Worked at MetLife until retirement, 1971 (600 Stockton)
15. "The bridge ruined the view"
16. San Francisco Art Institute drawing classes (800 Chestnut)
17. Drawing classes upstairs from the Black Cat bar (708 Montgomery)
18. Moved here, 1939 (Jones and Chestnut)
19. World War II grocery store, which sold black market eggs and meat
20. Home from 1940 to present (Green at Mason)

ELAINE JANG

1. Born in 1918 above Chinese Congregational Church (21 Walter U. Lum Place)
2. Grandfather lived in Golden Gate Park after earthquake
3. Home, 1924–1928 (Trenton between Pacific and Jackson)
4. Chinatown YWCA (965 Clay)
5. Home from 1928 (Washington and Powell)
6. Jong Wa Chinese school (Stockton)
7. Sutro Baths: Asians not admitted
8. Lowell High School (Hayes between Masonic and Ashbury)
9. UC Berkeley 1936, met husband
10. Married at City Hall, 1946
11. Fort Mason, worked as optometrist for departing troops
12. Husband's uncle's grocery store, where husband worked (Grant and Jackson)
13. Opened optometry shop, 1948; first Chinese-owned business in North Beach (Columbus and Green)
14. Built Royal Pacific Motor Inn with group of investors (661 Broadway)
15. Lok tong kuan exercises at Washington Square Park

Boston, Vancouver, New Delhi. At a nightclub perched on the edge of the shipbuilding docks, a banker from Moscow leaned into me and said, by way of explanation, "Some birds, they travel twice around the world before they die." In the black light, she glowed ultraviolet. She had sold her house, and was taking flight.

In 1851, Nathaniel Hawthorne, one of America's first writers of science fiction, viewed the railroads, which began to link the country together during his lifetime, as the solution to the prudishness and greed that he saw reaching out from the old world to calcify the new one. "Transition being so facile," he wrote, in *The House of the Seven Gables*, "what can be any man's inducement to tarry in one spot? Why should he build a more cumbrous habitation than can be readily carried off with him? Why should he make himself a prisoner for life in brick, and stone, and old worm-eaten timber when he may just as easily dwell nowhere?"

Why indeed? Over a hundred years later, Willie Brown, then mayor of San Francisco, delivered the following piece of advice to his less well-off constituents: "I know you love San Francisco," he said. "But you are better off living someplace where the cost of living isn't so great." Brown seemed mystified by an idea that San Francisco's voters kept expressing at the polls: the belief that living, working, cooking, voting, raising children, falling in love, and generally going about having a life (as interesting or as dull as seems appropriate) are activities that confer a right to stay in place. And that this right should be conferred regardless of income, even in a city as desirable and liminal as San Francisco.

What makes a city yours? Is it cannonballing off the broken walls of a factory destroyed in the great earthquake, and paddling around in the flooded foundation below? Is it singing opera to raise money for the city's trashpickers? Is it cooking foil-wrapped potatoes in the dirt of the vacant lot by the house where you live? What about decades of opening your storefront shop every morning, asking your neighbors if they can read one line of letters, and then the line below that, and then the line below that, and fitting them with eyeglasses accordingly?

San Francisco is a city made of wood and steel and stone, of social relationships, and of laws, contracts, and agreements. The four people whose lives are mapped here—Add Bonn, Elaine Jang, Maria Canonica, and Bill Del Monte—never met, though they must have passed one another on the street a thousand times. But they all had one thing in common: they owned their own homes. Their right to remain in place has never been called into question.

In 1977, the sheriff of San Francisco spent five days in jail for refusing to evict fifty tenants, mostly Filipino senior citizens, from the International Hotel, a residence hotel that a group of overseas investors intended to turn into something more lucrative. The sheriff ultimately caved and led four hundred police in full riot gear through the hotel. Together, they broke down each door with a sledgehammer and dragged the remaining elderly tenants out into the street. "The land," said Justin Herman, the former head of the San Francisco Redevelopment Agency, "is too valuable to permit poor people to park on it."

Decades earlier, when many of the tenants of the hotel moved in, the land had been deemed perfectly appropriate for poor people. Then it was a working-class neighborhood known as Manilatown, inhabited by men from the Phil-

Sutro Bath ruins with Cliff House, 2010. Photo by Michael Rauner.

ippines who worked in the city as day laborers, dishwashers, and fishermen. These men were passengers on a train, looking out their windows at a land-scape that moved faster and faster every day.

In contrast, the lives mapped here are more like core samples: historically dense, geographically static. They reveal a San Francisco whose neighborhood boundaries were less porous. Bill Del Monte and his friends traveled out to play in the tidal flats that would one day be the site of the Oakland airport. As a teenager with the then almost unheard-of luxury of a car, he would drive to Seattle on a whim. But he never set foot inside Chinatown, even though he grew up just a few blocks away.

Elaine Jang rarely left Chinatown except to go to school: first Lowell High School, then the University of California in Berkeley. The commute between her home and Berkeley was an hour and a half each way via cable car, ferry, and streetcar. But cultural and financial necessity kept her tied to her neighborhood: she still returned home every night after a full day of classes to cook dinner for her father and brothers. When she opened an optometry shop in North Beach, it was a sign that borders were shifting; for the next thirty-five years, her clientele would come to her from both neighborhoods.

The Battle of the International Hotel was an aria in an opera that has yet to end. San Francisco's voters (who are, after all, two-thirds renters) continue to try to spin a legislative web of protection around city residents who'd like to stay put. Those who see a lot of gold in the hills of enforced nomadism try to undo those protections—usually on the state level, where voters are more conservative and politicians are less worried about being seen as unfriendly to tenants. In 1979, rent control became law in San Francisco. In 1995, vacancy control was preemptively banned across California. Virtually

every statewide election in recent years has contained a ballot measure that seeks to permanently end rent control, usually couched in language so confusing that it verges on poetry.

The battle over who gets to live in the city, and for how long, goes on. It is one fought with legal terms, designations, obscure precedents. So many ways of saying "home"—from the TIC (tenancy in common) to the live/work loft to the illegal in-law unit (with such innovative subcategories as "the garagelo"—usually a garage with a futon and a space heater) to the rare and much yearned-after designation of "condominium."

The city itself educates you about the rules of flight and stasis, at times forcibly. After a few years of lived experience, the city becomes more than just a place in which to march down the street behind an eighteen-piece brass band, or dance all night by an abandoned chemical factory. San Francisco unfolds before you like a big beautiful primer in real estate law.

The Ellis Act is an obscure piece of state legislation that was used like a wedge in the dot-com era to keep the real estate market open for speculators who wanted to continue buying buildings that sold for lower prices because they contained rent-controlled tenants, evicting all of said tenants, and then reselling the buildings at a stunning profit. It is not a devastatingly well-written piece of legislation. It is not even especially ironclad. It's certainly not the only law used to persuade people to move on.

But in the pitched battle over who stays, and who goes, it has proved remarkably effective in compelling people to go. In 1995, a total of 14 apartments were cleared of their inhabitants via the Ellis Act. By 1999, that number had risen to 664. Overall, a total of 1,280 units have been lost through Ellis Act evictions, their inhabitants dispersed and replaced. Which is a way of saying that this may be a city that is built for flight, but that not all birds do so voluntarily.

One hundred and four years ago, most of San Francisco was homeless. The 1906 earthquake had temporarily undone the careful habitation of the city, mansions and slums alike. Elaine Jang's grandfather lived in Golden Gate Park. Maria Canonica's parents moved to an earthquake cottage in Berkeley. Bill Del Monte's family cooked soup in the rubble of their restaurant after harvesting the ingredients from the garden of their family cottage in Oakland. Every night, the cottage filled up with sleeping waiters and chefs and dishwashers from the restaurant. These centenarians grew up in a society that was knitting itself back together, rebuilding the social clubs and ballrooms and baths and young ladies' societies that both kept people in their place and gave them a place to hold on to. The city continues to destroy and renew itself, sometimes in surprising ways. In 2005, the last two living residents of the original International Hotel were invited to take residence in a new structure, built over the twenty-year-old rubble of the first one.

The older the photograph, the more deceptively unpopulated San Francisco appears. The buildings and streets are perfectly defined—every weed, every crack in the sidewalk. But the people are gone. Which is not to say that they weren't there. The people are missing because they were in motion. The light reflected off them for a moment and then shone through the space left by their absence. The few whose images do show up are the ones who, despite all the movement around them, managed to stay in place ∞

18 THE WORLD IN A CUP

Twenty years ago, I would hear New Yorkers, in particular, proclaim that their lives were totally separate from nature, and I'd muse that if only they would think systemically, they'd see they were in fact utterly entangled in it. This map makes visible the systems extending from a single cup of coffee, drunk in an urban café: hydraulic engineering that brings water from the mountains, water treatment plants and sewer lines that outflow to the bay and the Pacific, dairy farming, coffee importing and distributing. Documentary photographer Robert Dawson added the human side of the systems, the cafés that provide social spaces, liveliness, and community of sorts. We mapped cafés that seemed most significant to their neighborhoods or resonated for other reasons, but we left out many, many of the thousand or so that dot the city. CARTOGRAPHY: SHIZUE SEIGEL; PHOTOGRAPHS: ROBERT DAWSON ∞ MAP APPEARS ON PAGES 122–123

HOW TO GET TO ETHIOPIA FROM OCEAN BEACH

BY REBECCA SOLNIT

A café is a place where people in the neighborhood gather; a cup of coffee is where pieces of the world gather. A cup of coffee from Java Beach at the end of Judah Street at Ocean Beach is itself a remarkable map of regional and global economies. It contains water from Hetch Hetchy, the reservoir that concentrates Sierra snowmelt and feeds it downhill more than 170 miles to the faucets of San Francisco. It includes milk from the Clover Stornetta dairies in West Marin and Sonoma and organic fair-trade coffee distributed by Due Torri, which could be from Sumatra, Ethiopia, Brazil, Guatemala, Mexico, Costa Rica, or elsewhere, or a combination of any of these.

Which is to say that a cup of coffee from Java Beach—or indeed from any café—holds three major landscapes and economies: pastoral, alpine, and tropical. And that combination is drunk in San Francisco hundreds of thousands of times a day (though some take their coffee black). If you figure half a million cups every morning among the eight hundred thousand inhabitants, you're picturing production on a vast scale. And then there's plumbing: the story that begins in Hetch Hetchy's dammed valley inside Yosemite National Park ends with the two wastewater treatment plants that outflow into the bay and the Pacific and with the composting of coffee and filters in the city's industrial-scale composting facilities in Vacaville.

Learning to see those people and landscapes in your cup is among the demands of the world we live in, where we are constantly using, wearing, relying on, and consuming products created by forces far beyond the horizon. The

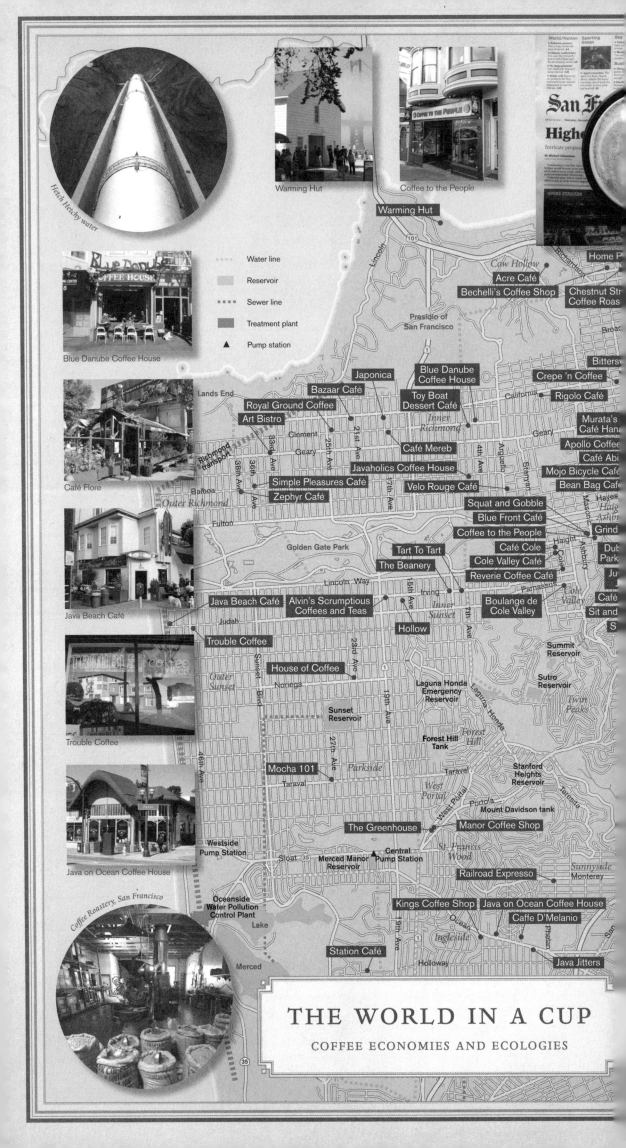

Hetch Hetchy water

Warming Hut

Coffee to the People

San F

High

Intricate propos

Home P

Blue Danube Coffee House

Cow Hollow Richardson

Acre Café

Bechelli's Coffee Shop Chestnut Str
 Coffee Roas

Presidio of
San Francisco Broad

Bitters

Warming Hut

Lincoln

101

Water line

Reservoir

Sewer line

Treatment plant

▲ Pump station

Crepe 'n Coffee

California Rigolo Café

Blue Danube
Coffee House

Japonica

Bazaar Café

Royal Ground Coffee

Art Bistro

Toy Boat
Dessert Café

Inner
Richmond

Geary Murata's
 Café Hana

Apollo Coffee

Café Abi

Lands End

Richmond transport

Clement
Geary

33rd Ave

25th Ave

21st Ave

17th Ave

4th Ave

Arguello

Stanyan

Café Mereb

Javaholics Coffee House

Velo Rouge Café

Mojo Bicycle Café

Bean Bag Café

Café Flore

36th Ave

38th Ave

Balboa

Outer Richmond

Simple Pleasures Café

Zephyr Café

Squat and Gobble

Blue Front Café

Coffee to the People

Masonic

Hayes
Haig
Ashb

Grind

Fulton

Golden Gate Park

Tart To Tart

The Beanery

Café Cole

Cole Valley Café

Reverie Coffee Café

Haight

Ashbury

Cole

Dub
Park

Ju

Java Beach Café

Alvin's Scrumptious
Coffees and Teas

Lincoln Way

15th Ave

Irving

7th Ave

Inner
Sunset

Parnassus

Boulange de
Cole Valley

Cole
Valley

Café

Sit and
S

Java Beach Café

Judah

Hollow

Trouble Coffee

House of Coffee

Noriega

Outer
Sunset

Sunset
Blvd

23rd Ave

19th Ave

22th Ave

Laguna Honda
Emergency
Reservoir

Summit
Reservoir

Sutro
Reservoir

Twin
Peaks

Forest Hill
Tank

Forest
Hill

Summit

Trouble Coffee

Sunset
Reservoir

Stanford
Heights
Reservoir

Mocha 101

Taraval

Parkside

46th Ave

Taraval

West
Portal

West Portal

Taraval

Portola Mount Davidson tank

Teresita

Java on Ocean Coffee House

The Greenhouse

Manor Coffee Shop

St. Francis
Wood

Westside
Pump Station

Sloat 35

Merced Manor
Reservoir

▲ Central
Pump Station

Railroad Expresso

Sunnyside
Monterey

Coffee Roastery, San Francisco

Oceanside
Water Pollution
Control Plant

Lake

Kings Coffee Shop Java on Ocean Coffee House

Caffe D'Melanio

9th Ave

Ocean

Phelan

San

Merced

Station Café

Holloway

Ingleside

Java Jitters

35

THE WORLD IN A CUP

COFFEE ECONOMIES AND ECOLOGIES

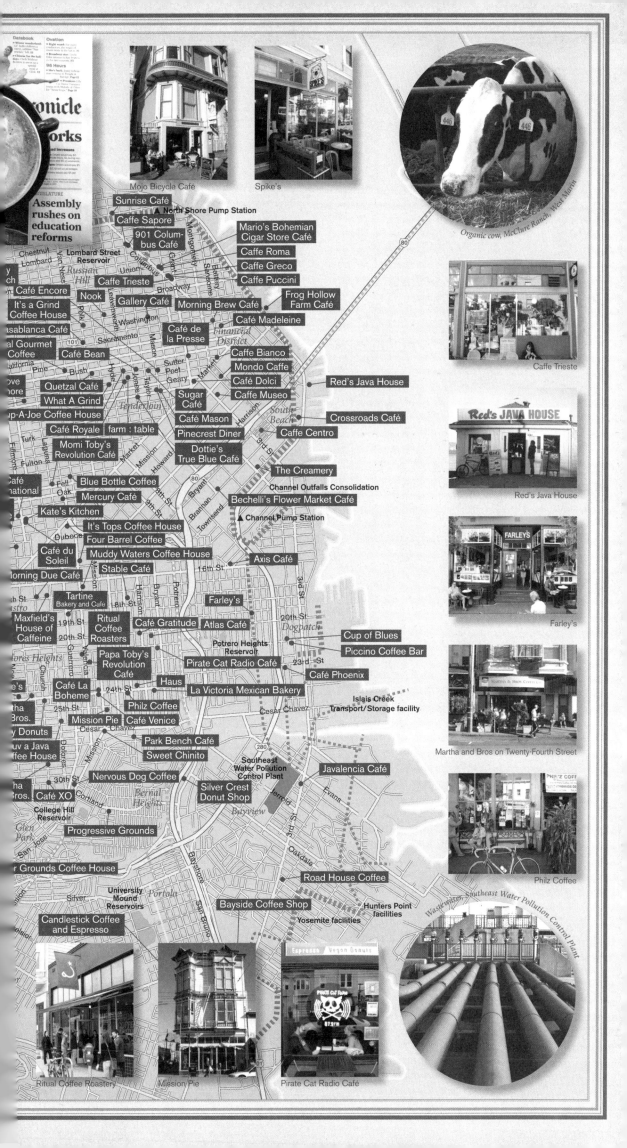

Mojo Bicycle Café

Spike's

Organic cow, McClure Ranch, West Marin

Caffe Trieste

Red's Java House

Farley's

Martha and Bros on Twenty-Fourth Street

Philz Coffee

Wastewater Southeast Water Pollution Control Plant

Ritual Coffee Roastery

Mission Pie

Pirate Cat Radio Café

Sunrise Café

Caffe Sapore

North Shore Pump Station

901 Colum-bus Café

Mario's Bohemian Cigar Store Café

Caffe Roma

Caffe Greco

Caffe Puccini

Café Encore

Nook

Caffe Trieste

Gallery Café

Morning Brew Café

Frog Hollow Farm Café

It's a Grind Coffee House

Casablanca Café

Café Madeleine

Café de la Presse

Financial District

Gourmet Coffee

Café Bean

Caffe Bianco

Mondo Caffe

Quetzal Café

Café Dolci

Red's Java House

What A Grind

Sugar Café

Caffe Museo

Tenderloin

Cup-A-Joe Coffee House

Café Mason

Café Royale

farm : table

Crossroads Café

Momi Toby's Revolution Café

Pinecrest Diner

Caffe Centro

Dottie's True Blue Café

Café International

Blue Bottle Coffee

The Creamery

Mercury Café

Channel Outfalls Consolidation

Kate's Kitchen

Bechelli's Flower Market Café

It's Tops Coffee House

Channel Pump Station

Four Barrel Coffee

Café du Soleil

Muddy Waters Coffee House

Axis Café

Morning Due Café

Stable Café

16th St

Tartine Bakery and Cafe

Farley's

Maxfield's House of Caffeine

Ritual Coffee Roasters

Café Gratitude

Atlas Café

Dogpatch

Papa Toby's Revolution Café

Potrero Heights Reservoir

Cup of Blues

Piccino Coffee Bar

Pirate Cat Radio Café

Café Phoenix

Haus

La Victoria Mexican Bakery

Café La Boheme

Islais Creek Transport/Storage facility

Martha Bros.

Philz Coffee

Mission Pie

Café Venice

Donuts

Cesar Chavez

Luv a Java Coffee House

Park Bench Café

Sweet Chinito

Javalencia Café

Nervous Dog Coffee

Southeast Water Pollution Control Plant

Café XO

Silver Crest Donut Shop

Bayview

College Hill Reservoir

Bros.

Progressive Grounds

Grounds Coffee House

University Mound Reservoirs

Portola

Road House Coffee

Bayside Coffee Shop

Hunters Point facilities

Candlestick Coffee and Espresso

Yosemite facilities

Industrial Revolution has been about alienation—not only of producers from their work but also of consumers from the source of the products they use. Much of the work of the environmental and social justice movements during the past few decades has been to make these forces visible: to see sweatshop workers when you see cheap clothes; to see child labor in some brands of chocolate; to see toil and geography, just or unjust, ugly or beautiful, in everything you touch. This knowledge brings demands that can also be pleasures. You can get to Ethiopia from Java Beach if you learn to read your coffee; and one of the big questions about fair-trade versus commercial coffee, independent cafés versus chain stores, is about drinking in meaning, or meaninglessness.

San Francisco once was and Oakland now is the port through which a huge portion of the nation's coffee flows. Years ago, when Folgers and MJB were still south of the Bay Bridge, everyone driving by smelled roasting coffee at all hours; you can still sometimes travel through that aroma on 880 in East Oakland near where the coffee is now unloaded and roasted both by big plants and by small places like Due Torri Organic Coffee Roaster, a distributor of organic fair-trade coffee. Vincent, the proprietor of Due Torri—a two-person roasting, blending, and distributing operation in a concrete bunker in a small East Oakland industrial park—told us one rainy morning he estimates that the beans have been handled by a hundred people by the time they reach your cup. In the fifty-pound sacks of coffee he receives raw from the Oakland docks, he's found many things, including jewelry, bullets, and teeth. The people behind the coffee are real to him. His family owns a finca, a coffee plantation, in Guatemala, and he grew up spending summers there.

For me, a cup of coffee is an ingathering of worlds: coffee growing in tropical highlands, dairy farming in the surrounding countryside, and hydraulic engineering that gets the water from the mountains to the plumbing and then cleans it for the sea. For Bob Dawson, the photographer for this map, the same cup of coffee, bought and drunk in a neighborhood café, is a sort of communion with the people and place around you. Of course, a cup of coffee is both, and the way that dual identity works models many other situations. In the mid-seventeenth century, London coffeehouses were intellectual and political hotbeds, so much so that Charles II considered suppressing them. But even then the coffee itself was a globalized product, coming in from the Arab world and the subtropics, part of the same colonial landscape as tea, cotton, rum, sugar, slaves, and plantations; and businessmen were conducting their deals in the coffeehouses, too. So the material coffee was most likely about exploitation and oppression, whereas the social space was about the free exchange of ideas and the growth of urban public life—early newspapers were read and passed around in these places.

San Francisco has always been a coffee town: Tadich Grill, the oldest restaurant in the city, began as a wharfside coffee stand in 1849, at the beginning of the Gold Rush, when sacks of coffee were as much a part of the wharves as the coffee factories were of the old industrial city, now lost. But the cafés that freckle the city are a relatively new phenomenon. My friend Jesse Drew reminded me that he'd lived in the Mission in the days when there were two cafés: the Picaro on Sixteenth Street and Café La Boheme on Twenty-fourth— both still open daily, but now with dozens of other coffeehouses in between. I

Café La Boheme, 2010. Photo by Robert Dawson.

also remembered the hippie-ish Café Clarion at Mission and Clarion Alley back in the early 1980s, but Jesse was right that there had once been few cafés outside North Beach. They sprang up like mushrooms after a rain in the 1980s and became a way of passing time, of visiting and working and reading and meeting. Perhaps because so many people live in small apartments, the cafés are their other living rooms; perhaps because so many lead eccentric, freelance, unsettled lives, they pass through these places all the time like migratory birds. It can be astonishing how many people seem to be at everything and anything but work on a weekday midmorning.

Sometimes I think that upscale cup of coffee with the foam poured into a little rippled heart is the last luxury a lot of the young here can afford, some of them, and they buy it still. But these are my opinions, and nearly everyone here has strong opinions about which cafés are great and which suck, just as everyone here and elsewhere has strong opinions about San Francisco as the promised land or the catchall of abominations. Whatever San Francisco once was, it is now a place identified with cafés. Other cities seem to have more domesticated citizens, citizens who go to work in the morning and go home in the evening; even in New York, cafés seem to be antithetical to the thrust of the citizens, their urgency about doing, and doing more, faster. When New Yorkers sit, they spend, in restaurants.

Perhaps the golden age of cafés has passed, for everyone now complains about the people who come into San Francisco's coffee emporia latched as if by magnetic force to their electronics, talking or typing to someone who's anywhere but here, a little oblivious to the people around them, though proximity was once the point. Even so, the café owners and workers are a society, too, and there are subgroups such as Martha and Bros., the several cafés owned by a Nicaraguan family who came here when the Sandinistas came to power—another tie to the lands where the coffee grows. Some of the cafés have gotten precious with their rites of producing the perfect artisanal cup; many have gone for more justice per cup with fair-trade organic coffee. Though Starbucks has proliferated—in 2000 there were about sixty-six outlets in San Francisco; there are now more than a hundred—it and the other chains are still in the minority, and more than a thousand versions of the neighborhood café exist in this town.

Bob Dawson has been taking photographs related to water issues in the American West for more than thirty years—and joking much of that time about a sequel featuring his beverage of choice, Coffee in the West, so he was a natural for the assignment of taking photos for this map. He set out to photograph cafés and, in the course of visiting and photographing a hundred, found that they were lenses through which he could see his familiar city—he's lived here since 1982—in a new way, neighborhood by neighborhood, and see the ways that the cafés reflect and gather their surroundings. Their very specificity is a window onto architectural variety, from elegant Victorian façades in candy colors to freestanding huts like Red's Java House or Crissy Field's Warming Hut to the thatched-cottage oddity of Java on Ocean, at Ocean Avenue and Faxon, where Supervisor John Avalos likes to meet his Excelsior District constituents. There are great landmark cafés, like the Flore at Noe and Market in the Castro; or the Puccini and, inevitably, Caffe Trieste in North Beach; cafés that come and go; innovations like the Mojo Bicycle Café on Divis, which is also a bike shop, or Pirate Cat Radio Café, which is an underground radio station. The sheer abundance of them, the vast variety, is a little overwhelming, though when a café or coffeehouse slides over into being a diner or restaurant was a philosophical question we never resolved.

Bob found the cafés moving, vital, places where people mediated being strangers and being at home. He speculates that this is because so many people have come here from elsewhere that they are trying to finish the job of arriving. Maybe home can be found at the bottom of a cup of coffee. And so can the faraway, traveling across a sea of questions ∞

Left: Caffé Puccini; right: Velo Rouge Café. Photos by Robert Dawson, 2010.

19 PHRENOLOGICAL SAN FRANCISCO

Even the most unlikely starting point can lead somewhere illuminating. This fanciful map imagines a way to describe the character of the city and its neighborhoods with the nineteenth-century pseudo-science of phrenology, which argued that one's character and talents could be read from bumps on the skull. In this portrait of the mind and bumpy head of San Francisco, all but a couple of the categories are traditional phrenological ones, as applied by Paul La Farge. CONCEPT: SARAH STERN; CARTOGRAPHY: BEN PEASE;

ARTWORK: PAZ DE LA CALZADA ∞ MAP APPEARS ON PAGES 128–129

CITY OF FOURTEEN BUMPS BY PAUL LA FARGE

If any city can be understood phrenologically, it must be San Francisco, city of fourteen big bumps and countless smaller irregularities. The city is even head-shaped: its occiput is washed by the Pacific, its crown pokes up toward the Marin headlands, its chin sticks into the bay. Of course there's something quixotic about the project. Phrenology, the science of divining a person's character from the bumps on his or her skull, was invented in the 1790s by a German neurologist named Franz Gall. It was wildly popular in the nineteenth century; everyone from the abolitionist Reverend Henry Ward Beecher to British Prime Minister David Lloyd George had themselves phrenologized. Walt Whitman carried the reading of his head ("leading traits of character appear to be Friendship, Sympathy, Sublimity and Self-Esteem") with him everywhere. By the early twentieth century, however, phrenology had been replaced by more subtle mappings of the mind. Psychoanalysts read the bumps of the soul; imaging technologies bypass the skull to look directly into the brain.

And yet, and yet. What if there were some truth to the old idea that character is expressed in bumps? What if the truth of a city resides not in its statistics but in the development of mental organs, which manifest themselves in hills and valleys, changes in terrain? To read a city's bumps would be to know its real psychogeography, the contours not of its surface but of its depth. The phrenologist works by touch, an intimate sense: to know a city phrenologically is the opposite of the lofty knowledge dispensed by satellites or the disembodied image stream available to anyone with a copy of Google Earth. Phrenological knowledge is harder won; it requires eyes *and* feet. What follows is an exercise in urban bump-reading—fanciful, yes, but strictly carried out: our map uses the bumps (or "faculties," as they are properly known) described by Lorenzo Niles Fowler (1811–1896), America's leading phrenologist, and immortalized on his famous ceramic head. Note that the faculties don't always correspond to San Francisco's fourteen hills; sometimes they follow subtler boundaries of character.

Presidio

VENERATIO[N]

SUBLIMITY

ALIMENTIVENESS

Inner Richmond

Outer Richmond

Golden Gate Park

Ha
Ash

HUMAN NATURE

Cole
Valle

Inner Sunset

Outer Sunset

Twin Peaks

FIRMNE

INHABITIVENESS

Forest
Hill

Parkside

West
Portal

St. Francis
Wood

Sun

LOVE OF
ANIMALS

PHILOPROGENITIVENES

Ingleside

Oceanview

PHRENOLOGICAL SAN FRANCISCO

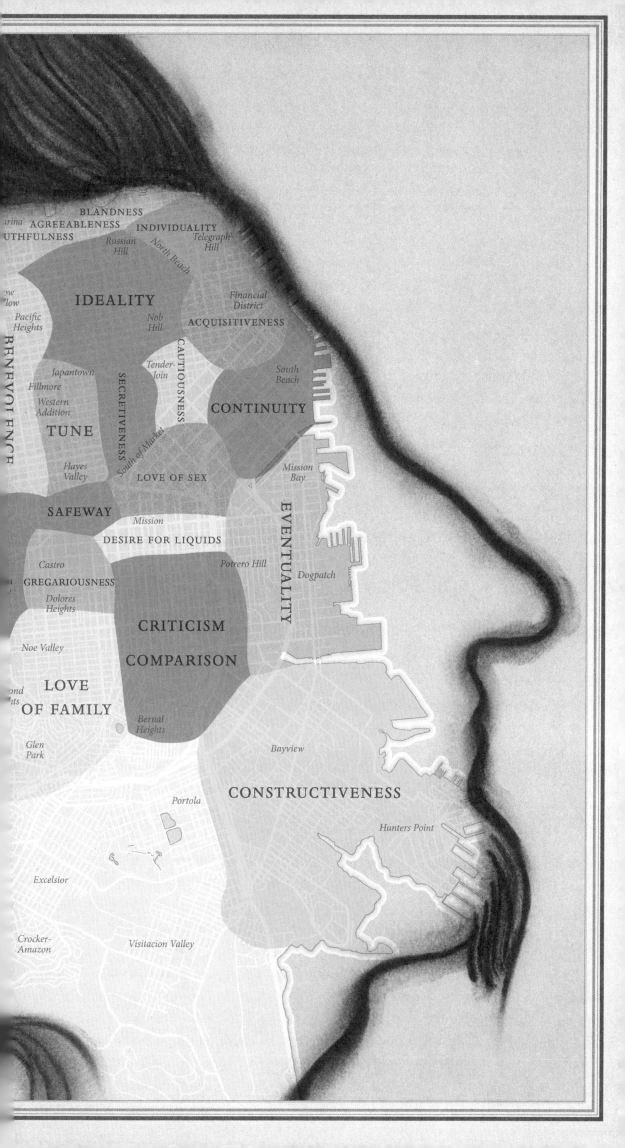

We begin in the northwestern corner of the city, with the faculty of Sublimity. What could be more sublime than the Marin headlands and the vast Pacific, seen from the mansions of Sea Cliff or the cliffs of Lincoln Park? To the east, ocean views give way to the tidy streets of the Presidio and to the Palace of Fine Arts: this is the seat of Veneration and its subfaculties Antiquity, Perseverance, and Worship. The Presidio, built by the Spanish in 1776, kept dogged watch over the entrance to the bay until the 1990s, when it was turned over to the National Park Service and Lucasfilm. Trekkies also know the Presidio as the location of Starfleet Academy. Does that qualify it as a site of Worship? For some, for some.

Next comes the Marina, where firm-thighed consultants rollerblade on a bed of landfill, and Ghirardelli Square, where children are subdued with sweets and taken to work in an underground factory, breaking large blocks of chocolate into those irregular chunks you find in supermarkets. Then Fisherman's Wharf, inhabited by tourists, crabs, and harbor seals, which live in a state of happy interdependence, eating one another and taking souvenir photographs. This strip of land is, without doubt, the region of Blandness, Agreeableness, and Youthfulness, faculties that Fowler situates on the phrenological hairline, between Causality and Imitation.

To the south of this pleasant zone is North Beach, where the Beats once lurked. I was in North Beach for a reading the night Allen Ginsberg died; people who had barely risen from their seats in thirty years got up to share their stories of the poet. The only one I still remember was a man who concluded his oration, "Allen, you still owe me five dollars!" The Beats are mostly gone now, but their bookstore, City Lights, remains; as long as its doors are open— late!—North Beach will be the seat of Individuality in San Francisco. It is not a big region, but it is very well developed: note the prominence of Telegraph Hill, with Coit Tower stuck into the sky like a single (middle) finger.

To the south is Acquisitiveness, its symbol the Aegon (formerly Transamerica) Building, designed by architect William Pereira to look like a ballpoint pen. Banks and brokerages gather at its knees; their excess capital flows through underground pipes to Union Square, where it is used to light the shop windows. Anything may be had here, except dinner; for that, you have to go to Chinatown.

Uphill from Acquisitiveness, we find Ideality: Grace Cathedral, the Pacific-Union Club, the Mark Hopkins, the Fairmont. I never had much to do with this part of town, except for occasional visits to the Fairmont's Tonga Room to watch the artificial rainstorm fall on the artificial lagoon each time the band went on break. My companion, A., believed for some reason that there were live deer in the Tonga Room, but they never showed up. For her, Ideality was always something of a disappointment.

To the west of Ideality (we're circling around) is Benevolence. It has two parts: the donors, up in Pacific Heights, and the recipients, down in the Haight. Historically, the Haight was benevolent in other ways: in the '60s, the Diggers opened a "free store" there and gave people what they needed, just for the asking. Nowadays the commerce on Haight Street is mostly the regular kind, some of it legal and some of it not; meanwhile kids from all over ask you for spare change. Will you give it to them? If so, the city's faculty of Benevolence may grow even larger.

To the west of Benevolence is Alimentiveness, which is to be found everywhere in the Richmond. Burmese brunch! Shanghai tea! Dim sum steaming on trays, seafood swimming in blue tanks, oblivious to its fate. At the western edge of Alimentiveness, the Cliff House stares off into Sublimity (see above). I only ever went there once, with my friend K., who was working as a mystery shopper. We didn't eat, but ordered drinks and kept an eye on the bartenders. K. picked up the check: she was going to bill it to mystery, she said.

The Richmond borders Golden Gate Park, where San Francisco keeps its Human Nature. Golden Gate Park was modeled on New York's Central Park, and if it doesn't blend Human and Nature quite as thoroughly as Central Park does, perhaps that's its charm. Seemingly impenetrable groves give way to lawns where shirtless men in great numbers wave bright flags; dusty paths on their way back to being forest lead to greenhouses and roller-skating ovals and museums. The park is too big to be groomed and too small to be wild; its attractions seem slightly lost, like change in a too-big purse. Roses; windmills; rowboats; bison. These last huddle at the far end of their paddock, composed, like everything in the park, but out of place.

To the south of the park is the Sunset. People live there. So the faculty of Inhabitiveness is to be found in the southwest quadrant of the city, just as Fowler situated the domestic propensities on the back of the head. Love of Animals is tucked away in a corner of the neighborhood, at the zoo (although animal-rights activists may disagree that the best way to show our love of animals is by imprisoning them in a panopticon guarded by middle-schoolers). And Philoprogenitiveness, which encompasses Love of Children and Parental Love, is right next door, in St. Francis Wood, Ingleside, Sunnyside, San Francisco State U., the Stonestown Galleria. Philoprogenitiveness shades into Love of Family over in Noe Valley: people there love the *idea* of families, whether or not they have families of their own. Whereas people in the Castro, next door, just like people: they are the city's bump (and grind!) of Gregariousness.

Twin Peaks, which rises out of these domestic regions, surely represents Firmness: an upswelling of bedrock that resists the battering of wet ocean winds from the west and sightseeing buses from the east. The prominence of Twin Peaks might suggest that San Francisco is an exceptionally resolute city, but not so: the wind on the top of Twin Peaks is so blustery that no one stays there long—except the mission blue butterfly, which is, one could conclude, stronger-willed than the city's human inhabitants.

Upper Mission or Lower Mission? Inner Mission or Outer Mission? New Mission or Old Mission? Proud resident of the Mission for __ years? Do you remember when the Dovre Club was on Eighteenth Street, in the Women's Building? Do you remember Mission Street before Foreign Cinema? Valencia before Amnesia? Do you remember the old Rainbow? El Toro or Cancún? Adobe Bookshop or Abandoned Planet? What are your 17 Reasons why the Mission is the site of Criticism and Comparison?

At the north end of the Mission, the Sixteenth Street corridor houses San Francisco's Desire for Liquids. In the bleary, busy 1990s, my friends talked about organizing a Sixteenth Street pub crawl. We would begin at Jackhammer on Sixteenth and Sanchez (now defunct), then visit Jack's Elixir Bar, then Doctor Bombay's, then Kilowatt, then the Albion, Dalva, Skylark, Esta Noche with

its Latino drag artists, Liquid . . . If we'd had one drink in each bar, we never would have made it home. Not that, having discovered Liquid, I wanted to go home anyway.

To the north, Love of Sex extends from the crotch of Highways 80 and 101 to Market Street, encompassing the Folsom Street Fair, the Erotic Cake Guy, various sex clubs, porn theaters, leather bars, adult-DVD emporia, and the Crazy Horse, a topless *and* bottomless joint. On Fowler's phrenological head, this faculty abuts Amativeness and Defiance (it *was* the nineteenth century); here it touches Secretiveness (City Hall—where else?) and Cautiousness (the Tenderloin, a neighborhood with one of the city's highest crime rates). A sign of the times.

Then there's Tune, centered on Fillmore Street, where the city's great jazz clubs used to be: the Bird Cage, the Texas Playhouse, the Blue Mirror, Jack's of Sutter. All those clubs are gone now; in their place there's the Boom Boom Room, the Fillmore, and Yoshi's, a branch of the East Bay joint. Does this mean that the city's faculty of Tune has atrophied? What about all those clubs around Folsom Street: the DNA Lounge, the Paradise Lounge, Slim's? Maybe Tune has moved south of Market, but it's hard to walk up Fillmore Street and not hear an echo of the old days.

Last we come to San Francisco's profile, which runs from the bill of its baseball cap, the Bay Bridge, to its goatee, down by Hunters Point. If the back of the head is the bedroom, the place of children and dreams, then the front is the shop, the place where the city builds and plans. Here's Continuity and its subfaculties Application and Connectedness, to be found in abundance in the offices that overlook South Park. Constructiveness is still to be found in Hunters Point, even though the naval shipyard has closed down and the ground has been poisoned by military research and Pacific Gas and Electric. Now construction happens in artists' studios: more than 250 of them, all told, one of the largest arts communities in America.

Between Constructiveness and Continuity is Mission Bay, where the University of California, San Francisco, built its new research campus a few years back, near Old Navy's world headquarters, a pharmaceutical lab (under construction), and some fancy condos. What will come of this combination? Vat-grown sweaters in jewel tones, which make you calm just looking at them? A cure for the sadness associated with baggy tights? The city keeps its Eventuality here; eventually, something must be coming.

I draw certain conclusions from this map: San Francisco is a benevolent city; it loves its children almost as well as it loves its adults. It lacks a faculty of Destructiveness (with subfaculties Executiveness and Extermination), ever since Survival Research Labs took its fire-spewing robots to Petaluma in 2008. Its Literary, Observing, Knowing faculties are better developed than its Reasoning and Reflective faculties, or its Moral and Religious Sentiments. In short, it's an Ideal place for someone who's looking for the Sublime; it has moments of Firmness but generally gives in to its Desire for Liquids. The city constructs more than it acquires; it anticipates the future more than it venerates the past. Of course, some people will say San Francisco isn't like that. To them I reply: phrenology was never a hard science. Go ahead and draw up a different map, with different faculties. The bumps you read are in the last analysis your own ∞

20 DHARMA WHEELS AND FISH LADDERS

The Bay Area is a region defined in geography and nomenclature by its water—but we too often focus on the land alone. Mapping the little-noticed great salmon migrations, ancient and so important to the life of Northern California, draws attention to the intricate waterways that link the Sierra watershed to the Central and San Joaquin valleys to the delta to the Bay to the Pacific, as well as to the smaller coho streams that trickle down from all the waterfront counties. As a pairing on this map, Zen Buddhism, both an opposite and an analogous phenomenon, made sense. They divide the land and the water between them, and the pure biological cyclicality of the salmon and the once-only arrival of Shunryu Suzuki-Roshi, with their fecund consequences, resonated together. The salmon are declining while Soto Zen is spreading—but at Green Gulch Farm they overlap. CARTOGRAPHY: BEN PEASE ∞ MAP APPEARS ON PAGES 134–135

A WAY HOME BY GENINE LENTINE

A small silver flash—a coho salmon glints, for a moment, in the shallows of Green Gulch Creek. A tributary of Redwood Creek, this creek runs along the fields of Green Gulch Farm, one of the three practice centers that constitute San Francisco Zen Center, founded in 1962 by émigré Soto Zen teacher Shogaku Shunryu Suzuki.

The slight body of the young salmon is the locus for the literal intersection of the subjects of this map: patterns of salmon migration and the footprints of Suzuki-Roshi (venerable teacher Suzuki) in the geological reprieve currently known as the San Francisco Bay Area.

Trace any line on this map, and it will pass through this three-inch body.

Five salmon species ring the northern Pacific in an unbroken arc beginning in Japan and spanning up through Alaska and, until the mid-twentieth century, as far south as the San Joaquin River. The massive nutrient load the salmon hauls upstream, one of the greatest transfers of ecological energy on the planet, shapes the forest and river ecosystems.

At one time, several million salmon swam through the Golden Gate annually. Now, in the inverse ratio so grimly familiar, the rising human population and such concomitant factors as overfishing, pollution, dams, and roads have set off a precipitous drop in this keystone species's numbers, with barely more than fifty thousand chinook swimming through the San Francisco Bay and much diminished coho populations in local streams and rivers.

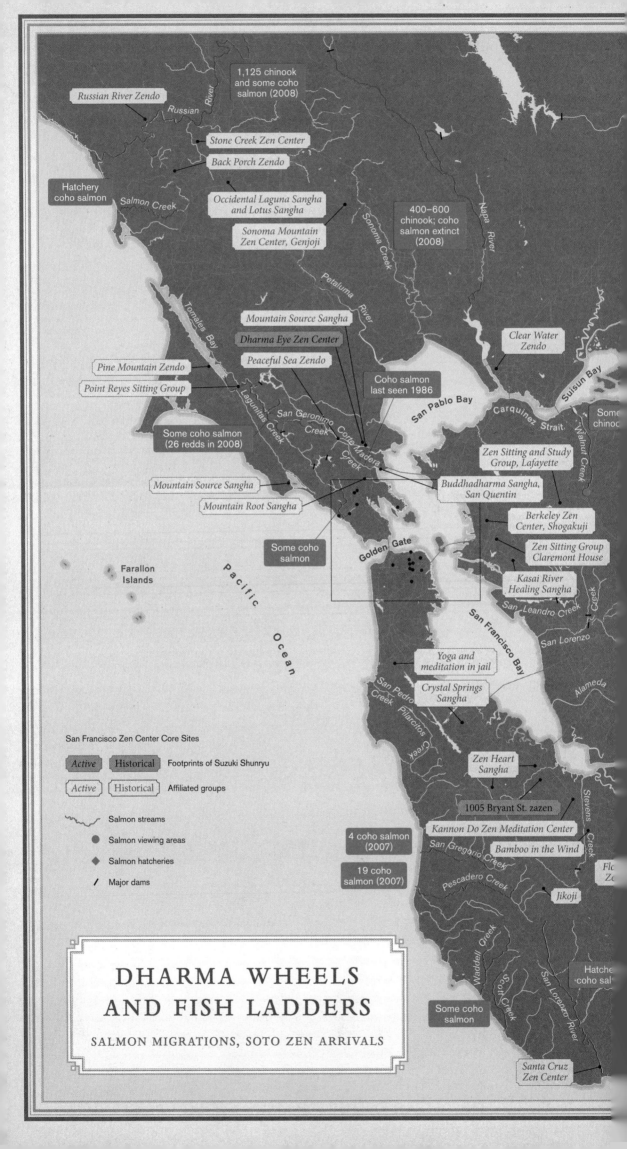

Russian River Zendo

1,125 chinook and some coho salmon (2008)

Stone Creek Zen Center

Back Porch Zendo

Hatchery coho salmon

Salmon Creek

Occidental Laguna Sangha and Lotus Sangha

Sonoma Mountain Zen Center, Genjoji

400–600 chinook; coho salmon extinct (2008)

Russian River

Sonoma Creek

Petaluma River

Napa River

Mountain Source Sangha

Dharma Eye Zen Center

Peaceful Sea Zendo

Clear Water Zendo

Pine Mountain Zendo

Point Reyes Sitting Group

Tomales Bay

Coho salmon last seen 1986

San Pablo Bay

Carquinez Strait

Suisun Bay

Some chinoo

Some coho salmon (26 redds in 2008)

Lagunitas Creek

San Geronimo Creek

Corte Madera Creek

Zen Sitting and Study Group, Lafayette

Walnut Creek

Mountain Source Sangha

Mountain Root Sangha

Buddhadharma Sangha, San Quentin

Berkeley Zen Center, Shogakuji

Zen Sitting Group Claremont House

Some coho salmon

Golden Gate

Kasai River Healing Sangha

San Leandro Creek

Creek

Farallon Islands

Pacific Ocean

San Francisco Bay

San Lorenzo

Alameda

Yoga and meditation in jail

Crystal Springs Sangha

San Pedro Creek

Pilarcitos Creek

Zen Heart Sangha

Stevens Creek

1005 Bryant St. zazen

Kannon Do Zen Meditation Center

Bamboo in the Wind

4 coho salmon (2007)

San Gregorio Creek

19 coho salmon (2007)

Pescadero Creek

Jikoji

Flo Ze

San Francisco Zen Center Core Sites

| *Active* | Historical | Footprints of Suzuki Shunryu |
| *Active* | Historical | Affiliated groups |

⌇ Salmon streams

● Salmon viewing areas

◆ Salmon hatcheries

╱ Major dams

Waddell Creek

Scott Creek

San Lorenzo River

Hatche coho sal

Some coho salmon

DHARMA WHEELS AND FISH LADDERS

SALMON MIGRATIONS, SOTO ZEN ARRIVALS

Santa Cruz Zen Center

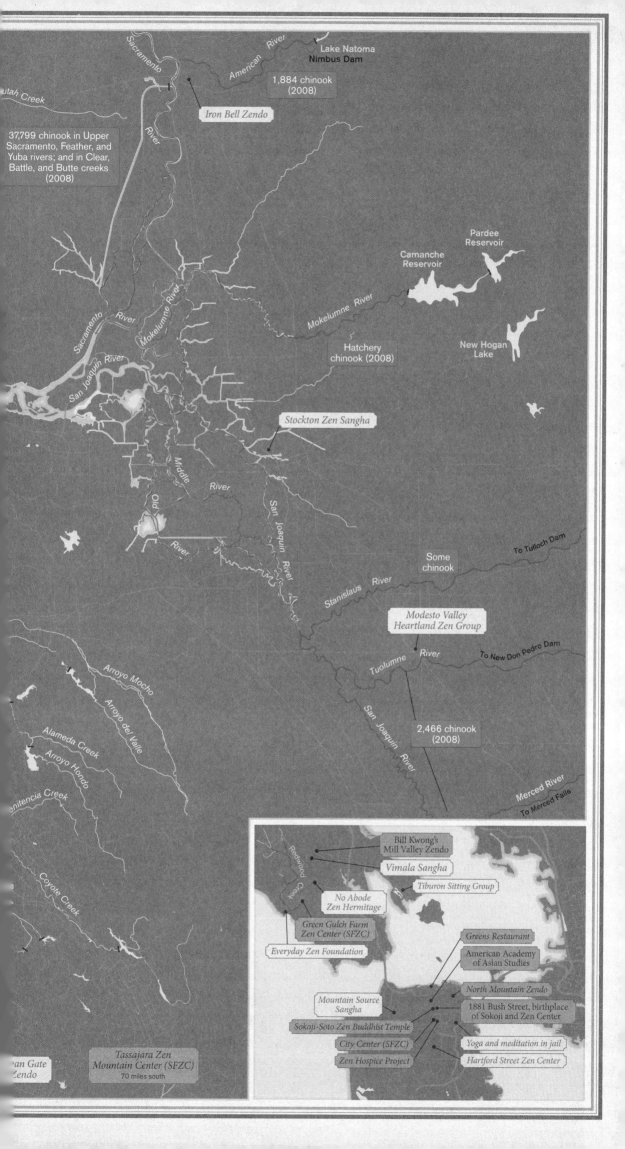

Lake Natoma
Nimbus Dam

1,884 chinook
(2008)

Iron Bell Zendo

37,799 chinook in Upper
Sacramento, Feather, and
Yuba rivers; and in Clear,
Battle, and Butte creeks
(2008)

Sacramento

Sacramento

American River

River

Putah Creek

Mokelumne River

Pardee
Reservoir

Camanche
Reservoir

New Hogan
Lake

Sacramento River

Mokelumne River

San Joaquin River

Hatchery
chinook (2008)

Stockton Zen Sangha

Middle

River

Old

River

San Joaquin River

Some
chinook

To Tulloch Dam

Stanislaus River

Modesto Valley
Heartland Zen Group

Tuolumne River

To New Don Pedro Dam

San Joaquin River

2,466 chinook
(2008)

Merced River

To Merced Falls

Arroyo Mocho

Arroyo del Valle

Alameda Creek

Arroyo Hondo

Penitencia Creek

Coyote Creek

Redwood Creek

Bill Kwong's
Mill Valley Zendo

Vimala Sangha

Tiburon Sitting Group

No Abode
Zen Hermitage

Green Gulch Farm
Zen Center (SFZC)

Everyday Zen Foundation

Greens Restaurant

American Academy
of Asian Studies

North Mountain Zendo

Mountain Source
Sangha

Sokoji-Soto Zen Buddhist Temple

City Center (SFZC)

Zen Hospice Project

1881 Bush Street, birthplace
of Sokoji and Zen Center

Yoga and meditation in jail

Hartford Street Zen Center

San Gate
Zendo

Tassajara Zen
Mountain Center (SFZC)
70 miles south

The presence of Suzuki-Roshi (1904–1971) continues on in the breath, in stories, in the very bodies of those who practiced with him. This is the essence of "warm hand to warm hand transmission," the unbroken lineage, or "bloodline," of the Soto Zen school.

Hold a Zen master and a Pacific salmon in the mind long enough, let the ample metaphorical resonances hum in the proximity thought affords, indulge the associative reveries and the lexical confluences, and soon it's difficult to tell who's leaping and who's sitting. Soon it doesn't matter whose ceremonial robes, with their saturated hues, are shimmering.

Indeed, many core Zen texts—*The Wholehearted Way, The Mountains and Rivers Sutra*—sound as if a salmon might have written them.

If a chinook—the species that travels through the San Francisco Bay estuary to the Upper Sacramento, Feather, Yuba, American, Mokelumne, Stanislaus, Tuolumne, and Merced rivers—were to set forth the qualities of pure salmon nature, they might include vigor, patience, and a willingness to attempt what appears impossible. As Dana Velden, a Zen priest and former board secretary for the Zen Center, puts it, "great effort, totally natural, without striving," though she was talking about zazen, the meditative practice central to the Soto Zen school founded by the thirteenth-century Zen master Eihei Dogen.

Salmon or Zen master? Both are symbolic heavyweights, invoked for their wisdom, courage, equanimity, and penchant for extreme sports.

But this map is not concerned with symbol; this is a map of motion, of embodied vow. The chinook salmon propels its actual body to its natal stream to begin the whole cycle again.

As tempting as it is to draw tidy parallels, the inexorable biological boomerang of the salmon proves difficult to track in human beings, whose capacity for lostness is unfathomable and whose path "home" is often improvisational, indirect, and triangulated.

This is a map of the unmappable, of the infinite traces of one person, just over five feet tall, crossing seven thousand miles of ocean.

"When he was young, Suzuki-Roshi noticed ships being loaded with cheap manufactured goods," Blanche Hartman, senior dharma teacher at San Francisco Zen Center, tells me. "He wished he could bring something authentic. What he brought was the practice of zazen, the teachings of Eihei Dogen."

Suzuki-Roshi's twelve years in America began in 1959 when he came to San Francisco to serve as abbot for the Japanese congregation at Sokoji, located then at 1881 Bush Street. "There was a man who went to San Francisco to open the minds of young Americans, to create a home for their hearts," wrote one of his Japanese students, in *The Nikkei*, after his teacher's death.

This is a map of coincidence, contingency, and commitment.

Not long after Suzuki-Roshi travels east to San Francisco, another person travels west, from New York, drawn to the Bay Area poetry scene. One day he walks into Fields Book Store, hears about Suzuki-Roshi's morning sittings, and decides to investigate. Ten years later, one week before Suzuki-Roshi dies, this person, Richard Baker, is installed as abbot, a position he holds for another twelve-year cycle in the life of the organism that is San Francisco Zen Center.

And as with so many organic cycles, this one begins with a generative flurry and ends with dissolution. And then the next cycle begins.

Suzuki-Roshi lives on in the three practice centers of San Francisco Zen Center, in three valleys: Green Gulch Farm, situated on 115 acres in a valley that opens onto Muir Beach; City Center, established as an urban practice center in San Francisco, housed in a Julia Morgan building in Hayes Valley; and Tassajara, the oldest Japanese Buddhist Soto Zen monastery outside of Asia, nestled in a riparian valley in the Ventana Wilderness.

As San Francisco Zen Center approaches its fiftieth anniversary in 2012, as of this writing 162 priests have been ordained in Suzuki-Roshi's lineage. A network of "Branching Stream" sanghas and other affiliated centers extends worldwide, including groups in England, Iceland, Ireland, Italy, Japan, Poland, and Slovenia. Approximately five thousand people visit Tassajara in the summer guest season. San Quentin State Prison, in Marin County, has a thriving Zen meditation program; and several Bay Area hospitals now engage Zen students as interfaith chaplains. Greens, the landmark Fort Mason restaurant that evolved from Zen Center kitchens, has been a vital force in establishing vegetarian cuisine in the United States.

While San Francisco Zen Center has become the largest Soto Zen organization in the West, the intimacy of face-to-face interaction between teacher and student remains the heart of Zen practice.

More than anything, this is a map *home*.

The field a teacher creates, while cartographically elusive, continues to radiate decades later. Teah Strozer, a dharma heir in the Suzuki-Roshi lineage, serves as chaplain at the Bay School of San Francisco, where students begin each morning with a short period of meditation. Teah offers students what Suzuki-Roshi offered her: a steady, vast presence that helps them viscerally experience their own natural wisdom. She asked a student one afternoon, "I'm curious—what do you do during meditation?" His answer: "Oh, no, no, no, no, I don't meditate." "Oh, okay. What do you do?" she asked, and he explained, "*Well, the first thing I do is relax my body, and then I dive into a cool quiet pool.*" "Okay, don't meditate," she told him. "That's fine, you just keep doing what you're doing."

This is a map that locates what was never lost.

Celestial cues—day length, the sun's angle—along with magnetic compasses help salmon navigate from the ocean to fresh water. In coastal waters, currents, tides, temperature, and an olfactory memory of the natal stream draw them toward the constellation of geology, botany, and biology, the chemical signature that tells them, *this* water flowing over *this* granite.

Students giving "way-seeking mind" talks, exploring their path to meditation practice, frequently describe their first experiences with zazen as "coming home."

This is a map of *here*.

The salmon's migration patterns from fresh water to salt water and back place them in the category of anadromous fish. Hatching in small freshwater streams, in six to nine months they're ready to begin the journey to the ocean, where they will live for an average of three years before returning to fresh water.

Coho return to their smaller local streams during the midwinter rainy season. But spring-run chinook salmon return when the rivers are raging with melted snow, and while they appear muscular and robust, at this point they're done eating. The moment they transfer to the estuary and into fresh water, they're entering into the death process.

Spring-run chinook arrive well before fall, when it's time to lay the eggs, so they hover motionless in the deepest pools available for up to six months. Temperature and chemical cues awaken them to the spawning process, and they start to find gravel of the right size with the right degree of shallow flow to ensure ample oxygen for the eggs. The females turn onto their sides and beat the water and carve out their nest, or redd, for their cache of three thousand to ten thousand eggs, burnishing the rocks white in their effort.

Anyone who practiced with Suzuki-Roshi at Tassajara celebrates his affinity with stone, his sense of ballast, the precision of pivot that allowed him to move massive slabs with preternatural ease.

"Zen is making your best effort on each moment." Blanche Hartman lives into this signature quote from Suzuki-Roshi, the way the coho I watched in a swirling pool at the base of the Inkwells, a series of small waterfalls on San Geronimo Creek, "practiced" with the onrush of water. About salmon, she points out, "their efforts are not for themselves but for the benefit of the species."

After the female releases the eggs, sperm has less than a second to penetrate the cell walls of the eggs. After depositing their milt, the males almost immediately bolt. The females then rebury the eggs. Within twelve to thirty hours, the parents will die.

What is the self? Ask a chinook, and it might reply, "The river." It might tell you the self extends for hundreds of miles, the distance it has traveled to spawn. It might identify the dam blocking its passage or refer you to the teeming aggregate. Or ask you, as the water washes away a cluster of eggs, "Where does the body begin?"

Asked to sum up Buddhism, Suzuki-Roshi answered, "Everything changes."

As the salmon die, "they go through this mystical transformation," offers Derek Hitchcock, an ecologist with the South Yuba River Citizens League. "It's not like life/death or death/life. They're floating in the middle for this dreamy period. They die and they awaken. They play with the veil."

Lew Richmond, who leads the Vimala Sangha in Mill Valley, recalls, "When Suzuki-Roshi became terminally ill with cancer, our whole world seemed to collapse. But not his. Even though his skin was gradually turning green, . . . he hobbled about in the halls, joking about his illness, . . . apologizing for being a 'lazy monk.'"

This is a map of "the veil."

In his 1999 biography *Crooked Cucumber*, David Chadwick describes Richard Baker's Mountain Seat Ceremony, in which Suzuki-Roshi installed Baker as his first successor. "Suzuki was walking with the staff Alan Watts had given him. Affixed to the top was a bronze headpiece with rings. . . . With each step he struck the floor with his staff, as if continuing to plant the dharma in America."

He died one week later, on the first morning of Rohatsu Sesshin (a seven-day silent retreat commemorating Buddha's enlightenment). Steve Weintraub, dharma heir in the Suzuki-Roshi lineage, said of that morning, "Shortly after Baker-Roshi sat down, there was a commotion, somebody walking fast in the zendo. Big whoosh of robes. And we all sat there."

The blue mountains are constantly walking.

This line from Dogen's *Mountains and Rivers Sutra* reminds us that everything is in motion. Grammatically, mountains are categorized as events in some languages. The human skull is not one solid mass, but twenty-two bones held together by sutures, in constant subtle motion. Twenty thousand years ago, the Farallones were the west coast of California.

Coho salmon come up Redwood Creek through Muir Woods, near Green Gulch Farm, from November to February. After heavy rains in 2004, a student walking back from Muir Beach along the farm road heard a slapping sound in the adjacent smaller creek that runs through Green Gulch and found two adult coho building their redd.

The following April, Darren Fong, an aquatic specialist from the National Park Service, came out to Green Gulch. With one dip of his net, he pulled out a coho fingerling. Further investigations indicated the presence of a large brood, which established Green Gulch Creek as a salmonid creek. Based in part on this designation, the California Department of Fish and Game awarded a grant to the Zen Center in February 2009 to create a design for restoring the creek to its original course.

A few days before he died, Suzuki-Roshi told his son, Hoitsu, "I will become American soil."

Usually, nutrients flow downstream to the sea, but the salmon reverse this flow. As Derek Hitchcock notes, "The salmon cross an unusual threshold, transmitting nutrients from the biological engine of the planet, the ocean, far upstream into the headwaters of our mountain rivers." Nearly one hundred and fifty known species—bears, otters, raccoons, an array of insects, even the next generation of salmon themselves—along with the topsoil and trees are nourished in this process.

From ten thousand eggs, if all goes well, two fully grown salmon might make it back.

Mitsu Suzuki petitioned her husband as he prepared the talks that became *Zen Mind, Beginner's Mind*, which has reached millions of readers in at least fourteen languages: "But why do you put so much energy into a talk for one person?" ∞

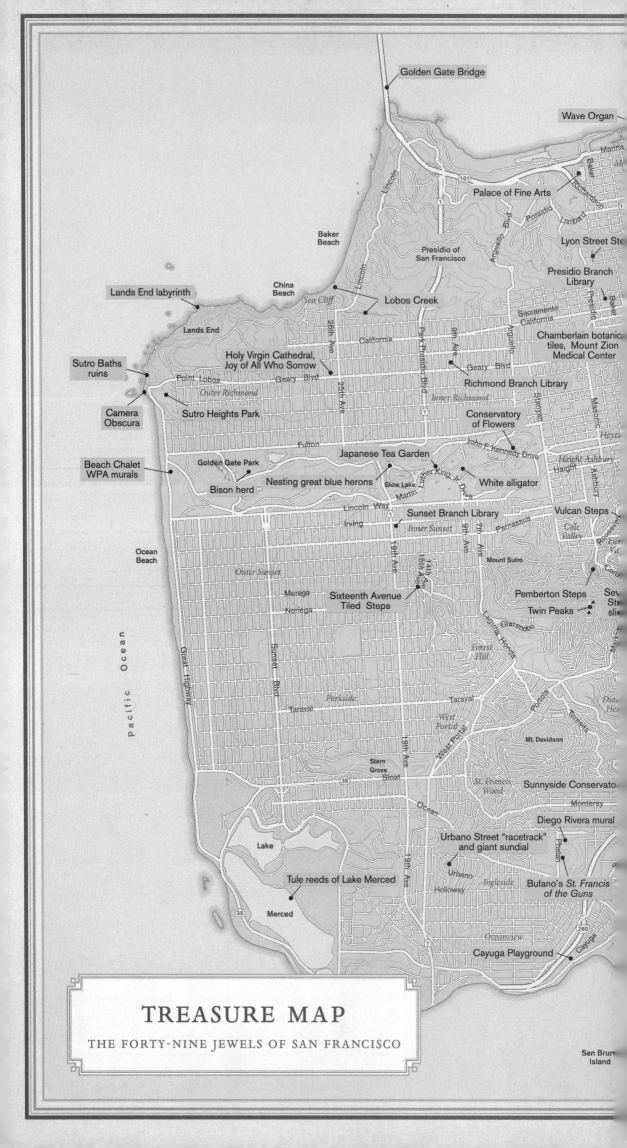

Golden Gate Bridge

Wave Organ

Palace of Fine Arts

Lyon Street Ste

Presidio Branch
Library

Baker
Beach

Presidio of
San Francisco

Lands End labyrinth

China
Beach

Sea Cliff

Lobos Creek

Chamberlain botanic
tiles, Mount Zion
Medical Center

Lands End

California

Sutro Baths
ruins

Holy Virgin Cathedral,
Joy of All Who Sorrow

Geary Blvd

Richmond Branch Library

Point Lobos

Geary Blvd

Outer Richmond

Camera
Obscura

Sutro Heights Park

Inner Richmond

Conservatory
of Flowers

Fulton

Beach Chalet
WPA murals

Golden Gate Park

Japanese Tea Garden

John F. Kennedy Drive

Haight Ashbury

Haight

Bison herd

Nesting great blue herons

Stow Lake

White alligator

Lincoln Way

Sunset Branch Library

Vulcan Steps

Irving

Inner Sunset

Cole
Valley

Ocean
Beach

Outer Sunset

Mount Sutro

Sixteenth Avenue
Tiled Steps

Pemberton Steps

Sev
St
sli

Moraga

Twin Peaks

Noriega

Clarendon

Pacific Ocean

Laguna Honda

Forest
Hill

Great Highway

Sunset Blvd

Taraval

Parkside

Taraval

Pomona

Teresita

Dia
He

West
Portal

Mt. Davidson

Taraval

West Portal

Stern
Grove

St. Francis
Wood

Sunnyside Conservato

Sloat

Ocean

Monterey

Diego Rivera mural

Lake

Urbano Street "racetrack"
and giant sundial

Phelan

Tule reeds of Lake Merced

Urbano

Ingleside

Bufano's St. Francis
of the Guns

Holloway

Merced

Oceanview

Cayuga

Cayuga Playground

San Brun
Island

TREASURE MAP

THE FORTY-NINE JEWELS OF SAN FRANCISCO

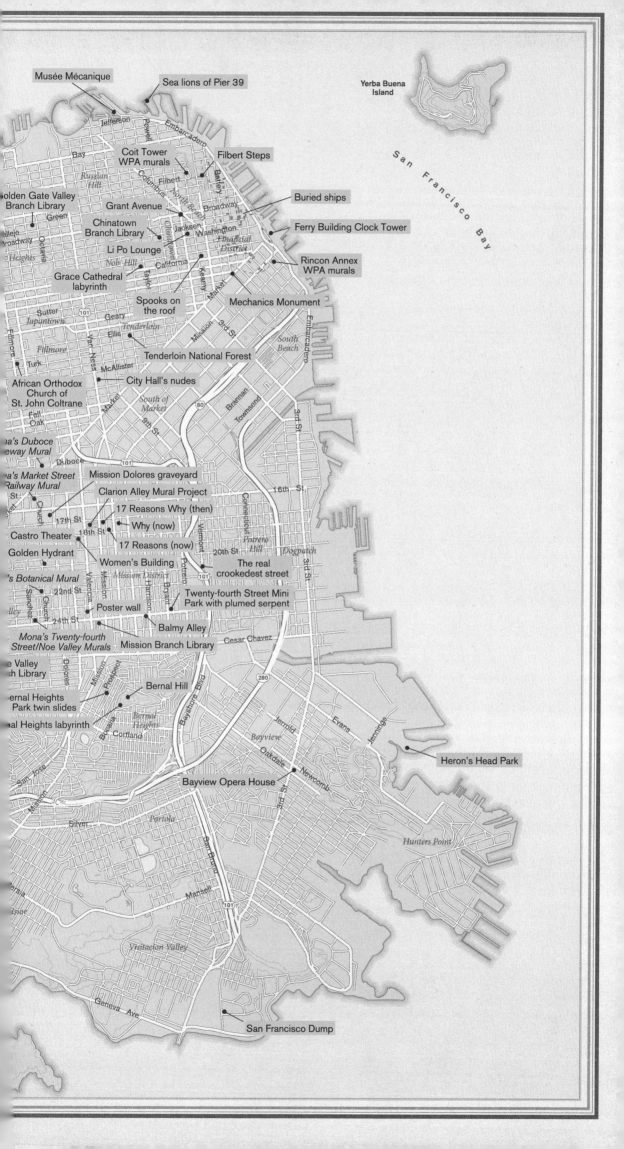

Musée Mécanique

Sea lions of Pier 39

Yerba Buena
Island

Jefferson

Embarcadero

Bay

Coit Tower
WPA murals

Filbert Steps

San Francisco Bay

Russian
Hill

Powell

Filbert

North Beach

Battery

Golden Gate Valley
Branch Library

Grant Avenue

Broadway

Buried ships

Green

Chinatown
Branch Library

Columbus

Chinatown

Jackson

Washington

Ferry Building Clock Tower

Broadway

Li Po Lounge

Financial
District

Heights

Nob Hill

California

Keary

Market

Rincon Annex
WPA murals

Grace Cathedral
labyrinth

Taylor

Spooks on
the roof

Mechanics Monument

Sutter

Japantown

Geary

Van Ness

Mission

Embarcadero

3rd St.

South
Beach

Ellis

Tenderloin

Tenderloin National Forest

Fillmore

Turk

McAllister

African Orthodox
Church of
St. John Coltrane

City Hall's nudes

Market

South of
Market

Fell

Oak

9th St.

Brannan

Townsend

80

3rd St.

Mona's Duboce
way Mural

Duboce

101

Mona's Market Street
Railway Mural

Mission Dolores graveyard

16th St.

Clarion Alley Mural Project

Connecticut St.

17th St

17 Reasons Why (then)

Church

Vermont

Castro Theater

18th St.

Why (now)

Golden Hydrant

17 Reasons (now)

20th St.

Potrero
Hill

Dogpatch

's Botanical Mural

Women's Building

Potrero

The real
crookedest street

Sanchez

22nd St

Mission District

Valencia

Mission

Harrison

Bryant

101

Twenty-fourth Street Mini
Park with plumed serpent

Church

Poster wall

24th St

Balmy Alley

Mona's Twenty-fourth
Street/Noe Valley Murals

Mission Branch Library

Cesar Chavez

e Valley
h Library

Dolores

Mission

Prospect

Bernal Hill

280

ernal Heights
Park twin slides

Bocana

Bernal
Heights

Jerrold

Evans

Jennings

al Heights labyrinth

Cortland

Bayview

Heron's Head Park

San Jose

Oakdale

Newcomb

Bayview Opera House

3rd St.

Silver

Portola

Hunters Point

San Bruno

ersia

Mansell

101

Visitacion Valley

Geneva Ave

San Francisco Dump

21 TREASURE MAP

I've often thought of San Francisco as nearly an island, and it was a pleasure to saw off its southern edge and make it truly one on this treasure map. I collected ideas from many people about the most enchanting public sites in this city, whose treasures are as numerous as its residents. For a city whose growth exploded in 1849 and whose dimensions are seven miles square, forty-nine seemed like a suitable quantity of sites to map, and so here they are, some architectural, some natural, and all available to visit except for the buried ships of that bygone Gold Rush city, imaginable whenever you're downtown and standing above them. CARTOGRAPHY: SHIZUE SEIGEL ∞ MAP APPEARS ON PAGES 140–141

FROM THE GIANT CAMERA OBSCURA TO THE BAYVIEW OPERA HOUSE BY REBECCA SOLNIT

One rainy summer day in Scotland in 1881, a twelve-year-old boy born in San Francisco began drawing a map of an island. His stepfather finished it, added names, and then wrote in the upper right-hand corner, "Treasure Island." The boy was named Lloyd Osbourne; the stepfather was named Robert Louis Stevenson. The map inspired the stepfather's novel, which bequeathed its name and some of its motifs—notably pirates—to a Disneyland ride, then a Las Vegas casino, and finally a series of films that grossed billions of dollars. It was the map of an imaginary place, and when the original scrap of paper was sent to the publishers, they lost it, much to Stevenson's chagrin.

Every map is a guide to finding the desirable and navigating the dangerous. Every landmass is in some sense an island, a fragment of the mother island Pangaea, which fragmented into the floating continents. California was long imagined as the island at the end of the world, because that's how the stories went and because they needed an island. Every map is a treasure map, every island a Treasure Island. The actual Treasure Island in San Francisco Bay is only a constructed pancake of landfill joined by an isthmus to the geological cupcake of Yerba Buena Island. But San Francisco is very nearly an island—the tip of a long peninsula connected by two bridges and two roads to the rest of the world, separated even from the rest of the peninsula by the long hunch of San Bruno Mountain and possessed of culture and weather that separate it from the region and the nation. So, at my request, Shizue Seigel finished the job and gave it a south coast on this map.

Stevenson actually lived in San Francisco for a little while, at 608 Bush Street in Chinatown, while waiting for Osbourne's mother, Fanny, to obtain her divorce from the child's father, Samuel Osbourne (who was, by most accounts,

a whoring, gold-chasing, dry-land pirate himself); and aspects of the local landscape are said to have found their way into Stevenson's book. His broad and deep imagining of pirates and buried treasure is a waterlogged version of the Gold Rush and the West in many ways, and this makes isolate San Francisco a treasure island of another kind.

Choosing treasures for this map was an adventure in itself, and many friends helped. A lot of treasures were left out—some because they're celebrated elsewhere in this book, some because they're fragile or secret—and, of course, the treasures are as infinite as the city; everyone has their own list.

Here they are, with addresses when necessary.

1. The Golden Gate Bridge, which speaks for itself, in red.

2. The Palace of Fine Arts, 3301 Lyon Street, in the Marina. The recently restored structure represents the last remains of the Panama-Pacific International Exposition of 1915, a fantasy that didn't dissolve. It is also the longtime home of the Exploratorium, slated to move to a pier soon.

3. Lobos Creek, off Lincoln Boulevard opposite Baker Beach. Lobos is the last free-flowing creek in San Francisco, a thread of continuity with the past and a hope for nature in the city of the future, as well as a good excuse to go tramping through the eucalyptuses and Monterey pines. It is a jewel amid former military land.

4. Camera Obscura, Cliff House. This is both an eclectic architectural joy and a wonder inside, where the magnificent surrounding landscape is projected into a dark basin through the agency of nothing but light and lenses, a movie of this very moment made of pure light. The device is a precursor of photography and cinema, and the enterprise was once the subject of a battle to protect it, in which one ardent devotee changed her name legally to Camera Obscura.

5. Sutro Baths ruins and Sutro Heights Park, Lands End. In a city where real estate interests have turned over nearly every vacant lot, ruins themselves are treasures; and the site of mining magnate Adolph Sutro's once-magnificent bathing establishment has a unique magical melancholy, there at the end of the world. A garden full of statuary sits on the bluff above, also courtesy of Sutro.

6. Ann Chamberlain's botanical tiles, University of California, San Francisco, Mount Zion Medical Center, 2356 Sutter, near Divisadero, and Breast Care Center, 1600 Divisadero. This public artwork gathers a vast collection of stories by those undergoing treatment for cancer and the people who love them, by a beloved artist who herself died of the disease in the spring of 2008.

7. The seven Carnegie branch libraries of the San Francisco Public Library system: Richmond Branch, 351 Ninth Avenue; Mission Branch, 300 Bartlett Street, at Twenty-fourth; Noe Valley Branch, 451 Jersey Street, near Castro Street; Golden Gate Valley Branch, 1801 Green Street; Sunset Branch, 1305 Eighteenth Avenue, near Irving; Chinatown Branch, 1135 Powell Street; Presidio Branch, 3150 Sacramento Street, at Baker Street. All libraries are jewel boxes, holding troves of books, but these seven small libraries, built between 1914 and 1921, look it, with their arched windows, ornate coffered ceilings, and enchanting entryways.

8. The Wave Organ, off the Marina, 1 Yacht Road. Sometimes when the water is right, artist Peter Richards's and stonemason George Gonzales's 1986 Wave

Organ actually makes low moans and songs. But silent or not, it's an occasion for an excursion that ends in a stone garden built of cemetery rubble with a ravishing view.

9. The sea lions of Pier 39. This population, thought to have migrated from Seal Rocks, near the Cliff House, was originally regarded as a nuisance and a menace. But the Marine Mammal Center recommended removing the boats rather than the beasts, and so a sanctuary was born. More than a thousand sea lions at a time have been counted in May and June.

10. The Musée Mécanique, Pier 45, Shed A. The Musée was once part of Playland at the Beach, an amusement park destroyed in the early 1970s, and was subsequently housed under the Cliff House, near the Camera Obscura, until it was driven forth early in the current century. The new home is less enchanting, but, for a quarter, the Mystic Ray still reads your palm and the toothpick Ferris wheel still spins.

11. Grant Avenue between Bush and Broadway. This portion of Grant Avenue boasts the dragon lamps of Chinatown and the only American bar with a Chinese poet's name in neon: the Li Po Lounge, 916 Grant Avenue, across the street from the equally scruffy Buddha Lounge.

12. The labyrinths at Grace Cathedral, 1100 California Street at Taylor, and the handmade and ephemeral labyrinths on Bernal Hill and at Lands End. Labyrinths are newly popular features of the North American landscape, and at least ten are reputed to be in the city, including these four.

13. Holy Virgin Cathedral, Joy of All Who Sorrow, 6210 Geary Boulevard, near Twenty-sixth Avenue. Russian icon–style paintings cover the high-vaulted interior, and the body of the founding saint lies in a glass reliquary. On the holidays, Russian Orthodox services with shaggy priests, brocade robes, and magnificent chanting transpire.

14. The Japanese Tea Garden, Golden Gate Park. Orange pagoda, moon bridge, cherry trees, bronze cranes, stepping stones, golden fish in narrow channels— this is the oldest Japanese garden in the United States. A deep bow to Makoto Hagiwara, founder and caretaker until World War II.

15. The white alligator at the California Academy of Sciences (only one of its myriad treasures, from meteors to electric eels), the bison who have long resided northeast of Chain of Lakes, and the great blue herons who nest near Stow Lake—all in Golden Gate Park. To say nothing of the fast-moving glory of the endangered snowy plovers at Ocean Beach, the sooty and the pink-footed shearwaters, the storm petrels, the marbled godwits, the curlews, the sandpipers, the wandering tattlers, the brown pelicans, the seven sorts of gull; and inland the mourning doves, the swallows, the California quail, three sorts of hummingbirds, the azure Steller's jays and scrub jays, the feral parrots in squeaky green flocks all over the east and central city, the migratory raptors, and the songbirds too numerous to name. And the raccoons on their midnight raids and the elusive coyotes.

16. The Conservatory of Flowers, Golden Gate Park. A cloud forest habitat and several others in a series of climates all their own can be found inside a fairytale palace building erected in the park in 1878–1879.

17. The Sixteenth Avenue Tiled Steps, by Colette Crutcher and Aileen Barr, at Sixteenth and Moraga; the Vulcan Steps between Ord and Levant streets, near Seventeenth Street; the Filbert Steps on Telegraph Hill; the Pemberton Steps

from Clayton up to Crown Terrace; the Lyon Street Steps between Broadway and Green. These are only some of the stairways that take you up to view the city from its heights. The Sixteenth Avenue Tiled Steps are a mosaic wonder.

18. The African Orthodox Church of St. John Coltrane, 1286 Fillmore Street, near Turk. Evicted in 1999 from its longtime Divisadero home, this church, with its devotion to jazz mysticism and its beautiful icons, found a new perch on the old jazz boulevard.

19. City Hall's nudes. City Hall is all kinds of magnificence: the tallest dome in the nation, forty-two feet taller than the dome of the nation's Capitol building, and the marble nudes all over it are apt icons for a city of eros and liberation. Indoors, voluptuous women represent liberty, equality, strength, and learning. Even Father Time is muscular and unclothed, above the inscription "San Francisco, o glorious city of our hearts that has been tried and not found wanting, go thou with like spirit to make the future thine."

20. Tenderloin National Forest, Cohen Alley, off Ellis near Leavenworth. This small, crowded paradise garden is made entirely out of love and will—and plants, murals, and paving by an old Portuguese stonemason and dedication by Rigo and by Darryl and Laurie from the Luggage Store and others, a lush refuge in a tough neighborhood.

21. Spooks on the roof: the statues atop 580 California Street, at Kearny. The neo-classical forms of Muriel Castani's "corporate goddesses" are surprises hidden up high in the Financial District.

22. Douglas Tilden's Mechanics Monument, Market at Battery and Bush. This pile of muscular male form—corporeal gods, the antithesis of those corporate goddesses nearby—has been a downtown landmark since 1901 and a testament to physical labor in an increasingly disembodied work zone. A plaque at its feet marks the old shoreline, now several blocks inland.

23. The buried ships of downtown San Francisco. These are rarely seen but can always be imagined: the old wooden sailing ships around which land was built or ones that were dragged ashore to become hotels and storehouses in the early years of the Gold Rush. Their hulls periodically resurface in downtown excavations.

24. The tower of the 1898 Ferry Building on the Embarcadero, especially seen from very far up Market Street. Modeled after the Giralda Tower, a Spanish minaret said to have once been the tallest tower in the world (and now the bell tower of the Cathedral of Seville), the Ferry Building Clock Tower is a landmark from any point on Market Street and many other points on the bay, one of the centers of the many-centered city. The great hall is marvelous too, even if the treasures within are a little too precious.

25. The Castro Theater, 429 Castro Street, at Market. The Castro is the last great movie palace of San Francisco, the anchor of the neighborhood, and the home of many film festivals.

26. The graveyard at Mission Dolores—the trees, the tombstones, and the replica of an Ohlone hut—Dolores between Sixteenth and Seventeenth. A melancholy beauty pervades this place, one of only two cemeteries left in the city from which all the other dead were evicted. The Ohlone hut appeared suddenly a few years ago, as if staking a claim for life and the original residents, in this garden of death and colonial intrusion.

27. The Golden Hydrant, Church Street at Twentieth. This is the smallest treasure on the map, but it is, as "the hydrant that saved the Mission," perhaps responsible for much around it. Early on the morning of April 18 every year, it's regilded to commemorate its role as one of the very few hydrants that still supplied water to fight the fires in the wake of the 1906 earthquake.

28. "Mona Caron Boulevard." This series of murals by a much-loved San Francisco artist and activist includes her *Duboce Bikeway Mural*, at Church and Duboce behind Safeway; the *Market Street Railway Mural*, at Fifteenth and Church; the *Botanical Mural*, at Twenty-second and Church; and the *Twenty-fourth Street/ Noe Valley Murals*, at 3871 Twenty-fourth Street, between Vicksburg and Sanchez, which feature botanical illustrations reflecting the farmers market held there. Her newest mural is at Jones and Golden Gate.

29. The mural-covered Women's Building, 3543 Eighteenth Street, near Guerrero. Feminism and Rigoberta Menchu, writ large by local muralist Juana Alicia and her team. Some still miss the evicted Irish Republican bar, the Dovre Club, that once inhabited the building's corner.

30. Clarion Alley Mural Project (CAMP), between Mission and Valencia, parallel to Seventeenth and Eighteenth streets. The Mission may be the mural capital of the United States. While most derive from the Diego Rivera / Chicano revival style, Clarion Alley brought in a panoply of other styles by young local artists and made a drug-and-debris-infested alley a carnival of visions.

31. The dismantled 17 Reasons Why sign. For nearly half a century, a huge sign stating with poetic opacity "17 Reasons Why" in cutout metal letters towered above the southwest corner of Mission and Seventeenth streets. In 2002 it was replaced by a depressingly ordinary commercial billboard, but its memory and fragments live on nearby: the 17 Reasons piece resides at Oddball Films, 275 Capp; and Why sits in architect David Baker's backyard at 337 Shotwell.

32. Bruce Tomb's poster wall, Valencia between Twenty-third and Twenty-fourth streets. The architect / artist says that in the suburbs, he'd tend a lawn; in the Mission, he tends the twenty-foot-square wall of the former police precinct he lives in. It's become the preeminent poster wall in the city and maybe the country, a gathering place for a constantly metamorphosing dialogue about local and global issues and a landing zone for huge and handmade posters and prints, sometimes furious, often gorgeous.

33. Balmy Alley, between Twenty-fourth and Twenty-fifth streets in the Mission, parallel to Harrison. Another great collection of murals—during the 1980s many of them addressed the dirty wars in Central America; during Día de los Muertos, a candlelit procession would wind through the alley.

34. The Twenty-fourth Street Mini Park playground with murals by various parties, a fountain, and Colette Crutcher's mosaic sculpture of Quetzalcoatl, the plumed serpent god, at Twenty-fourth and York, in the heart of the Latino Mission.

35. The wild top of Bernal Hill, with its views, its owls, its coyotes, and its air. In spring it's a green dome visible from across town.

36. The Bernal Heights Mini Park twin slides at Esmeralda and Winfield, on the west side of Bernal; the Seward Street slides at Seward and Douglass.

37. The real crookedest street, Vermont between Twentieth and Twenty-second streets.

38. Cayuga Playground and its sculptures by Demi Braceros, 301 Naglee, at Cayuga Avenue. A fantastic collection of wooden carvings that sits in a park lovingly maintained by the neighbors. It is one of many folk-art environments around the city, some as ephemeral as storefront window installations, some as lasting as the shoe garden in Alamo Square.

39. The top of Twin Peaks. Buffeted by wind, this hilltop remains the habitat of the mission blue butterfly and offers a view of the city below, of four or five other counties, of the Farallon Islands on the horizon, or of nearby tourists shivering in the fog.

40. Urbano Street, which follows the oval outline of the former Ingleside Racetrack, and the giant sundial inside it on Entrada Court. This must be San Francisco's suburban answer to the Nazca lines.

41. The tule reeds of Lake Merced. In this semi-wild environment, tule reeds grow ten feet tall. They were used by the indigenous inhabitants to make boats akin to those of Bolivia's Lake Titicaca.

42. Beniamino Bufano's *St. Francis of the Guns*, in front of the Science Hall at City College. This sculpture is made of two thousand melted-down handguns. It depicts Abraham Lincoln, Martin Luther King Jr., and the Kennedy brothers, all assassinated by such weapons.

43. Diego Rivera's grand mural, Diego Rivera Theater, City College of San Francisco. Painted for the 1940 Golden Gate International Exposition on Treasure Island, this mural about pan-American unity was moved to the community college and installed in 1961. The great Mexican muralist said, "It is about the marriage of the artistic expression of the North and of the South on this continent."

44. Heron's Head Park, at the end of Cargo Way. Formerly Pier 98 on the city's industrial coast, this spit of land shaped like a heron's head is home to lupines, poppies, horizontal space, solitude, wild birds, coyote bush, and wetlands restoration.

45. Bayview Opera House, 4705 Third Street. A longtime community center, scene of many historic moments.

46. Sunnyside Conservatory, 236 Monterey Boulevard, at Congo. A ruin restored.

47. The San Francisco Dump, 501 Tunnel Avenue, off Bayshore. The city dump is the site of many treasures lost and found, an artists' residency program, a hillside of recovered toys, a smell that kept development at bay in the fragile San Bruno Mountain habitat, and great flocks of gulls and corvids.

48. The Depression-era murals at the Beach Chalet, the Rincon Annex, and Coit Tower, painted under the auspices of the Works Progress Administration (WPA). The Beach Chalet murals, by Lucien Labaudt, are pure arcadian imagery; but the Anton Refregier historical murals at the Rincon Annex Post Office downtown were so incendiary that the artist was forced to paint out portions of them. The Coit Tower murals by Ralph Stackpole and more than a dozen other painters include all kinds of workers in the industries of the era, a traffic accident, a bank robbery, left-wing newspapers, rich ladies in furs, local scenes, and far, far more.

49. The fog ∞

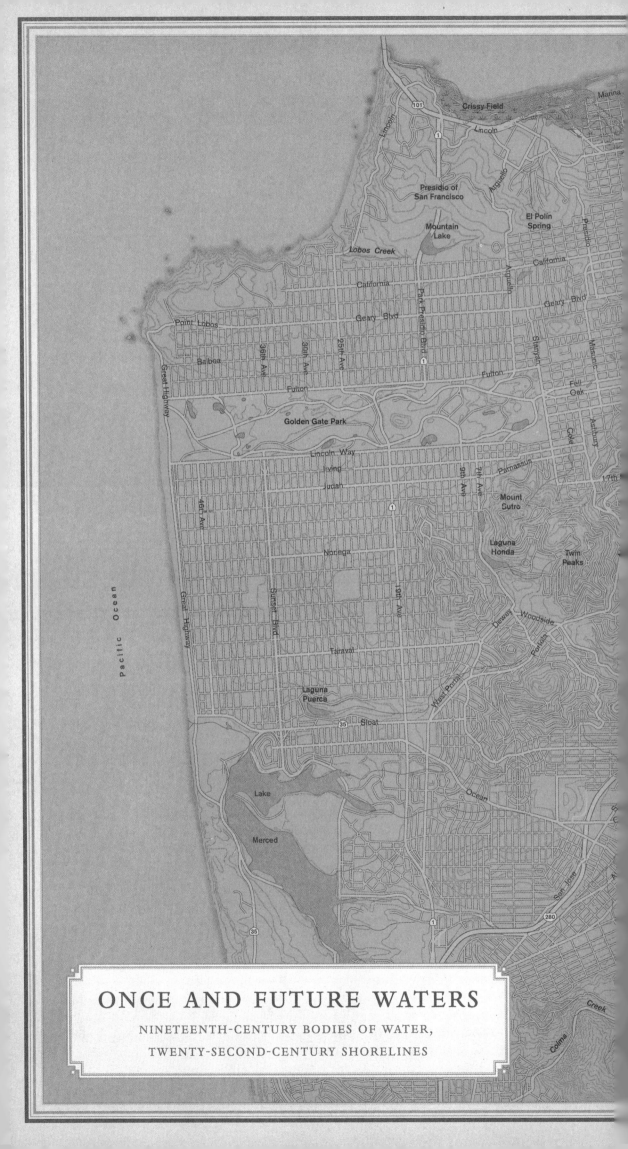

Marina

Crissy Field

Lincoln

101

Lincoln

Presidio of
San Francisco

Arguello

El Polín
Spring

Presidio

Mountain
Lake

Lobos Creek

California

California

Point Lobos

Geary Blvd

Park Presidio Blvd

Geary Blvd

Stanyan

Masonic

25th Ave

Fulton

Fell

36th Ave

30th Ave

Balboa

Oak

Fulton

Cole

Asbury

Great Highway

Golden Gate Park

17th

Lincoln Way

Irving

9th Ave

7th Ave

Parnassus

Judah

Mount
Sutro

46th Ave

1

Laguna
Honda

Twin
Peaks

Noriega

Pacific Ocean

Sunset Blvd

19th Ave

Dewey

Woodside

Great Highway

Portola

Taraval

West Portal

Laguna
Puerca

Sloat

35

Ocean

Lake

Merced

San Jose

1

280

35

Creek

Colma

ONCE AND FUTURE WATERS

NINETEENTH-CENTURY BODIES OF WATER,
TWENTY-SECOND-CENTURY SHORELINES

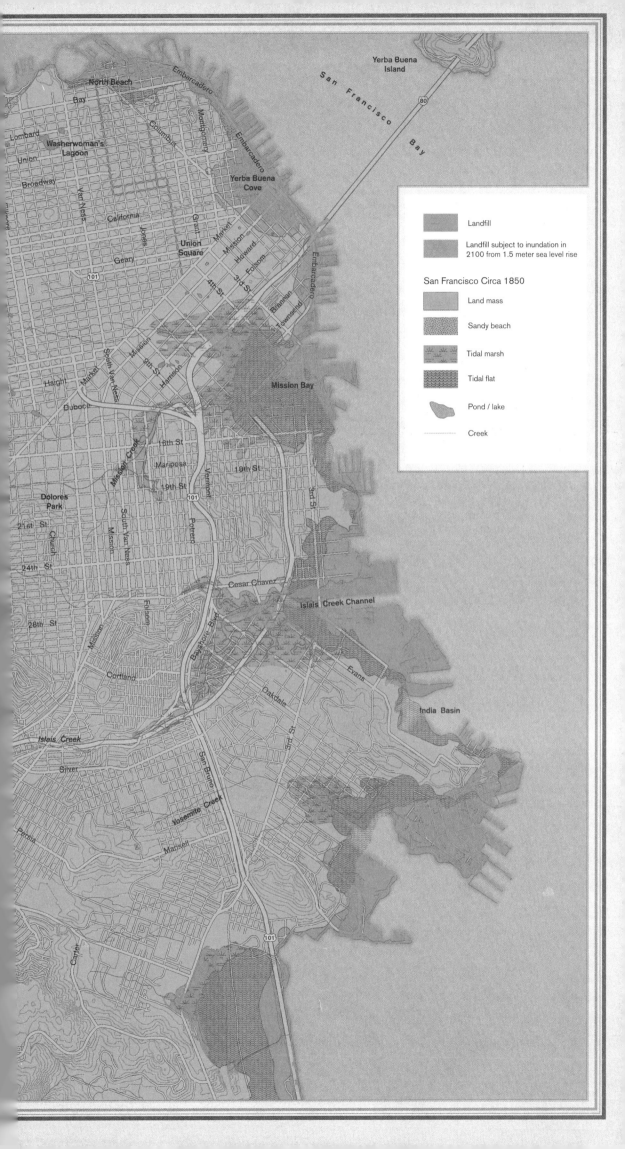

San Francisco Bay

Yerba Buena
Island

80

North Beach

Bay

Lombard
Washerwoman's
Lagoon
Union

Broadway

Embarcadero

Columbus

Montgomery

Embarcadero

Yerba Buena
Cove

Van Ness

California

Grant

Jones

Union
Square

Market

Mission

Geary

Howard

4th St

3rd St

Folsom

Brannan

Townsend

Embarcadero

101

Market

Mission

South Van Ness

Haight

9th St

Harrison

Duboce

16th St

Mission Creek

Mariposa

18th St

Mission Bay

19th St

Vermont

101

3rd St

Dolores
Park

21st St

Church

South Van Ness

Potrero

24th St

Mission

28th St

Cesar Chavez

Islais Creek Channel

Folsom

Cortland

Bayshore Blvd

Evans

India Basin

Islais Creek

Oakdale

3rd St

Silver

San Bruno

Yosemite Creek

Persia

Mansell

Cortez

101

San Francisco Bay

	Landfill
	Landfill subject to inundation in 2100 from 1.5 meter sea level rise

San Francisco Circa 1850

	Land mass
	Sandy beach
	Tidal marsh
	Tidal flat
	Pond / lake
-----	Creek

22 ONCE AND FUTURE WATERS

Next to the Mechanics Monument on Market Street at Battery and Bush, just north of First Street, is a small plaque in the sidewalk informing passersby that it marks the old shoreline. Although today several streets lie east of First Street, the cove that downtown first grew up around once reached to this point. During the height of the Gold Rush, when the city began to explode with new citizens and new construction, the cove was rapidly filled in to create land—speculators bought "water lots" and turned them into (somewhat) solid ground. Similarly, much of the open water of the city has been buried, as marshes, lagoons, ponds, streams, and tidal flats were filled in at the behest of developers and real estate magnates.

This is a map of both that lost water and the water yet to come when the ocean rises—and when it does rise, the sea will take back much of what was taken from it long ago, unless levees and dikes are erected. Based on the 1.5-meter rise in sea level shown on the map (a conservative projection), Mission Bay could become a bay again, as could downtown's cove, and Islais Creek's great delta could reassert itself to make Bayshore Boulevard part of a shoreline again, while Crissy Field's newly restored Crissy Lagoon could increase in size. Some of the underground springs and buried streams could reappear (some of them, such as those in a few rocky outcrops of Twin Peaks, still seep water today).

Sea-level rise is only one of the consequences of climate change that San Francisco faces: the snowmelt in the Sierra that produces such a steady flow of spring and summer water to the city's reservoirs and the state's rivers could instead cause floods as winter rainfall; species could die out or migrate; and refugees from the many other areas that will be far more devastated could show up here. All coastal maps show sea level as it has been recently but in looking at how it will change in the coming century, it's worth remembering that sea level has also been far lower—once, the Farallon Islands were part of an ice age coast that extended thirty miles west of the current San Francisco shoreline. This map reaches forward and back in time from the present; reach further and you find greater change.

CARTOGRAPHY: BEN PEASE, FROM A MAP CREATED BY ROBIN GROSSINGER AND RUTH ASKEVOLD OF THE SAN FRANCISCO ESTUARY INSTITUTE, BASED ON INFORMATION FROM *BAY AREA ECOATLAS: GIS OF WETLAND HABITATS PAST AND PRESENT* (SAN FRANCISCO ESTUARY INSTITUTE, 1998), *POTENTIAL INUNDATION DUE TO RISING SEA LEVELS IN THE SAN FRANCISCO BAY REGION* (N. KNOWLES, 2010), AND *CREEK & WATERSHED MAP OF SAN FRANCISCO* (M.T. RAMIREZ-HERRERA, J.M. SOWERS, C.M. RICHARD, AND R.M. GROSSINGER, 2006) ∞ MAP APPEARS ON PAGES 148–149

ACKNOWLEDGMENTS

This atlas is a valentine of sorts to a complex place, and much of its richness and range is manifest in the splendid crowd of characters who helped me bring *Infinite City* into being. These people—researchers, cartographers, artists, editors, curators, old-timers, biologists, Buddhists, musicologists, lovers of their city and their subjects—are the best of the place in miniature (in my version of it). There are infinite other versions. I worked on every map in this book with cartographers, researchers, writers, and artists, and I came out of this project with a much deeper sense of my region and with deeper ties to people as well as to locations, and of course a place is made of both. A valentine it is, but one that tries to see the place whole, with its toxic sites and crimes and tragedies as well as its treasures and cultures.

The project began when Frank Smigiel, public programs curator of the San Francisco Museum of Modern Art, asked me to propose a project for the museum's seventy-fifth anniversary year, 2010. I proposed what I'd wanted to do for a long time: an atlas, this atlas, with SFMOMA distributing seven of the maps as free broadsides and holding public events associated with the release of these maps (which is indeed part of the project, though this book is its ultimate form). To my surprise, the museum said yes, and Frank became a friend and a valuable collaborator as the project unfolded over the next three years. Once SFMOMA had expressed interest, I took the proposal to Niels Hooper, my wonderful editor at University of California Press, and was again encouraged to move forward—in this case, with a complex book that demanded a lot of resources from the press, and for that confidence and generosity I am grateful. Early on, my friend Susan Schwartzenberg, a great visual artist and urbanist, was to be part of *Infinite City*; as a result of her hectic schedule and my strong notions about the nature of the project, we did not end up working together, but her friendship, encouragement, and insight were great gifts to me as I moved forward. (Her public artwork, the Rosie the Riveter Memorial in Richmond, California, is one of the significant locations marked on the "Shipyards and Sounds" map.)

This project could not have come into being were it not for Lia Tjandra, UC Press's art director and this book's designer. We had not met before the project began, but I quickly became enchanted by her vision and talent, her ability to cope calmly with the mountain of work and chaos of data we sent her way and her skillfulness in making some kind of order and harmony out of it all, her eye for color, and her ability to solve problems with beauty. This book is hers as well.

Ben Pease began as chief cartographer for *Infinite City*, and somewhere in the summer of 2009 his wife, Shizue Seigel, joined him in making the maps. With great patience, Ben

and Shiz invented a viable process for turning data into beautifully designed maps, while contributing immensely from their own knowledge of the area again and again as well as drawing on their own creativity in figuring out how to represent stories and histories on maps. (Both of them arrived in San Francisco at age eleven, separately.) Their other local mapping projects—such as one that depicted California's Japantowns, past and present—were models for some of these maps and are treasures in their own right.

San Francisco–born Stella Lochman became my research assistant and Girl Friday for this project and quickly became an expert at locating lost landmarks of the city. She brought a deep knowledge of and love for the place to the project and was a delight to work with.

Early in the project, I went to visit the extraordinary map collector, librarian, and historian David Rumsey. His encouragement, and that of his wife, librarian Abby Smith Rumsey, was immensely valuable in launching the project, as was viewing his collection, both in person, which was glorious, and online at davidrumsey.com. One of the highlights of the project came in 2009, when more than a dozen of the participants visited his map rooms, a treasure trove of centuries of atlases and maps in all scales. Maps make many people happy, I discovered in the course of this project, and the excursion was a great joy.

Alison Pebworth was one of the people I had my eye on from the beginning. Though all the other maps here are original to the project, she graciously let Ben and Lia turn her big painting *Phantom Coast* into our small map "Third Street Phantom Coast." She is also the artist of the stunningly, elegantly apt iconographic title page and cover design and is herself one of San Francisco's little-known treasures.

Additional cartography came from Robin Grossinger and Ruth Askevold of the San Francisco Estuary Institute, who oversaw the creation of the "Once and Future Waters" map, both superb historians and lovely people. I met Ohlone tribal activist and environmental historian Chuck Striplin at the Estuary Institute early in the project's history, and the maps and ideas he generously shared with me steered me toward what became "The Names before the Names." Artist-librarian Lisa Conrad, who has a deep interest in place names and indigenous names, took on the task of assembling the data for that map and writing the accompanying essay. For their generosity and assistance, she adds her thanks to Randall Milliken, Paul Scolari, Chuck Striplin, and Nick Tipon. Ben Pease completed the map with details of wetlands and other lost geographical features of the region.

Richard Walker and Darin Jensen of the Department of Geography at the University of California, Berkeley, gave us the map Jensen had made for Walker's magisterial book *The Country in the City: The Greening of the San Francisco Bay Area.* It became "Green Women," and Dick helped me select the women environmentalists to commemorate and wrote an invaluable essay. The map is a monument to those extraordinary women and also to his research into how the region's vast green space was saved. Hugh d'Andrade quite literally put the women on the map with his wonderful commemorative border.

Sandow Birk, whose work I have long and fervently admired, brought his wit and talent for revising art historical iconographies and aesthetics to "Right Wing of the Dove." Photographer Jim Herrington shot images for an earlier version of "Cinema City" (one of which appears in the text) and for "Death and Beauty," more gifts.

Individual maps were created in consultation with scholars and experts who gave generously of their time. Liam O'Brien, who knows San Francisco butterflies better than anyone, met with me at the Café Flore to share his knowledge, on display in "Monarchs and Queens." My dear friend and neighbor Aaron Shurin, who has written gorgeously about queer San Francisco from his youth in the 1960s onward in his book *King of Shadows,* blessed the selection of bars and public sites shown on this map and wrote an exquisite essay. Another dear friend, San Francisco muralist and artist Mona Caron, found a brilliant way to both respect all the data already on the map and fill the entire space with her vision—a Sister of Perpetual Indulgence with diaphanous wings and an array of local butterflies (each painted butterfly on the map represents a real species).

Painter Sunaura Taylor brought her verve and sharpness as well as her wonderful draftswoman's talent to "Poison/Palate." Ben Pease and writer Heather Smith helped to assemble the data for that map. Heather also conducted interviews with the centenarians we tracked down for the map "Four Hundred Years and Five Hundred Evictions" and contributed an essay that is both a biting portrait of San Francisco as the very antithesis of a sanctuary city and a fine example of her ravishing prose. San Francisco designer Mike Kuniavsky kindly let us borrow his mapping of five hundred Ellis Act evictions over a five-year period, and Shiz turned each elder's life into a zigzag path across the city.

Frank Smigiel's question about why San Francisco has such a small African American population helped generate the map "Shipyards and Sounds," a project led by geographer and musicologist Joshua Jelly-Schapiro, who did much of the research (with additions by Stella, Shiz, and myself) and wrote a great essay—and he too was a pleasure to work with.

Writer Summer Brenner stepped in late to contribute a moving essay for the map "Death and Beauty," one that deepened my own sense of what we were doing in portraying these things, and Shiz again stepped up, helping me plot the Monterey cypresses on this map.

My friend Gent Sturgeon, who was my salvation twenty years earlier when I was working on my first book (about the visual artists who were part of beat culture in San Francisco), was the obvious person to adorn the map of the Fillmore. He created an artwork that is as enchanting as it is startlingly right as a design solution, and it was wonderful to work with him again. His husband, Patrick Marks, of Green Arcade bookstore (included in the "Who Am I Where? ¿Quién soy dónde?" map), was also a great aid to the project and a great friend before, during, and after.

Adriana Camarena was a natural for "The Mission" map, and she brought passion, compassion, insight, and genius to what became a huge project, of which her essay here is only a taste. (The research she began for that map and essay will continue as a separate book.) No one else could have done it nearly as well, and it was a joy to watch her research and thinking develop and to benefit from her empathic insight into the lives of the undocumented immigrants and inner-city residents who are her neighbors.

Excavating the lost industrial world of San Francisco was an adventure in which Stella led the way and Shiz and Chris Carlsson supplied crucial clues, and Chris also contributed an essay. Stella, Adriana, Frank Smigiel, and City Lights book buyer Paul Yamazaki joined me on an early-morning tour of the 6 A.M. bars that constitute the remnant of this working world, depicted in "Graveyard Shift." It was actually a comment by Paul that prompted me to map the bars, while a conversation with Supervisor John Avalos in a café on Ocean Avenue made me realize that these lost worlds of blue-collar San Francisco needed to be marked, so thanks to both of them.

Ira Nowinski's photographs of the lost world of the South of Market area constitute one of the most important documentary projects in the city's history, a project on a par with the Chinatown work of Arnold Genthe. I had long admired them and was grateful he allowed us to use them in "The Lost World," a map carefully assembled with research help from Stella and Ben early in the project when we were still figuring out what we were doing and how to do it.

Many of the maps overlap thematically: the Ellis Act evictions of "Four Hundred Years and Five Hundred Evictions" are part of the same story of erasure told by the "Fillmore" and "Lost World" maps, which depict the ravages of redevelopment. Together with "Third Street Phantom Coast" and "Graveyard Shift," they constitute a portrait of urban loss and economic change. The changed shores of "Third Street Phantom Coast" also link it to the final map in this book, "Once and Future Waters." And that final map reaches both into the future and back to the original landscape with which the book begins. These maps were meant to be read together as a way to sift and resift the flow of time and intent in this place and to recognize the multiplicity of layers, only a few of

which can be portrayed at a time, but all of which can be orchestrated into a vision of an infinitely complex city.

At a New Year's Eve party in 2008, at the Mission District home of Guillermo Gómez-Peña and Carolina Ponce de León, I asked Jaime Cortez whether he might have an idea for a map; happily, the answer was yes, and I had the double pleasure of getting to know him better and watching a gorgeous map in the mode of Covarrubias develop, as "Tribes of San Francisco."

"Who Am I Where? ¿Quién soy dónde?" was born in a conversation with my friend Ásta Sveinsdóttir, who teaches metaphysics at San Francisco State University. When she told me she was writing an essay on geographically contingent identities, she inspired me to come up with this map, which writer and performance artist Guillermo Gómez-Peña graciously joined me in creating. Guillermo's work is often about geographically inflected identities, transgressions, borders, and cross-cultural encounters, though usually on a larger scale than neighborhoods, but he is a great lover of San Francisco and brought a poetic vision and a very different perspective—by race, gender, and local geography, if not by values—to this map. Another joy, especially in working with a dear friend.

Environmental photographer Bob Dawson was for many years the codirector (with his wife, Ellen Manchester) of the Water in the West project, during which he often joked about a "Coffee in the West" parallel project, so he was a natural to investigate the systems depicted in "The World in a Cup." He did so beautifully and exhaustively. I joined Bob on a field trip to the organic dairy that is McClure Ranch in West Marin to photograph the cow on that map and to the coffee distributor Due Torri to see Fair Trade organic coffee being roasted, delightful outings both; we are grateful to Vincent Virzi of Due Torri and Bob McClure for their hospitality and for bringing us their superb coffee and milk year after year. (Many years before, I joined Bob and Ellen on a trip to Hetch Hetchy, the Sierra reservoir where most of San Francisco's water originates.)

It was at a brainstorming dinner with my friends Sarah Stern and former San Franciscan Paul La Farge that Sarah came up with the idea of the "Phrenological San Francisco" map, which Paul elaborated so festively. Once it was done, Paz de la Calzada was the obvious artist to finish off this portrait of the city as a busy head. Paul proved that the eccentric can be insightful in his delightful essay, and Paz made our city beautiful and hirsute.

For the salmon portions of "Dharma Wheels and Fish Ladders," wildlife biologist and salmon expert Derek Hitchcock provided crucial research, resources, and knowledge, while poet and Zen Center resident Genine Lentine provided great help in vetting the Buddhist locations on this map—and wrote a lovely essay reflecting on the connections between these two phenomena. Ben Pease added to both sides of the research and did a wonderful job in tying them together.

Michael Rauner came in late in the day and made the images that pulled together "Truth to Power"; he contributed enthusiasm for the project and love for the city as well.

A generous grant from Creative Capital was the source of nearly all the payments to the artists, writers, and cartographers, and their support made this project possible. Huge thanks to them, particularly Ruby Lerner and Sean Elwood.

Great gratitude is also due to UC Press editor Dore Brown, who came into the project midway, as the book itself began to take shape, and exercised the discipline and attention necessary to make all these fragments into an atlas at last. Mary Renaud's copyediting made considerable improvements to the project and saved me from some of my errors. Juliana Froggatt and many others at University of California Press and the San Francisco Museum of Modern Art also contributed to making this ambitious project possible, and thanks also goes to them, as well as to many others I may have forgotten—sometimes it seems as though I met and received the encouragement of a whole city of people in the course of this project.

CONTRIBUTORS

RUTH ASKEVOLD is a geographer at the San Francisco Estuary Institute. She specializes in historical maps and the application of geographic information system technology to historical landscape change.

SANDOW BIRK is a Los Angeles artist whose work has dealt with contemporary life in its entirety. His past themes include inner-city violence, graffiti, political issues, travel, prisons, surfing, skateboarding, Dante, and the Iraq War. He is the recipient of many awards and has exhibited extensively.

SUMMER BRENNER is the author of more than ten works of poetry and fiction, including *I-5*, a crime novel that explores sex trafficking, and *Richmond Tales: Lost Secrets of the Iron Triangle*, a novel for youth, which received a 2010 Richmond Historic Preservation award.

ADRIANA CAMARENA: Born in Mexico City, raised in the Americas, Mission District resident since 2007. Doctor of the science of law, Stanford Law School, Stanford University. Former senior officer of the Mexican federal government. International legal consultant; law and society researcher. Voluntary after-school tutor at Seven Tepees. Writer across borders.

CHRIS CARLSSON, director of the multimedia history project Shaping San Francisco, is a writer, publisher, editor, and community organizer who helped launch Critical Mass, bike-ins that have spread to five continents. His books include a novel, *After the Deluge* (2004), and his most recent work, *Nowtopia* (2008).

MONA CARON is a Swiss-born, San Francisco–based artist who has freelanced as an illustrator since 1996 and as a muralist since 1998. Her mural work includes large-scale public art projects as well as private commissions. Her illustration work includes editorial, poster, and book illustration, and pro bono graphics for progressive groups.

LISA CONRAD received her MFA in studio art from the University of Illinois at Chicago, School of Art and Design; her BA from Bennington College; and a master's in library and information science from San Jose State University. Her work has been shown in San Francisco, Chicago, New York, Minnesota, and Ohio. She resides in Oakland, California.

JAIME CORTEZ is a Bay Area writer and artist whose short stories and essays have appeared in more than a dozen anthologies. Jaime uses humor to explore queerness, poverty, and American acculturation. His visual art has been exhibited at the Oakland Museum of California, the Berkeley Art Museum, Galería de la Raza, and Intersection for the Arts.

HUGH D'ANDRADE is a San Francisco–based artist and illustrator. His work has appeared on posters for acts such as Elvis Costello and Lucinda Williams; on book jackets, T-shirts, and skateboards; and on the cover of *Communication Arts*.

ROBERT DAWSON is an instructor of photography at Stanford University and San Jose

State University whose books include *The Great Central Valley: California's Heartland; Farewell, Promised Land: Waking from the California Dream*; and *A Doubtful River*. He is the recipient of an NEA grant and numerous other awards.

PAZ DE LA CALZADA, a native of Spain, works in drawing, sculpture, and installation. She was originally invited to the Bay Area to participate in the Djerassi Resident Artist Program and has had additional residencies at Kala Art Institute and the Millay Colony for the Arts in New York. She maintains a studio in San Francisco.

GUILLERMO GÓMEZ-PEÑA is a performance artist/writer and the director of the art collective La Pocha Nostra. Born in Mexico City, he came to the United States in 1978 and has since explored cross-cultural issues through performance, multilingual poetry, journalism, video, radio, and installation art. He is a MacArthur Fellow and an American Book Award winner.

ROBIN GROSSINGER is a scientist at the San Francisco Estuary Institute, where he analyzes how California landscapes have changed since European contact. His research synthesizes history and science to guide the restoration of coastal, riverine, and terrestrial ecosystems.

JIM HERRINGTON has taken pictures since he was a teenager, when he photographed the big-band clarinet titan Benny Goodman. Herrington's photography has appeared in magazines, on album covers, and in advertising. Herrington is currently working on a series of portraits of the legends of American mountaineering. He lives in NYC.

JOSHUA JELLY-SCHAPIRO is a doctoral student in geography at the University of California, Berkeley. He writes about arts and culture for publications including the *Believer*, the *Nation*, and the *New York Review of Books*.

DARIN JENSEN is the staff cartographer and cartography and GIS lecturer in the Department of Geography at the University of California, Berkeley. His professional interest is in bridging the chasm between the aesthetics of traditional cartography and the computing power of GIS in the service of a new map paradigm.

PAUL LA FARGE is the author of three works of fiction: *The Artist of the Missing*; *Haussmann, or The Distinction*; and *The Facts of Winter*. He was a proud resident of the Mission for eight years and remains on the lease of an apartment there, although he has lived in New York since 2002.

GENINE LENTINE's chapbook *Mr. Worthington's Beautiful Experiments on Splashes* was published by New Michigan Press in 2010. Current essay projects include "Poses: An Essay Drawn from the Model" and "Slug or Snail: Assays on Velocity and Viscosity." She is the artist in residence at the San Francisco Zen Center for 2009–2010.

STELLA LOCHMAN is a born and raised San Franciscan. She is a product of Noe Valley, the Outer Sunset, and SoMA. Having recently graduated from the Art History department at San Francisco State University, she works in the Public Programs department at SFMOMA and is the film editor for *San Francisco Arts Quarterly*.

IRA NOWINSKI was born in New York City in 1942 and received an MFA in photography at the San Francisco Art Institute in 1973. His publications include *No Vacancy, Café Society, A Season at Glyndebourne, In Fitting Memory*, and *Ira Nowinski: The Photographer as Witness*. His work is in collections at SFMOMA; the Green Library, Stanford; and the Bancroft Library, UC Berkeley.

BEN PEASE has been exploring and mapping San Francisco since he arrived as a boy in 1976. A freelance cartographer since 1996, he makes custom maps for books, brochures, and websites. He also publishes a series of Pease Press trail maps showing hidden corners of San Francisco and Bay Area parks.

ALISON PEBWORTH is a project-based artist and painter. She has received support for her work from the Center for Cultural Innovation, Southern Exposure, San Francisco Arts Commission Cultural Equity Grants, and National Residency programs. Her most recent project, Beautiful Possibility, may be viewed at www.beautifulpossibilitytour.com.

MICHAEL RAUNER is a San Francisco–based photographer whose work resides in numerous private and public collections, including the collections of SFMOMA and the Bancroft Library. Rauner's' book projects about unusual and often sacred pockets of California include the acclaimed *The Visionary State: A Journey through California's Spiritual Landscape.*

SHIZUE SEIGEL is an artist, writer, and cartographer's assistant for Ben Pease. She is the author of *In Good Conscience: Supporting Japanese Americans during the Internment.* Her artwork has been exhibited by the Women's Caucus for Art, Asian American Women's Artists' Association, Kearny Street Workshop, UC Santa Barbara, and others.

AARON SHURIN is the author of a dozen books, including the poetry collections *Involuntary Lyrics* (2005) and *The Paradise of Forms: Selected Poems* (1999) and the essay collections *King of Shadows* (2008) and *Unbound: A Book of AIDS* (1997). He is a professor in the MFA in Writing Program at the University of San Francisco.

HEATHER SMITH arrived in San Francisco eight years ago with a one-way plane ticket and two suitcases. Much has happened since then. She is currently at work on a book about humans, insects, and the various misunderstandings that arise between them.

REBECCA SOLNIT has been in the Bay Area since shortly before kindergarten and San Francisco since slightly after turning eighteen. She is the author of twelve previous books, many of which deal with San Francisco, California, landscape, geography, or all of the above, but much terra incognita remains.

GENT STURGEON is an artist living and working in San Francisco. A native of Ojai, he trained at Chouinard Art Institute and studied with Charles White, Joe Mugnaini, and Judy Chicago. He currently is producing book illustrations and covers, among other projects.

SUNAURA TAYLOR is an artist, writer, and activist whose work explores issues of disability, pollution, and critical animal studies. She has exhibited at the CUE Art Foundation, the Smithsonian Institution, and the Berkeley Art Museum. She received a Joan Mitchell Foundation Award in 2008.

RICHARD WALKER has been a professor of geography at the University of California, Berkeley, for more than thirty years. Walker has published books on a diverse range of topics in economic, urban, and environmental geography, including *The Capitalist Imperative*, and has written extensively on California, in such works as *The Conquest of Bread* and, most recently, *The Country in the City.*

Octopus by Jaime Cortez, 2010